revival of the fittest
digital versions of classic typefaces

RC Publications
President and Publisher
Howard Cadel

Vice President and Editor
Martin Fox

Creative Director
Andrew Kner

Managing Editor
Joyce Rutter Kaye

Associate Editors
Katherine Nelson
Todd Pruzan

Associate Art Director
Michele Trombley

Assistant Editors
Robert Treadway III
Caitlin Dover

Intern
Ariana Donalds

Published by
RC Publications, Inc.
104 Fifth Avenue
New York, NY 10011

Manufactured in Singapore.

33079

Revival of the Fittest:
Digital Versions of Classic Typefaces
Library of Congress
Catalog Card Number 99-074781
ISBN 1-883915-08-2

revival of the fittest
digital versions of classic typefaces

Essays by
Carolyn Annand
Jamie M. Barnett
Sheilah M. Barrett
John Dixon
Charley Foley
Jennifer Gibson
Bonnie Hamalainen
Mary Beth Henry
Leland M. Hill
Janet Horst
Roy McKelvey
Philip B. Meggs
Ansel M. Olson
Pornprapha Phatanateacha
Julie L. Rabun
David Steadman
Jarik van Sluijs
Shih-Tien Yang

Edited by Philip B. Meggs
and Roy McKelvey
Design consultant: Ben Day

Published by
RC Publications, Inc.
New York, NY

Over the past two decades, digital technology has changed major aspects of our society. Many of these advances—from computer-regulated automobiles to retail laser scanners—impact our lives in a significant way, but do much of their work behind the scenes. In the realm of visual communications, new technology has completely altered our perceptual experience. Typography, images, and even the very nature of space in graphic and kinetic media have been profoundly reincarnated.

Very few other fields of human endeavor have undergone such rapid and irrevocable change as typography. Two decades ago, our typefaces were produced by a small number of equipment manufacturers and font distributors. Their dominance was challenged and destroyed by the digital revolution. The arrival, damnation, acceptance, and eventual embrace of microprocessors in the 1980s now seems like ancient history. New tools often spawn vast democratizing processes: people who were barely aware of the differences between serif and sans-serif type now discuss their favorite fonts with authority and ease.

Today, individual designers sit at their desktop computers and create all manner of experimental, expressionistic, and downright weird typefaces. Thousands of new fonts have been created by designers exploring every conceivable new direction. Many observers consider this a mixed blessing, as rampant weeds compete with exquisite new flowers in the typographic garden. And many designers disagree vehemently about whether certain new extreme fonts are indeed weeds or flowers.

Much recent typographic dialogue has focused on the new, the different, and the avant garde. An astounding array of books and periodicals have devoted themselves to documenting and presenting new digital typefaces and examples of their use in graphic design. Less attention has been directed toward a parallel and equally exciting trend. In recent years, as typeface designers hurled unprecedented

new typefaces into the cultural milieu, they have also worked intensely to adapt classic typefaces that have stood the test of time to the digital realm. This process is not simply the rote conversion of existing forms from a previous technology to a newer one: a complex set of options exists when one transforms typefaces designed for earlier methodologies into bits of information.

Should a typeface designer slavishly copy the original exemplar, including numerous imperfections and inconsistencies? Or should one draw inspiration from earlier fonts, then exploit the vast potential of digital technology to refine and perfect letters, spacing, and details in the new rendition? Many early type families consisted of only roman and italic variants, or perhaps two weights and matching italics. To what degree should artistic license be taken to create a myriad of weights, widths, and postures?

Sometimes designers draw inspiration from the look and feel of a classic font to forge a totally new typeface. Fascinating hybrids result when sensitive designers synthesize attributes of one or more typographic directions into completely new fonts. Even such unequivocal distinctions as sans serif and serif have been blurred.

Typography is as susceptible to shifting sensibilities and fads as the fashion industry. For those with even a modest experience with type, terms like "gay nineties," "art nouveau," "psychedelic," and "bit-mapped" evoke specific typographic forms related closely to earlier social and cultural eras. These different forms bring richness and historical vitality to typography. While many designers enjoy exploring both period-specific and new digital fonts, they also make wide use of classic typefaces. Digital technology provides unprecedented control over type, and designers are revitalizing classic typefaces in innovative ways. Spatial possibilities such as layering and three-dimensionality; combinations of fonts; extreme scale and size contrasts; and vibrant color applications: these are just some of the ways designers are reinvigo-

rating traditional forms, which would have been unthinkable or prohibitively expensive a decade ago. In the face of all this experimentation, even the most audacious designers are drawn to beautifully crafted traditional type.

This book presents 20 major categories of type, ranging from fonts based on Claude Garamond's work from 500 years ago to contemporary designs like Meta and Frutiger, already acclaimed as classics in their own time. The history and background of each category is discussed. Both historic and recent applications demonstrate these typefaces' potential for use in contemporary practice. Outstanding new versions by leading digital type designers are presented and analyzed. Numerous diagrams and font demonstrations display design properties characterizing closely related faces. A prologue presents several designers' views as to what fundamentally defines a classic typeface. The many forces influencing the evolution of typeface design are discussed in the introduction. This book grew out of our love and fascination with the vitality and diversity of typography today. We hope it will provide information and inspiration for others who share our passion and curiosity about type. —**pbm/rm**

acknowledgments

Many people generously contributed to this book. It would not have been possible without the participation of numerous typeface and graphic designers, who provided interviews, specimens of their work, and permission to reproduce it. They are acknowledged in illustration captions and text citations. Fonts and typeface specimens for reproduction in this volume were made available by the digital foundries, which are credited as the source of their typeface designs.

This book was researched, written, and designed at the Department of Communication Arts and Design at Virginia Commonwealth University's School of the Arts; it would not have been possible without the support of John DeMao, Jr., chair of the Department of Communication Arts and Design, and Richard Toscan, dean of the School of the Arts. The VCU Communication Arts and Design graphics lab manager, Jerry Bates, and his student assistants provided tireless energy in outputting countless laser proofs. Beata Dobrocsi provided design assistance. Joe Dimiceli, manager of our computer labs, was always able to resolve problems with hardware and software. In addition, both Jerry and Joe provided immeasurable counsel and advice. Ben Day worked closely with us as a design consultant on the development of the format, cover design, and chapter layouts. His invaluable

insights and masterful understanding of form and space made a significant contribution.

The prologue was compiled and designed by Sheliah Barrett and Philip B. Meggs. The introduction was written and designed by Philip B. Meggs and Roy McKelvey; Janet Horst contributed to the section about the effects of digital distortion on letterform design.

The author of each chapter designed the pages of that chapter. The format and typographic standards were developed by Carolyn Annand, Charley Foley, Mary Beth Henry, David Steadman, Jarik van Sluijs, and Shih-Tien Yang using the Caslon chapter as the prototype.

Our editors at RC Publications, publishers of *Print* magazine, devoted countless hours to this project. Katherine Nelson served as managing editor, with additional editorial work by Martin Fox, Joyce Rutter Kaye, Todd Pruzan, Caitlin Dover, and Ariana Donalds. John Berry read the manuscript and made numerous editorial suggestions.

ProVision of Singapore printed and bound this book. Alice Goh, Eloyse Tan, and Esther Goh guided it through the production process.

contents

the rebirth of the classic typefaces

brought with it a typographic revival

the world over...

jan tschichold

For the prologue to this book, we asked several designers this question: what makes a typeface a classic? Here are a few of their answers.

In addition to all the functional and esthetic concerns, a typeface that continues to be used beyond its period of fashion, in my book that is a classic.
Steven Heller, *editor and art director*

From my point of view, a classic typeface never goes out of style.
Paula Scher, *designer*

I assume that what makes a typeface a classic is what makes most things a classic:

1. It is representative of a certain time, created using current technology, for instance.
2. It is well-known. There are many capable fonts, but if they are not properly marketed they don't stand a chance.
3. It holds a certain significance. It has to be tied, philosophically, to a certain high-profile movement or person.
4. It is well-produced.
 Rudy VanderLans, *editor, designer, and publisher*

ITC AVANT GARDE

ITC NEW BASKERVILLE ITALIC

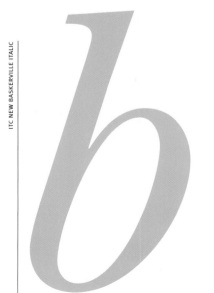

ADOBE CHARLEMAGNE

Classic: that which has not
been surpassed and which can be
repeated—again and again—
without suffering from the repetition.
David Colley, *designer and educator*

Four typefaces are enough to
address every typographic problem.
Every digitization of an old typeface
is, for me, a fake.

Back to your question, "What makes a
typeface a classic?" My personal, short
answer: typefaces that have survived over
decades have these hidden qualities.
Wolfgang Weingart, *designer and educator*

Traditionally, the classical Latin book face embodies the qualities of balance, proportion, practicality, and elegance of form. Our modern Latin alphabet was solidified during the Renaissance by such type notables as Nicolas Jenson and Francesco Griffo. Through craft and artistry, early type designers were able to distill from classical manuscripts and Roman inscriptional lettering the principles of form that they adapted to the rational medium of metal type. They laid the framework of our modern Latin alphabet, which all subsequent types must address, at least in principle.

From the early days of typefounding until the last 100 years or so, adherence to classic forms was standard practice. Typefaces were used primarily for text composition, and it was imperative that they comply with principles of legibility and functionality. Most types were rooted either directly or indirectly in proven handwriting or lettering disciplines. The engraved lettering styles and copperplate handwriting of the 17th century served as a springboard for the development of the modern face, and national scripts usually had a typeface counterpart. As running hands evolved, new variations on classical themes arose.

With the growth of industry and commercialism, type began to be used in nontraditional ways. The growing advertising industry began to employ more flamboyant and ephemeral display-type styles that drew attention to consumer products. The type-design field began to diverge into two factions, one of a traditional and utilitarian mindset, and the other an extension of graphic arts and pop culture. With the proliferation of computer-aided design tools, more people then ever are designing type; many exhibit little concern for classical principles, or even purposefully defy them.

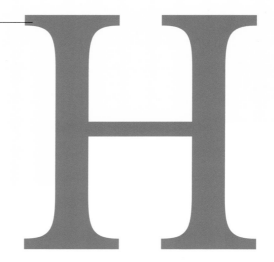

J

Today, those interested in updating classical ideals will continue to search for the stuff of modernity that feeds the slow evolution of the book face. The reservoir of classic styles from the last 500 years is continually drawn upon and updated in the form of modern revivals, or used as inspiration for new variations on historical themes. Interesting hybrids or experimental typefaces can be functional and classical if the designer demonstrates the appropriate skill and restraint. Although the well of national hands has run dry, there is an active community of skilled calligraphers throughout the world who have kept alive and modernized classical scripts, which can serve as models for new typefaces. Modernity is also influenced heavily by the nature of the digital medium, both in terms of its expectation of logically constructed forms and in its power to handle letterforms in ways that were not possible in the past.

What about the future of classicism in type design? Will nations continue to retain their individual language systems in a shrinking world? It may become necessary to adopt a universal language and simplified alphabet to accommodate the democratization of the globe. If so, the alphabets of today will eventually become obsolete. This outcome may be inevitable, but for the time being some designers will continue to strive to make typefaces that stand the test of time.

Robert Slimbach, *typeface designer*

mn

[Classic means] transcendence from context of
origin through use and reuse in new contexts.
Matt Woolman, *designer, author, and educator*

A classic typeface, especially for book work,
must be in use for many years before it can
become a standard for typographers. Letter-
forms must be designed to be easily read
without modish expression. Well-balanced
proportions and simplicity are important.
Hermann Zapf, *designer, author, and educator*

If you look at the typefaces we still use, three
things are true of them all. First, they are
typefaces employed for a wide variety of
purposes. They work; they are legible; and
generally speaking, they are the text typefaces
that we preserve. Second, they have a unique
identity that comes through even if people
make different versions of them. Third, they
retain something of the personality and charac-
ter of the person who created them, or as in the
case of Caslon, the dynasty that created them.
It is those faces that have a life of their own and
are propelled through time.

I would love to make something that was
infinitely popular, but you never know what will
succeed. The typefaces I did at Adobe were
like that. I had no idea that Lithos would be
successful, and Tekton barely got made. Tekton
was based on the lettering that architects use
in their drawings. I think a lot of successful
typefaces grow out of very utilitarian purposes
like that.
Sumner Stone, *typeface designer*

CC GALLIARD ROMAN

ADOBE GARAMOND

Your question supposes two kinds of scratching in the sand: one below the high-water mark, going out with the tide, and another higher up on the beach that will endure. Perhaps this was true once, but the mighty Mac bulldozer has leveled the beach and now nothing is safe from the next wave. Good. It's all a toss-up anyway; some of the most indestructible types have limited aims. Look at Times Roman. Besides, worrying about fitness for survival can only lead to more revivals of Bodoni. As far as I'm concerned, the 21st century can design its own lousy typefaces. I'm with [English essayist Joesph] Addison on this one: "We are always doing something for posterity, but I would fain see posterity do something for us."
Matthew Carter, *typeface designer*

My dictionary's definition of "classic" includes the words "of recognized value . . . a standard of excellence . . . traditional . . . enduring . . . authentic . . . authoritative." Any typeface imposes on the written word a certain voice, a certain personality. A trendy, gimmicky face will call attention to itself rather than the message. Beatrice Warde wrote about "invisible typography," meaning typography that steps aside to let the message speak loud and clear. A classic typeface is like a perfect radio announcer or newscaster, whose voice is free of all the quirky colorations of regionalism, colloquialism, accent, street slang, and the like.
Howard Paine, *art director*

Classic typefaces are marked by the harnessing of individually engaging letterforms within a harmonious whole. They have proportions— of x-height, width, and weight—that fall within a narrow range of acceptable forms bound by the letters of the Trajan Column inscription at one end and the 19th-century grots of Stevens, Shanks & Sons at the other. And, for a typeface to be truly classic, letterfit is as crucial as lettershape.
Paul Shaw, *typeface designer*

Marketing will determine which typefaces will continue to be used in the next century. Obviously, good esthetic qualities are important, too; but what will those esthetics be? That remains to be seen. Type will have to be big, so that advertising messages can be projected from satellites onto the mirrors on people's cars. These cars will of course be driven by computer chips, so people will need to have something to do while they're sitting there.

I have a hard time believing Helvetica will ever go away. And I'm sure that in the future, there will be some RAMs with Chicago on them. Legibility will continue to be challenged, as it always has been. In the old days, however, legibility was challenged by obscuring type with elaborate florals and other organic matter. Today there is an urban street-stomped, roadkill kind of font that is challenging legibility; it's more violent. The publishing community will continue to adopt this look because there is a market for it, but of course, there will always be people who will respond to classic typography.
David Berlow, *typeface designer*

FUTURA LIGHT

BUREAU GROTESQUE THREE-FIVE

MONOTYPE GILL SANS

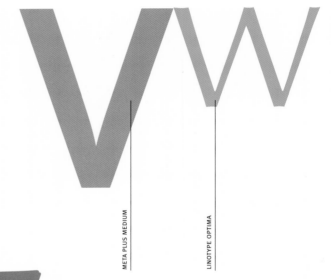

Behind every typeface are two distinct sets of influences: the personal tastes of the designer on the one hand, and the functional constraints of the machine on the other. For a face to become a classic, all of these concerns must reach an equilibrium, with no single attribute dominating another. The original cuts of Franklin Gothic and Meta are surely bound for a similar destiny. In these designs, the taste of the designer is as important as anything else. The face must be just as interesting as it is useful. A typeface cannot be timeless all on its own; people must want it to stay around, and for that a distinct flavor is necessary. Bare function is not enough.

There are designs, though, that nobody can be objective about, because they have been around so long. Helvetica is timeless, since it will simply never go away. For similar reasons, Garamond (in most versions, at least) is timeless, too. Bodoni and Calson are beyond the normal scope of consideration. Whatever their inherent qualities, these faces will endure because they have endured for so long already.
Tobias Frere-Jones, *typeface designer*

LINOTYPE NEUE HELVETICA 75

META PLUS MEDIUM

LINOTYPE OPTIMA

"What makes a typeface a classic?" [My answer] was inspired by a description of a DNA computer problem and the IVY tarot card.

A classic typeface is not an object but a relationship.

It is a path from start to finish going through all points only once.

A nondeterministic polynomial time problem. On its own in another existence.
Nancy Skolos, *designer*

ADOBE JENSON

With so many typefaces available, the Darwinian theory of survival of the fittest comes into play. Only for a short time is room made for typefaces that are deformed or misaligned by their creator.

A classic typeface adapts by appearing to change over time. It has to hold up in a society that says more is better and stand out among the proliferation of cheaply made typefaces that are produced in record time. It is not that a classic typeface has actually changed its structure or its appearance, it's an inanimate object, but it seems to have the ability to distinguish itself—it beckons within a sea of type. It is this innate quality that allows the observer to rediscover the beauty found within the typographic anatomy.
John T. Drew, *graphic designer*

MONOTYPE TIMES NEW ROMAN

ADOBE TRAJAN

A classic typeface is defined not only by its longevity, but also by its adaptability over time. It must not only be classically proportioned, but also hold up under current constraints. It must be accessible and that accessibility must be timely, and timeless.

Any typeface not used in the correct context can be abused. Classic typefaces are built in response to the fundamental understanding that abuse takes place, restraint is crucial, adaptability is essential, and use is paramount. The inheritance of a typeface and its embrace by the next generation through its use and rediscovery is by nature a divergent process. Its abuse in the eyes of one generation is the rediscovery and adaptability in the next. This resonance makes a typeface classic.
Sarah Meyer, *graphic designer*

typography is the craft of endowing

human language with a durable visual

form, and thus with an independent

existence.

robert bringhurst

INTRODUCTION

ue maria
gͤa plena
dominus
tecũ bene
dicta tu in mulierib⁹
et benedictus fruct⁹
uentris tui : ihesus
christus amen.

Glozia laudis resonet in oze
omniũ Patri genitoqȝ pzoli
spiritui sancto pariter Resul
tet laude perhenni Labozi
bus dei vendunt nobis om
nia bona. laus: honoz: virtuſ
potétia: ꜩ gratiaꝝ actio tibi
chziste. Amen.

Viue deũ sic ꜩ vines per secula cun
cta. Prouidet ꜩ tribuit deus omnia
nobis. Proficit absque deo null⁹ in
ozbe laboz. Illa placet tell⁹ in qua
res parua beatũ. Øe facit ꜩ tenues
luxuriantur opes.

Si fortuna volet fies de rhetoze consul.
Si volet hec eadem fies de cósule rhetoz.
Quicquid amoz iussit nó est cótédere tutũ
Regnat et in dominos ius habet ille suos
Vita data é vt́ da data é sine fenere nobis.
Mutua: nec certa persoluenda die.

Usus ꜩ ars docuit quod sapit omnis homo
Ars animos frangu ꜩ firmas dirimit vzbes
Arte cadunt turres arte leuatur onus
Artibus ingenijs quesita est glozia multis
Pzincipijs obsta sero medicina paratur
Cum mala per longas conualuere mozas
Sed propera nec te venturas differ in hozas
Qui non est hodie cras minus aptus erit.

Non bene pzo toto libertas venditur auro
Hoc celeste bonum pzeterit ozbis opes
Pzeclaris animi est bonis veneranda libertas
Seruitus semper cunctis quoque despicienda
Summa petit liuoz perflant altissima uenti
Summa petunt dextra fulmina missa iouis
In loca nonnunquam siccis arentia glebis
Øe prope currenti flumine man ar aqua

Quisquis ades scriptis qui mentem forsitan istis
Ut noscas adhibes protinus istud opus
Nosce: augustensis ratdolt germanus Erhardus
Litterulas istos ozdine quasqȝ facit
Ipse quibus veneta libzos impzessit in vzbe
Multos ꜩ plures nunc premit atqȝ pzemet
Quique etiam varijs celestia signa figuris
Aurea qui primus nunc monumenta pzemit
Quin etiam manibus propzijs vbicunqȝ figuras
Est opus: incidens dedalus alter erit

Nobis benedicat qui i trinitate vinit
ꜩ regnat Amen: Honoz soli deo est tribuendͧ
Aue regina celoꝝ mater regis angelo
rum o mama flos virginum velut rosa
velilium o maria : Tua est potentia tu
itgnn ͣ domine tu es super omnes gen
tes da pacem domine in dieb⁹ nostris
mirabilis deus in sanctis suis Et glozi
osus in maiestate sua ozb pantbon kyr

Quod prope sacce diem tibi sum conuiua futurus
forsitan ignozas atfore ne dubites
Ergo para cenam non qualem stoicus ambu
Sed lautam sane moze cirenaico
Nanque buas mecum flozente etate puellas
Adducam quarum balsama cunnus olet
Vernula sola domi sedeat quam nuper habebas
Si nondum cunnus vepzibus hozruerit
Sunt qui mfimulent ꜩ auari cottera amica
O bicant facto rumoz utiste cadat Hec Philelphus

Punc adeas mira quicunqȝ uolumina queris
Arte uel er animo pzessa fuisse tuo
Seruiet iste tibi: nobis iure sozozes
Incolumem seruet usqȝ rogare licet

Est homini uirtus fuluo preciosior auro: ænæas
Ingenium quondam fuerat preciosius auro.
Miramurqȝ magis quos munera mentis adornát:
Quam qui corporeis emicuere bonis.
Si qua uirtute nites ne despice quenquam
Ex alia quadam forsitan ipse nitet

Nemo suͤ laudis nimium lͤtetur honore
Ne uilis factus post sua fata gemat.
Nemo nimis cupide sibi res desiderat ullas
Ne dum plus cupiat perdat & id quod habet.
Ne ue cito uerbis cuiusquam credito blandis
Sed si sint fidei respice quid moneant
Qui bene proloquitur coram sed postea praue
Hic erit inuisus bina ꝙ ora gerat

Pax plenam uirtutis opus pax summa laborum
pax belli exacti præcium est præciumque pericli
Sidera pace uigent consistunt terrea pace
Nil placitum sine pace deo non munus ad aram
Fortuna arbitriis tempus dispensat ubi
Illa rapit iuuenes illa serit senes

κλίω Τευτερπη τε θαλεία τε μελπομένη τε
Γερψιχορη τερατω τε πολυμνεία τουρανιι
τε καλλιόπη θεͅΔη προφερεϡατη εϡίναπα
σαωψ ιεονͧ Χριϛονͧ μορια τελοϛ.

Indicis characteꝝ diuersaꝝ mane
rienͧ impzessioni parataꝝ: Finis.

Erhardi Ratdolt Augustensis viri
solertissimi: pzeclaro ingenio ꜩ miri
fica arte: qua olim Venetijs excelluit
celebzatissimus. In imperiali nunc
vzbe Auguste vindelicoꝝ laudatissi
me impzessioni dedit. Annoqȝ salu.
tis. Ø. LLLLL. LXXXVI. Lalé.
Apzilis Sidere felici compleuit.

Typeface design is shaped by a

These have interacted

fascinating interplay of three factors:

since the early decades of

technology, esthetics, and marketing.

printing and typography.

Advances in technology and craft have enabled designers of successive eras to create typefaces with greater complexity and refinement of form, and in a wider range of sizes. Over the past 500 years, technology has evolved from handicraft, through the machine production of the industrial revolution to the electronic processes of the digital age. Typography, like most areas of human endeavor, has developed within the framework of these sweeping advances.

While technology has extended the possibilities for typeface design, the vast library of letterforms is a direct result of designers' visual imaginations. The esthetics of typography have taken many directions over the centuries. During some periods, the creative vision of an individual designer propelled type design down untraveled roads. At other times, a prevailing esthetic spanning diverse areas such as architecture, furniture, and painting influenced the design of typefaces. Design approaches have ranged from efforts to create unusual typefaces for limited, highly visible display, to widespread movements seeking a uniform typographic approach that results in a universal typographic style for the period.

The marketing of typefaces began in the 1400s when typefounders first distributed simple specimen pages. As early as 1486, Erhard Ratdolt produced a typographic specimen sheet (Fig. 1) that displayed his type designs. Ratdolt had left Venice and relocated to Augsburg, where he printed the specimen to demonstrate his ability in designing and manufacturing type.

Typeface marketing reached a crescendo in the 19th century with elaborate specimen books (Fig. 2) showing hundreds of fonts and demonstration layouts. In the 1890s, type manufacturers made extensive use of trade-magazine advertisements to promote their new offerings. During most of the century, a small number of foundries and typesetting equipment manufacturers dominated the field; their marketing efforts included publication of newsletters, magazines, and tabloid newspapers combining editorial information with promotional material about their typeface designs. As the 21st century approached, CD-ROMs and the Internet (Fig. 3) emerged as the primary method to sell and distribute fonts. Marketing has inspired a relentless proliferation of typefaces. Contemporary electronic foundries, like the metal type foundries of the past, seek new typefaces to release and promote each year.

1

Typographic specimen sheet, 1486.
Designer: Erhard Ratdolt.

HANDSOME
Nineteen Matrons
Sworn to Adore

DINNERS
Choice Salads
Roast Duck

SOUNDS
Piano Music

2

Typographic specimen of Congo from Barnhart Brothers and Spindlers's 880-page specimen book, 1900.

BROADCAST
Ship to Shore Communication Breakdown
LOW FUEL GAUGE
Maritime Law Prohibits Unlawful Use of Forks
WIRELESS
First Telegraph Transmission
SPARKS QUALITY RADIO
Modulations at 42 KwH
Airways are jammed by the FCC

3

Screen from the Font Bureau Web site displaying Dispatch, a new type family by Cyrus Highsmith, 2000.

4 (overleaf)

Johann Gutenberg's 42-line Bible, c. 1450–1455. Courtesy of The Library of Congress, Washington, DC.

cõmemoratione amittebãt: ut ꝙ dee-
rant tormentis replere punitio: et ipse
quidem tuus mirabilit transiret: illi
aũt nouã morte inuenirẽt. Ɔĩs enĩ
creatura ad suũ gen⁹ ab initio refigu-
rabat deseruiẽs tuis preptis: ut pueri
tui custodirentur illesi. Ɱã nubes ca-
stra eoꝝ obũbrabat: ⁊ eꝛ aqua ꝙ ante
erat terra arida aparuit: ⁊ eꝛ mari ru-
bro via sine inpdimẽto: ⁊ camp⁹ ger-
minans de profundo nimio: per quẽ
omnis natio transiuit· ꝙ regebãt tua
manu vidẽtes tua mirabilia et mon-
stra. Tanquã equi enim depauerunt
escam: et tanquã agni eꝛultauerunt
magnificãtes te domine qui liberasti
illos. Ɱemores enĩ erãt adhuc eoꝝ
que in incolatu illoꝝ facta fuerãt: quẽ-
admodũ ꝓ natione animaliũ edux-
it terra muscas: et ꝓ piscibз eructauit
fluuius multitudinẽ ranaꝝ. Ɱouilli-
me autẽ viderũt nouã creaturã auiũ:
rum abducti cõcupiscentia postulaue-
runt escas epulationis. Jn allocutio-
ne enĩ desiderij ascendit illis de mari
ortigometra: et veꝛationes peccatori-
bus superuenerũt non sine illis ꝗ ante
facta erãt argumẽtis ꝓ vim fluminũ.
Juste enim patiebãtur secũ suas ne-
quitias. Etenĩ in detestabile hospitali-
tate instituerũt. Alij quidem ignotos
non recipiebãt aduenas. Alij autem
bonos hospites in seruitutem redige-
bant. Et non solum hoꝝ: sed ⁊ alius
quidem respec⁹ illoꝝ erat: quĩ inuiti
recipiebãt eꝛtraneos. Qui autem cum
leticia receperũt hõs qui eisdẽ usi erãt
institutis: seuissimis afflixerunt dolo-
ribз. Percussi sunt autem cecitate·sicut
illi in foribus iusti: cũ subitaneis coo-
perti essẽt tenebris. Ʋ nuisꝗз trãsitũ
hostij sui querebat. Jn se enĩ elementa

dũ cõuertũtur sicut ĩ organo ꝗlitatis
sonus immutat: et omia suũ sonum
custodiũt. Unde estimari eꝛ ipso visu
certo potest. Agrestia enĩ in aquatica
cõuertebant: et ꝗcumꝗз erãt natãcia ĩ
terra transiebãt. Jgnis ĩ aqua valebat
supra suã virtute: ⁊ aqua eꝛtinguẽtis
nature obliuiscebat. Ƒlãme ecõtrario
corruptibiliũ animaliũ nõ veꝛauerũt
carnes coãbulãciũ: nec dissoluebant
illã que facile dissoluebat sicut glaci-
es bonã escam. Jn omnibз enim ma-
gnificasti ppłm tuũ domine·⁊ honora-
sti: et nõ despeꝛisti ĩ omni tẽpe et ĩ oĩ
loco assistẽs eis. Explic lib sapie. Jn-
cipꝓlog⁹ ꞕꞟu fily Syꞃach in ecclesiasticũ

ⱮUltoꝝ nobis ⁊ magnoꝛ
ꝓ legem ⁊ ꝓphetas aliosꝗ
qui secuti sunt illos sapi-
entia demõstrata ẽ: ĩ quibз
oportet laudare israꞕel doctrine ⁊ sapi-
entie causa: quia nõ solum ipsos lo-
quentes necesse est esse peritos: sed etiã
eꝛtraneos posse et discentes et scriben-
tes doctissimos fieri. Auus me⁹ iheł
postꝗ se amplius dedit ad diligẽtiã
lectionis legis ⁊ ꝓphetaꝛ ⁊ alioꝝ li-
broꝝ qui nobis a parentibз nostris
traditi sunt voluit ⁊ ipse scribere aliꝗd
hoꝝ ꝗ ad doctrinã ⁊ sapientiã ꝑtinet:
ut desiderãtes discere et illoꝝ periti fieri
magis magisꝗз attendant animo: et
cõfirmẽtur ad legitimã vitã. Hortor
itaꝗз venire vos cum beniuolentia et
attenciori studio lectionẽ facere: ⁊ vni-
am habere in illis in quibз videmur
sequentes imaginem sapientie: ⁊ defi-
cere in verboꝝ cõpositione. Ɱã deficȋ-
unt verba hebraica: quãdo fuerũt trans-
lata ad aliã linguã. Ɲõ autẽ solum
hec: sed ⁊ ipsa lex et ꝓphete ceteraꝗ; alio-
rum libroꝝ nõ paruã habẽt differẽciã

quado inter se diritur. Nam in octauo
z tricesimo anno temporibꝰ prolomei
euergetis regis postḡ puem i egiptū:
et cum multū teporis ibi fuisse inuent
ibi libros relictos nõ ꝑuue neꝫ conte
mnēde doctrine. Itaꝗ bonū et necessa
riū putaui et ipse aliquā addere dili
gentiā z labore-interꝑtandi librū istū:
z multa vigilia attuli doctrinā i spa
rio teporis ad illa ḡ volūt animū
brum istū dare:et illis ḡ ad sine ducunt li
intendere et discere queadmodū opor
teat instituere mores qui secūdum le
gen domini ꝓposuerint viram agere.

Cephē plogꝰ Jncaꝗ lib eccliasticꝰ ꝓ

OMnis sapiētia a do
mino deo ē: z cū illo
fuit semper: z est an
te euum. Arenam
maris z pluuie gut
tas z dies seli: qs di
numerauit: altitudinē celi z latitu
dinē terre z ꝓfudū abissi: qs dimēsus
est sapientiam dei ꝓcedentem omnia:
qs inuestigauit prior omniū creata
est sapiētia: et intellctus prudentie ab
euo. Fons sapientie verbū dei iexcel
sis: et ingressus illius madata eterna.
Radix sapientie cui reuelata ē: et astu
tias illiꝰ qs agnouit? Disciplina sa
pientie cui reuelata est z manifestata:
et multiplicationem ingressus illius
quis intellexit? Vnus est altissimus
creator omniū omnipotēs · z rex potes·
et metuendus nimis:sedens sup thro
num illius:z dominās deus. Ipse cre
auit illā in spiritu sancto:z vidit z di
numerauit et mēsus ē. Et effudit illā
sup omnia opera sua:et sup omnem
carnē secūdum datu suū: z ꝑbet illam
diligentibꝰ se. Timor domini gloria
z glario: z leticia z corona exultaciõis.

Timor domini delectabit cor:et dabit
leticiā z gaudiū in longitudinē dieꝫ.
Timenti deū bene erit in extremis:z in
die defūctionis sue benedicet. Dilecto
dei honorabilis sapiētia: quibꝰ autē
apparuerit i visu-diligūt eā: i visione
z i agnicõne magnaliū suoꝝ. Initiū
sapientie timor domini: z cū fidelibꝰ
in vulua concreatus est: z cum electis
feminis graditē: z cum iustis z fidelibꝰ
agnoscitur . Timor domini sciētie
religiositas. Religiositas custodiet et
iustificabit cor:iocūditatē atꝗ; gaudi
um dabit . Timenti deū bene erit inex
tremis et in diebꝰ cõsolationis illius
benedicet. Plenitudo sapientie timere
deum: et plenitudo a fructibus illius.
Omnē domū illiꝰ implebit a generati
onibus:et receptacula a thesauris illi
us. Corona sapientie timor domini:
replens pacem et salutis fructum: z vi
dit et dinumerauit eam . Vtraque
autē sunt dona dei . Scientiā et intel
lectū prudentie·sapientia cõparcietur:
et gloriā tenentiū se exaltat. Radix sa
pientie ē timere deū:rami enī illiꝰ longe
ui. Jn thesauris sapientie intellectꝰ et
sciētie religiositas:execratio autē pecca
toribꝰ sapientia. Timor domini expel
lit peccatū . Nam qui sine timore est
non poterit iustificari:iracūdia enim
animositatis illius subuersio eius ē
Vsꝗ in tempus sustinebit patiens: z
postea redditio iocūditatis . Bonꝰ sen
sus. usꝗ i tempꝰ abscõdet verba illiꝰ:
et labia multoꝝ enarrabūt sensū illiꝰ.
Jn thesauris sapientie significatio di
scipline:execratio autē peccatori cultu
ra dei . Fili cõcupiscēs sapientiā cõser
ua iusticiā: z deus ꝓhebit illā tibi. Sa
piētia enī et disciplina timor domini:
z ꝗ beneplacitū ē illi fides z māsuetudo:

Punch.

Matrix.

Type mold.

6

Detail of a typecase.

7

Type stick.

Handset metal types

When printing with movable types appeared in Germany around 1440, these types were modeled after the scribal lettering (called Textura, or sometimes Old English or blackletter) in use at the time. Textura was adapted to the radical new technology of handset metal type. Textura has straight heavy strokes with diagonal serifs, giving the page a texture sometimes compared to a picket fence. Johann Gutenberg's 42-line Bible (Fig. 4), believed to be the first book printed with movable types, used a font of metal type based on the handlettering in books of the time.

Gutenberg's system for manufacturing types began by his preparing a steel punch tapered into the shape of a letter (Fig. 5). The punchcutter scratched a reversed drawing of the letter in the end of a steel bar. A second punch, called the counterpunch, was cut and used to stamp the depressed areas of a letter, such as the two rectangles in an **H**, into the steel bar. While filing away the top of a punch to form a letter, punchcutters made smoke proofs by holding the punch over a candle flame, then "printing" the smoke from the punch onto paper. These smoke proofs enabled the punchcutter to monitor his progress.

A completed punch was used to strike an impression of the letter in a matrix made of brass or copper, metals softer than steel. To cast a piece of metal type, a matrix was mounted in the lower end of a type mold; then molten lead was poured into an opening in its upper surface. As the lead cooled, it hardened into a block of metal with a raised letter on the top. The metal types were stored in wooden cases (Fig. 6) and set into lines by hand, with characters taken from the case one at a time and placed in a type stick (Fig. 7). Lines of type were then locked into the bed of a printing press, where their raised surfaces could be inked and printed. Early punchcutters struggled to improve their craft, searching for more consistent stroke weight, better baseline alignment, and more even spacing between letters. Over the decades, improvements in the craft enabled them to cut larger and smaller fonts and refine details on letters.

By the 1460s, Italian printers were designing fonts based, not on Textura, but on capital letters in ancient Roman inscriptions (p. 34, Fig. 1) and lettering from manuscripts circa 800 A.D. These influences evolved into what we now call old-style typefaces (Fig. 9), which contain a medley of vertical, horizontal, rounded, and diagonal strokes; thick-and-thin contrast between strokes; serifs connected to main strokes by smooth tapered edges called brackets; and the weight stress of curve strokes drawn at an angle. Roman inscriptions have a capital height-to-width ratio of about ten-to-one; this proportion was adopted for old-style types and remains the proportional norm to this day.

Around 1500, the first italic types (Fig. 10) were designed in Venice by Francesco da Bologna, surnamed Griffo, based on handwriting styles of the time. Italic letters slant to the right and are narrower than roman letters. During the Renaissance, italics were considered a separate category of type, used to conserve space in small books. Today we use italics primarily for emphasis and contrast, as a member of a coordinated type family. Early printers cut their own punches and cast their own types. Typefounding became an independent trade due largely to the exquisitely beautiful old-style types (Fig. 8) designed by French punchcutter Claude Garamond in the 1530s. The exceptional design and craft of Garamond's fonts prompted printers to purchase his types, ready for distribution into the compositor's case, rather than cast their own.

Old-style designs dominated typography during the 16th and 17th centuries, but during the 18th century advancements in technology permitted types with more refined details. Designers gradually increased the thick-and-thin contrast of their letterforms, made the serifs more horizontal, and gave the rounded forms less diagonal stress. Great care was given to the esthetic refinement of each letter, and type designers paid special attention to the reproduction size of each font. By 1800, typefaces were designed with extreme contrasts between thick and thin strokes. Serifs and thin strokes were reduced to horizontal hairlines. The weight stress became vertical, and the width of capitals, regularized. Fonts became more systematic, and similar letters had identical parts. These end-of-century fonts are categorized as modern (Fig. 12) while the mid-century typefaces combining both old-style and modern characteristics are called transitional (Fig. 11).

Comment ilz arriuerent en l'Isle

BEAVTE DE LAQVELLE EST IC

ensemble la forme de leur barque: & comme au descer
deuant d'eulx, plusieurs Nymphes, pour faire l
à Cupido leur maistre.

Oguans donc en ceste mar
de ou artimõ, mais auec les
auoit estendues au vent, co
moy conformes en volunt
paruenir au lieu determiné
au plus grand aise qu'onõs
tir, & langue dire, souspira
mour embrazée: & eschaul
lant à trop grand feu, leque
arriuames au port de la sai

la barque de Cupido, qui n'estoit estiuée ny chargée d
te sur les vndes, & faicte comme s'ensuyt.

Des quatre parties les deux estoiét employées l'vne e
proe, & les deux autres à la mizane, ou elle estoit plus la
Les postices auoient deux piedz de haulteur sur la cou
pied & demy. La carene & les costieres estoiét couuerte
le sortoit sur la proe, & sur la poupe esleuée en forme d
façon d'vn rouleau, au rond duquel y auoit vn riche o

8

Page detail from *Poliphili*, 1561.
Printer: Jacques Kerver. Courtesy of the
Library of Congress, Washington, DC.

old style
9
italic
10
transitional
11
modern
12

The impact of enlargement and reduction on letterform design

To fully understand the evolution of typeface design and technology, one must consider the impact of enlargement and reduction on letterform design. Designers creating contemporary versions of classic typefaces must evaluate myriad specimens of different weights and decide which printed impressions best reflect the original designer's intention. Much of the recent controversy concerning the authenticity of various type revivals based on the work of Claude Garamond or John Baskerville, for example, arises because a designer creating a new rendition can choose from so many different font sizes by the past master, and each of these is a different design. For example, a Caslon based on William Caslon's 14-point types will be a totally different typeface when compared to a font based on William Caslon's 96-point fonts, which were designed for use on posters.

Why the discrepancy among samples? Both enlargement and reduction alter visual forms dramatically, because length and width increase arithmetically, while area increases geometrically. When a two-inch tall Helvetica **H** (Fig. 13) is reduced to 50 percent, its length shrinks by one-half to become one inch long, but its area reduces to one-fourth. When the **H** is enlarged to four inches or 200 percent, its length doubles to four inches, while its area quadruples.

When any form is enlarged or reduced, the effect of this optical phenomenon is substantial. Enlargement makes shapes appear heavier and lines thicker, while reduction makes shapes appear lighter and lines thinner, to the point of vanishing. This was not a concern for typeface designers during the era of handcut punches. Since each size was individually cut on steel punches, a designer could subtly change the letters. Thin strokes and serifs were made heavier in small sizes (compared to large display types whose serifs were cut proportionally smaller) and thin elements were made thinner.

15

The impact of scale on type design can be seen by examining the work of the 18th-century English type designer William Caslon. Since punchcutters had to cut a set of punches for every size of type, they could make adjustments in design to accommodate the new proportions. Caslon's range of typefaces from small text sizes to large display letters represents a series of totally different designs developed for each reproduction size. For comparison, a 96-point display font (Fig. 15, left) is shown next to a 12-point Caslon text font (right). Enlarging the text type to 96 points and reducing the display type to 12 points reveals that punchcutters could cut smoother, more refined forms at larger sizes. Conversely, the enlarged text type appears crude and rough.

When very large or very small sizes of type are designed, optical adjustments become critical. In the design of small sizes of text type, several design changes are necessary. The characters should become slightly wider to improve legibility; the x-height should be slightly higher to keep small counters from filling in; thin strokes and serifs must be heavier to keep them from dropping out in printing; and letterspacing should be looser to keep letters from running together.

In the design of large display types, very different optical adjustments are necessary to maintain the design qualities. Enlarged strokes appear too thick and must be thinned down. Serifs appear too heavy, so they need to be reduced in size to restore their relationship with the strokes. Spaces between lines and letters seem too large, requiring tighter spacing. Punctuation and accents also look too large and should be proportionately smaller. Clearly, display and text faces require totally different designs.

14

This enlarged detail of heavily inked type printed in a 16th-century book demonstrates the effect of ink spread on the appearance of printed characters.

Another important and often controversial issue affecting the appearance of historical type specimens is ink spread. When metal letterpress type presses onto paper, the ink spreads around its edges (Fig. 14). Type weight varied from impression to impression depending on how heavily the ink was applied, and how much pressure was used on the press. Type designers compensated by cutting their punches slightly lighter in weight than they intended the final type to appear. As mentioned earlier, a punchcutter used smoke proofs to check his progress. Letterforms in the surviving smoke proofs are lighter in weight than book pages printed using the same fonts.

The industrial revolution: an explosion of design

During the 19th century, forces unleashed by the industrial revolution changed the technology, esthetics, and societal uses of typography. Type foundries pumped out unprecedented new designs, and marketed them by printing specimen books showing hundreds of pages of typefaces. A stream of mechanical inventions allowed a wider range of design possibilities while lowering typesetting costs. Large, bold types were needed for posters advertising transportation, manufactured goods, and services.

Types with exaggerated proportions were introduced into a world where old-style (Fig. 18), transitional, and modern fonts had been the only typefaces available. Heavy typefaces with lower stroke-to-height ratios were designed. New fonts called fat faces (Fig. 19) had height-to-width ratios as extreme as an astounding two-to-one.

Whole new categories of letterform designs were developed and offered in an unprecedented range of sizes. These included: Egyptians (Fig. 16), bold letters with heavy square

or rectangular serifs, usually without brackets; sans serifs (Fig. 17), which were simple letters without serifs; and Clarendons (Fig. 20), whose slablike serifs had brackets.

These were just a few of the 19th century's unbridled range of original typefaces. Designers explored the limits of letterform structure by expanding (Fig. 21) and condensing (Fig. 23) their widths, creating letters that were extremely narrow or wide. Stokes became very bold and thick or very thin. All manner of ornamentation was applied to types.

Letterforms were contorted into exaggerated shapes and embellished with bizarre serifs. More precise metal-casting technology permitted the design of outline (Fig. 22) and drop shadow (Fig. 24) fonts, including two-color versions. Many of the novelty fonts of this era have not stood the test of time and are rarely used except for special decorative or nostalgic purposes. The 19th century, with the ferment of industrial technology and economic expansion, stands with the late 20th century, when digital technology revolutionized the whole field of typographic communications.

David Bruce's typecasting machine, 1838.

Large wood types continued
to be used by letterpress printers well
into the 20th century.

The mechanization of typography

Scores of 19th-century inventors applied machine technology to the manufacture and setting of type. An American printer, Darius Wells, invented a pantograph-based powered lateral router in 1927 that made possible the manufacture of large wood type (Fig. 25). His wood type overcame the casting and weight problems associated with large metal types and enabled printers to create big posters using large-size typography. David Bruce's 1838 typecasting machine (Fig. 26) was able to replace the hand-held type mold with a fast mechanical process for casting metal type. It could produce as many as 3000 pieces of type per hour; a skilled worker using a ladle to pour lead into a type mold might achieve that volume in a day.

In 1885, type founder and inventor Lynn Boyd Benton introduced his new pantograph-based matrix-engraving machine (Fig. 27). By tracing a pattern with a stylus, an operator controlled the mechanical cutting of a matrix or punch. This eliminated the need to handcut a steel punch for each letter in every size. A metal pattern plate was made from the drawing of a letter; then an operator ran a stylus around the pattern, controlling a mechanical engraving tool that cut a matrix. Often only three or four different drawings of each letter were used for a whole range of type sizes. Although design adjustments were not made for every size, enough were usually made to maintain acceptable letterform design. The matrix-engraving machine reduced the time and expense involved in issuing new fonts. Foundries marketed their new releases in printing magazine advertisements and specimen books, hoping to create the latest fashion.

Typesetting was successfully automated by Ottmar Mergenthaler's Linotype machine (Fig. 28) in 1884. A Linotype machine was controlled by a keyboard that caused brass matrices to be released from a storage unit called a magazine. These matrices slid down chutes and were automatically assembled in a mold. A line of the matrices was filled with a molten lead alloy to cast a metal slug with a line of raised type characters across the top; hence the name Linotype. After the line was cast, a distributor system returned the matrices to the magazine for reuse.

Tolbert Lanston invented the Monotype machine in 1887. Instead of casting a line of type, the Monotype cast individual letters. A matrix case (Fig. 29) with 225 brass matrices was automatically moved under a mold, positioning the matrix for the next character in position to receive the molten lead. By casting one letter at a time, a Monotype machine achieved high-quality typesetting, with single letters to be changed or corrected. However, Linotype machines were faster and more economical. Improvements to both machines during the 1890s enabled them to completely automate the setting of text type. Setting type with both machines involved casting molten lead into a matrix bearing a depression in the shape of a letter, and matrices could only be purchased from the machine manufacturer. Linotype and Monotype managers realized the long-term success of their machinery was dependent in part on the development of a desirable library of typefaces; so both companies began an ambitious typeface development program, with extensive marketing efforts.

Linn Boyd Benton's matrix
engraving machine, 1885.

29

Monotype matrix case.

Designers creating or adapting typefaces for machine composition faced several difficult limitations. Kerning was not possible. A type family's roman, italic, and bold versions of each character had to have the same width for linecasting machines. Italics for Linotype composition had to conform to one of three predetermined angles: 12, 15, or 22 degrees. The widest character in a Monotype font was assigned a unit width of 18; then every character had to be set at one of 15 unyielding unit widths. These and other constraints restricted designers of machine fonts to exacting technical limitations. In spite of these difficulties, designers at Monotype and Linotype were able to create typefaces with good fit, consistency, and color.

Because hot-metal typesetting machines could do the work of up to eight hand typesetters, the need for skilled hand compositors declined rapidly. A drastic oversupply of type foundries quickly developed. The resulting price wars and economic difficulties led 23 foundries from across the U.S. to merge and form American Type Founders Company (ATF) in early 1892. ATF hired Morris Fuller Benton, son of Lynn Boyd Benton, to oversee its typeface development program. The best fonts from all of the merged foundries were selected for continued manufacture; the typeface library was standardized to the recently adopted point-and-pica[1] measuring system; and manufacturing was centralized using efficient large-scale production methods. Once the merged firms were integrated and ATF stabilized the type founding industry in the U.S., Benton turned his attention to designing new typefaces as well as revivals of earlier designs (Fig. 30).

Linotype and Monotype devastated the demand for handset text type, but by dramatically reducing the cost of typesetting, these machines caused a publishing explosion. The cost of magazines, newspapers, and books dropped dramatically, enabling more people to afford them. The number of publications increased, along with the size of press runs and the sum total of advertising pages. One result was a booming demand for handset display types for advertising and editorial material. Benton and his staff produced a steady stream of new and revival typefaces, which were effectively marketed by ATF's manager of publicity, Henry Lewis Bullen. ATF became skilled at what is now called brand extension, transforming a successful typeface into an extended family with bold, italic, expanded, and condensed versions.

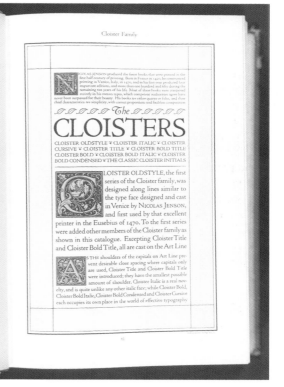

30

Page from American Type Founders *Specimen Book and Catalogue,* 1926, showing the Cloister Oldstyle type family based on Nicolas Jenson's fonts from the 1470s.

g

The West goes Eastward generous valour with which they risked their individual lives in its defence. But from the first, the tendency was towards this freedom of hand and mind subordinated to the co-operative harmony which made the freedom possible. That is the spirit of Gothic Architecture.

LET us go on a while with our history : Up to this point the progress had always been from East to West, i.e., the East carried the West with it; the West must now go to the East to fetch new gain thence. A revival of religion was one of the moving causes of energy in the early Middle Ages in Europe, and this religion (with its enthu-

34

Typeface revivals in the early 20th century

William Morris, the Englishman who led the Arts and Crafts Movement, became a major impetus for an extensive reexamination of earlier typefaces. Morris founded his Kelmscott Press in 1890 and designed three typefaces, including Golden (Fig. 34), based on 15th-century models. The Kelmscott Press inspired a movement of printers who, like Morris, based their types on historical models and printed them on fine handmade paper using old hand presses. The private press movement produced limited-edition books of great quality and beauty.

In the early 20th century, this fascination with revivals moved into the world of commercial typesetting. ATF, Linotype, and Monotype issued revivals of earlier typefaces—with now-familiar names such as Garamond, Bodoni, and Baskerville—based on fonts designed by past masters (Fig. 31). Morris Fuller Benton and his staff at ATF played a prominent role in this effort, and his 246 typeface designs include many well-crafted and enduring interpretations of classics, as well as new faces such as Franklin Gothic (Fig. 32) and Century

Schoolbook (Fig. 33), now considered classics in their own right. ATF built a prominent library of resource materials, including books printed with types cut by early masters such as Nicholas Jenson and William Caslon.

Although ATF, Mergenthaler Linotype, and Lanston Monotype were dominant in the American industry, small metal-type foundries Ludlow (a manufacturer of a display typesetting system used to cast a line of type from handset matrices) and Intertype (the producer of a typesetting machine similar to the Linotype) actively produced typefaces as well. Since Europe did not have a dominant monopoly like ATF, scores of smaller foundries faced a highly competitive market and were prolific in their production of both revivals and new designs. German type foundries including Klingspor, Bauer, and Berthold; Deberny et Peignot in France; and the Italian foundry Nebiolo were esteemed for their precision and craft in design and production. (When German fonts became a desirable export commodity in the 1920s, foundries in other European countries and North America plagia-

5

siasm for visible tokens of the ob⸗ jects of worship) impelled people to visit the East, which held the centre of that worship ✦ Thence arose the warlike pilgrimages of the crusades amongst races by no means prepared to turn their cheeks to the smiter. True it is that the tendency of the extreme West to seek East did not begin with the days just before the crusades ✦ There was a thin stream of pil⸗ grims setting eastward long before, and the Scandinavians had found their way to Byzantium, not as pil⸗ grims but as soldiers, and under the name of Vœrings a body⸗guard of their blood upheld the throne of the Greek Kaiser, and many of them,

The West in the East

c 2 35

34

Pages from *Gothic Architecture: A Lecture for the Arts and Crafts Exhibition Society* using Golden type based on Nicolas Jenson's fonts, 1893. Designer: William Morris; printer: Kelmscott Press.

rized designs and improved manufacturing to halt the onslaught of German fonts.)

The Monotype Corporation of London hired an American engineer, Frank H. Pierpont, to establish an English manufacturing facility in 1899. A letterdrawing office headed by Fritz Max Stelzer produced a steadily expanding typeface library. These were largely based on existing fonts but were redrawn to meet Monotype technical requirements. Pierpont oversaw typeface development closely, achieving fonts celebrated for their fit and form. By the early 1920s, Monotype versions of Bodoni, Caslon, and Garamond were available. In 1924, the director of Monotype's English operations, H. M. Duncan, hired 35-year-old Stanley Morison as typographical advisor charged with anticipating typeface needs rather than adapting proven designs to Monotype machinery. Pierpont had ruled over the typeface arena for a quarter century, so relations between the senior engineer and young scholar of typography were frequently strained. Overcoming frequent resistance from Pierpont, Morison guided the development of Monotype's versions of classic text faces including Baskerville and Bembo. He also guided the development of one of the most widely used typefaces of the 20th century, Times New Roman (Fig. 35). Issuing designs by contemporary artists was an important part of the Monotype program, with Eric Gill's Perpetua, Felicity, and the widely used Gill Sans being notable successes.

Extensive cross-fertilization occurred, as Linotype and Monotype developed machine-set text faces based on ATF handset display faces; designs were licensed to foreign companies; and popular typefaces were blatantly plagiarized. When new typeface designs became popular, competitive foundries and machine manufacturers needed similar fonts. Business was lost when printers and designers specified popular handset metal fonts available only from rival foundries. Likewise, orders declined when desirable text types could only be set on a competitor's keyboard typesetting equipment. For example, when Futura (Fig. 36) became wildly popular in the 1930s, ATF cast a handset variation of Futura named Spartan, and Linotype commissioned W. A. Dwiggins to design a similar type family named Metro.

FIG. 35 MONOTYPE TIMES NEW ROMAN

FIG. 36 BAUER FUTURA

As this film font for a Photo Typositor demonstrates, light passing through a negative is the fundamental medium of phototype processes. Photograph: Mary Beth Henry.

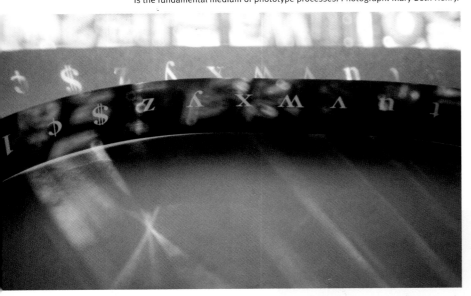

The phototype era

Compared to the centuries-long dominance of metal type, the phototype era was comparatively brief. Phototype came into prominence in the 1960s and was supplanted by the 1980s digital revolution. Phototype systems are based on basic photography. Light is flashed through a transparent letter on a film negative, exposing it on a sheet of photographic paper. Two phototype systems emerged: hand-operated systems for superb display typesetting, and keyboard systems for rapid production of text.

Display phototype machines, like Visual Graphics Corporation's 1960s Photo Typositor, set type from film negatives (Fig. 37). All the characters in a font were clear images on a strip of black photographic film. The operator turned two handles to bring the negative of the next character into position. This character was projected through an amber filter onto a strip of photo paper in a small tray of developer, where previously exposed characters were already developed. Looking through a viewer, the operator carefully spaced each character, then pressed a lever to flash a light and expose the letter onto the photo paper.

Display phototype had several advantages over handset metal type. Metal type came in a limited range of sizes, but film characters can be enlarged or reduced to any size, just like any photo negative. Since each metal-type letter was cast on a block of metal, letter- and linespacing could be increased, but not decreased. Phototype allowed letters to be set very tightly, even touching or overlapping. Distortion lens could italicize, back slant, expand, or condense the type. Film fonts accommodated many extra characters, so display fonts often had alternate characters, such as swashes. The cost of issuing new typefaces dropped dramatically, because film fonts cost a fraction of metal fonts or machine-set matrices. Alphabets were drawn in one size only, and optical adjustments for enlarged or reduced sizes were not made. VGC heavily promoted the benefits of phototype over handset metal: an unlimited range of sizes; an inexhaustible supply of characters; and sharp, clear letters that could be enlarged, unlike metal type with its ragged edges. The 1960s saw a steep decline in foundry type as designers and printers turned from metal to photographic display typesetting.

By the late 1960s, keyboard-operated, computer-controlled phototypesetters challenged the dominance of Linotype and Monotype for setting text type. The Mergenthaler V-I-P, introduced in 1970, was one of a new generation of typesetters that could set up to 80 newspaper lines a minute. When setting phototype, film fonts on a rapidly spinning disk or mobile flat plate (Fig. 38) were positioned over a sheet of photo paper, and each character was exposed in turn by a flash of light. As the disk or plate changed position to expose the next character, the photo paper advanced by the set-width of the previously exposed letter. After a column of type was exposed to photo paper, it was developed in an automatic photo processor. The speed and economy of keyboard photocomposition enabled it to rapidly replace hot-metal typesetting machines. Linotype and Monotype manufactured phototype systems and converted their type libraries to the new technology; while new phototype equipment manufacturers including Compugraphic and Alphatype assembled type libraries filled with familiar designs under new names.

As early as 1967, "second generation" phototypesetters stored characters on a computer disk as digital data, then displayed its image on a cathode ray tube to expose photo paper or film. Technical advances improved typesetting speed, but had limited impact on typeface design. Their typical size range ran from 4- to 72-point type. Manufacturers sold master fonts in from one to as many as five sizes, but many typesetting firms only purchased one font size, then used it for all sizes.

38

Keyboard controlled phototypesetters set type from film negatives with characters in predetermined positions from 4 to 18 fonts.

Specimen book covers for ITC phototype fonts, 1970–1981.

STEMPEL GARAMOND

Garamond

ITC GARAMOND

Garamond

40A

Comparison of metal-type Stempel Garamond and phototype ITC Garamond at the same cap height reveals significant differences in x-height, set width, and spacing.

40B

41

ITC Zapf Book combines the thick-and-thin contrast and unbracketed serifs of Bodoni with oval-shaped curved strokes inspired by Melior, 1976. Designer: Hermann Zapf.

Since photographic fonts were cheap and easy to copy, and typeface designs are not protected by U.S. copyright law, design piracy and plagiarism became rampant. To combat this problem, in 1970 typographers Aaron Burns and Ed Rondthaler joined designer Herb Lubalin as founders of the International Typeface Corporation (ITC). This firm marketed and licensed new font designs. Manufacturers of typesetting equipment, film fonts, rub-down lettering, etc., were able to acquire rights to original typefaces and produce their products from authentic master drawings. Designers garner royalties for their creations.

ITC became highly successful in its marketing initiatives. Attractive specimen books of new releases (Fig. 39) and a tabloid newspaper, *U&lc* (Upper and lowercase)—with a circulation of hundreds of thousands of readers—introduced and demonstrated ITC fonts. Effective publicity, along with font designs possessing wide appeal, propelled ITC into type-design leadership in the 1970s, similar to the position occupied by ATF in the early 20th century.

During the phototype era, a single set of drawings frequently was used for all sizes of a typeface. The impact of enlargement and reduction on letterform design made many phototype fonts unsatisfactory at certain sizes. Some were undesirable for small text because thin stokes become weak and often drop out. In large display sizes, serifs and thin strokes often seem too thick and heavy. Phototype, unlike metal type, could be tracked or kerned tightly; the prevailing esthetic favored very tightly set headlines and text. Designing fonts with large x-heights and correspondingly shorter capitals, ascenders, and descenders became a significant design direction. This trend began with Adrian Frutiger's 1957 sans-serif family, Univers, and dominated the phototype era.

In designing revivals for phototypesetting, many typeface designers were concerned less with authenticity than with exploiting phototype's expanded range of possibilities. Photographic processes can hold finer detail than metal types. This technical advance inspired designers to push design parameters. Ultra light sans serifs, fat faces with extreme stroke contrasts, and other exaggerated design elements were commonplace. Many revivals from the period were not revivals at all, but rather, mannerist reinterpretations. Exaggerated serifs, serpentine curves, and overstated details typify the sensibility. Wayward revivals might have fared better if they had been presented as new faces, rather than labeled with the old names. For example, if ITC Garamond (Figs. 40a, 40b) had been named Stan Old Style (after its designer, Tony Stan), critics may have evaluated it as favorably as ITC Zapf Book (Fig. 41)—as a new face inspired by earlier models but also incorporating contemporary ideas. Focus might have shifted to unique character designs, the wide range of weights, large x-height, and condensed variations instead of differences with earlier versions.

Compromises required by phototype technology, along with the 1970s passion for large x-heights, caused many widely used phototype versions of classic fonts to fall into disfavor by the 1990s. A growing awareness of the limitations of phototype fonts accompanied the arrival of digital type and digitized versions of early 20th-century classic faces that were embraced by many designers.

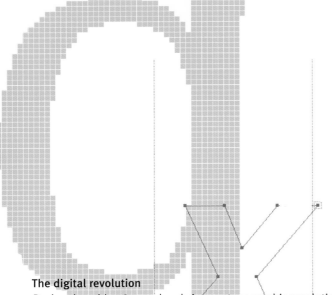

The digital revolution

During the mid-1980s and early '90s, a typographic revolution as radical as Gutenberg's invention of movable type matured rapidly. Using microprocessors, personal computers, Adobe's PostScript page-description language, and page-layout software such as Pagemaker and QuarkXPress, designers combined type and images into seamless on-screen layouts. The 1984 Apple Macintosh computer had a 72-dpi (dots per inch) screen resolution, chosen deliberately for its correspondence to the 72 points-per-inch measure used in typography. The Macintosh made an initial impact with the design community primarily for its introduction of the concept of direct manipulation of type and graphics. For the first time, designers could interact directly with a simulation of a printed piece through what were termed WYSIWYG ("what-you-see-is-what-you-get") displays. The introduction of the PostScript-driven Apple Laserwriter in 1985 provided 300-dpi output at what was called "near-typeset quality." Despite the promise that this confluence of technologies held for the future of typography and design, a number of issues surfaced that would take years of increasing technological sophistication to resolve.

41

Typographic layout with PageMaker 1.0. Prior to the release of PostScript display technology (such as Adobe Type Manager), precise typographic placement was almost impossible.

One issue was the resolution between the computer display and higher resolution output devices. Subtle typographic adjustments were imperceptible on 72-dpi screens, and the job of accurately rendering type at various sizes overwhelmed earlier processors. Apple Computer initially solved this problem by treating fonts in two distinct forms. Type for output was represented in outline form and could be scaled by PostScript printers to any resolution. On-screen type was represented in bitmap form, with a standard set of point sizes hand-built for optimal display (Fig. 41). Many designers rejected 300-dpi laser-printer output and the crude bitmapped fonts they encountered on the Mac display, but a small number embraced and explored the potential of the new technology. Zuzana Licko used public-domain character-generation software to create typefaces based on low-resolution screen display and laser printers. While Licko championed the staircased contours of bitmapped type in her early work, others addressed the issue of designing types specifically for 300-dpi laser output. Charles Bigalow's Lucida and Sumner Stone's Stone family were outstanding examples of type designed within the particular constraints of the contemporary technology.

By the late 1980s, advances in printing technology, computing power, and display technology began to make digital typesetting an undeniable force. Laser-printer resolution increased to 600 dpi and digital image-setters such as Linotype's Linotron (with 1270- and 2540-dpi output onto photographic paper or film from Macintosh computers) produced type rivaling the quality of phototype. With the increases in resolution, type that had earlier evidenced clear aliasing in curvilinear and diagonal strokes could now be rendered so finely that the digital origins of the form became virtually imperceptible. This, coupled with the rapid improvements in design software, resulted in the wholesale conversion of the type industry to digital technology within a few short years.

Designing digital type

While the introduction of software and digital typefaces was revolutionizing the practice of graphic design, the use of digital technologies had a comparable effect in the life of type designers. Not only were they compelled to adapt their designs to a new set of technological constraints, but they also found themselves forced to use new tools to do their job. New affiliations were being forged between type designers and technical professionals. The partnership between type designers, mechanical engineers, and machinists was now replaced by alliances with computer scientists and information-systems specialists.

b b b b b b b

42

Sequence demonstrating the steps in converting a Stone Serif medium **b** into the bold **b**. The figure second from left shows the complete set of Bézier control points used to define the character.

The use of digital tools in type design did not start with the desktop publishing era, but began in the design of type for photocompositors in the late 1960s and early 1970s. The first application of digital technology to type design has been credited to Rudolph Hell of Germany, who introduced his Digiset machine at an exhibition in 1965. With this technology, type designers specified letterforms as a set of pixels, drafting "small squares by hand to make a large bitmap of a letter suitable for digital reproduction."[2] Later digital systems, such as Peter Karow's *IKARUS* and Donald Knuth's *Metafont*, were able to automatically convert bitmap representations into outlines specified by Bézier and B-Spline curves. These formats defined complex boundaries of type forms as a series of control points and tangency vectors that could easily be adjusted by the type designer (Fig. 42).

The mathematical description of font outlines provided many benefits. Like phototype, digital fonts could be scaled to any size without distortion or loss of detail, and they could be used quite effectively as the basis for creating variations within a face, thus saving type designers time and effort. Hermann Zapf, one of the first established designers to embrace digital technology, stated in a 1988 lecture that a designer "[can now] save and recall from the computer's memory repeating parts of letters and move them about while the program automatically adjusts the thickness of hairlines, the design of serifs, or the width of the stems. In addition, he can derive condensed versions and italics [obliques] from the same master design"[3] Interestingly, this ability to copy and manipulate type forms would later lead Zapf to speak out frequently and forcefully against the abuses of font plagiarism and font distortion in the 1990s.

On the one hand, digital type representation saved labor; on the other, it allowed for font scaling and distortion. As with phototype, type designs based on a single scalable form can lead to gross distortions at small and large settings. Two solutions emerged for this

weight – *light to black*

a a a a a **a a a a a a**

width – *condensed to extended*

a a a a a a a a a a a

style – *wedge serif to slab serif*

a a a a a a a a a a a

optical size – *6 pt. to 72 pt. (scaled to same size)*

a a a a a a a a a a a

43

Demonstration of four of the control variables or "axes" available in a multiple-master font.

problem, one based on the computer's ability to dynamically alter various dimensions of a given shape, the other founded on more traditional practice. In 1991, Adobe introduced multiple-master font technology. One multiple-master font exists as a kind of prototype from which new fonts are generated by a set of controls that allows variation of a form along prescribed "axes." Stroke weight, character width, optical size, and even serif dimensions can be interpolated through a continuous range of values (Fig. 43). The second approach, taking less advantage of the computer's capability to dynamically reshape form, extends the practices of classic type designers by developing unique designs to handle various sizes of type. Examples of this approach can be found in the chapters discussing Bodoni and Didot, and Caslon.

Digital fonts range from new fonts carefully engineered for the medium itself to retooled versions of the classics. Fonts like Dead History reflect the current ambivalence towards the proper role of tradition.

Digital type design software originally was limited to expensive proprietary systems and mainframe computers and therefore was accessible only to professional type designers. Desktop font design programs appeared early in the desktop publishing era, however, and programs like Fontographer and FontStudio generated a groundswell of interest in font design among young designers. Not since the 19th century had there been such a proliferation of unique and eccentric typefaces. Responding to the postmodern sensibilities of the era, these faces reflected a dizzying array of vernacular forms, drawing on everything from postwar advertising type to comic books. Classic typefaces were not an exception, as designers freely copied elements from the faces stored on their personal computers. Perhaps the most notorious example of this practice was Dead History, P. Scott Makela's brash cut-and-paste combination of the serifed Centennial and sans-serifed V.A.G. Rounded (Fig. 44).

The digital type industry

The digital type revolution posed significant challenges for established type suppliers and created opportunities for new type houses devoted solely to the development of digital types. Linotype, ITC, Monotype, and Berthold launched and completed programs to digitize their extensive type libraries and also began commissioning new typefaces to address the unique requirements of the digital medium. Adobe Systems, established in 1984 by computer scientists John Warnock and Chuck Geschke, followed the classic formula of building a type foundry business on top of a proprietary typesetting technology. After introducing PostScript in 1985, Adobe hired Sumner Stone, a type designer with a background in both calligraphy and mathematics, to head up its typography department. It then began an aggressive program in digitizing and developing new types in PostScript's Type 1 format. In addition to its efforts in converting existing typefaces, Adobe began to release typefaces of its own design. Sumner Stone's Stone Family, published in 1987, was the first of these, and it was soon followed by an impressive array of new typefaces and authoritative revivals. Robert Slimbach, who joined Adobe in 1987, was responsible for the highly successful Adobe Garamond and Jenson revivals, and contributed a number of new faces including Utopia and the multiple-masters Minion and

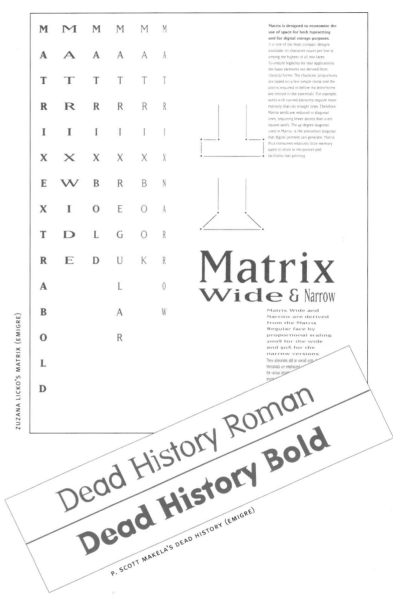

ZUZANA LICKO'S MATRIX (EMIGRE)

Matrix is designed to economize the use of space for both typesetting and for digital storage purposes.

Matrix
Wide & Narrow

P. SCOTT MAKELA'S DEAD HISTORY (EMIGRE)

JONATHAN HOEFLER'S DIDOT BOLD 96 (HOEFLER TYPE FOUNDRY)

Myriad (codesigned with Carol Twombly). Twombly joined Adobe a year after Slimbach and was responsible for the company's first display faces—Trajan, Charlemagne, and Lithos, as well as the highly regarded Adobe Caslon.

New font houses emerged throughout the '80s and '90s dedicated to the design and distribution of digital fonts to the rapidly expanding desktop market. The earliest of these was Bitstream, founded by Matthew Carter and Mike Parker in 1981. Carter, a classically trained type designer from England, brought experience in metal and phototype to the company, and the firm's earliest projects displayed a level of refinement and accomplishment to a technology that was still in its infancy. Bitstream's business was based on a new reality made possible by the transformation of type from a physical commodity to an abstract set of data points—type was now a product that could exist without any direct tie to a particular machine. As Carter observed in a 1998 interview, "[With a] digital PostScript imagesetter, you could buy your type from Linotype, Adobe, Compugraphics—or Bitstream. With the desktop computer, type ceased to be a machine part. You could buy it anywhere.[4] Bitstream has recently evolved a number of type technologies, specializing in typography for the Web, and now sells both fonts and font rendering software.

As the technologies of digital type production have matured and the cost of entering the type design business has been drastically reduced, a number of smaller, specialized type houses have emerged. While many of these concern themselves with exploring new and experimental approaches raised by the current digital culture, others have devoted a significant amount of energy to the question of typeface revivals. Four of these foundries, prominently featured in this book, are Emigre, Font Bureau, the Hoefler Type Foundry, and FontFont.

Emigre was founded in 1984 in San Francisco by Zuzana Licko and Rudy VanderLans. A pioneer in the grass-roots typography movement, Emigre issued a catalog remarkable for its low-resolution "coarse fonts," experimental fonts, and postmodern revivals. The Font Bureau in Boston, founded by Roger Black and type designer David Berlow, specializes in fonts for magazine and book publishers including display faces derived from historical models. The Hoefler Type Foundry was begun by Jonathan Hoefler in 1989. Hoefler has built his reputation on a series of influential revivals of classic fonts commissioned for leading magazines. In Europe, FontFont, a division of FontShop, Erik Spiekermann's mail-order firm for digitized typefaces, began developing its own designs in 1990. FontShop has been instrumental in nourishing the global experimental typography movement, particularly through its digital publication, *Fuse*.

Conclusion

As we enter the new century, we find ourselves in possession of technology that allows us to essentially recreate the entire history of letterforms, and to distribute them to just about anywhere in the world at the speed of light. As with any new medium, it is always valid to ask whether the new realities posed by that technology demand new forms, and to question which aspects of our formal heritage should be maintained. When applying this question to typography, the science and art of making language visible, it is essential to remind ourselves that various types are not simply arbitrary permutations of form, but manifestations of various attitudes pertaining to the requirements and contexts of reading. Regardless of how letterforms are produced, they still function independent of their technical origins, as signs used to communicate human speech. The psycho-physiological aspects of reading can and do change over time, if slowly. Classic typefaces are classic because they have been found over decades and over centuries to be eminently readable and versatile vessels for communicating thought. This book celebrates the continued vitality of some of type history's most successful products. We fully anticipate the emergence of new type classics, born entirely of the digital era, but we are equally confident that the faces chosen for this book will continue to be vital players in the future.

NOTES

1. The traditional typographic measuring system is based on picas and points. There are 6 picas in an inch; 12 points in a pica; and 72 points in an inch. (Originally, a point was 1/72.27 of an inch, but this was revised to exactly 1/72 of an inch in digital typography.

2. Hermann Zapf, "Letterpress Printing, Photocomposition, and Desktop Publishing" in *Classical Typography in the Computer Age* (Pasadena: The Castle Press,1991), 7.

3. Ibid.

4. Interview from Potlatch Paper promotion, "American Design Century," volume 1 (1998), 8.

I firmly believe that the best types for
our use must be newer letterforms
based on the shapes fixed by tradition,
fresh expressions into which new life
and vigor have been infused...

frederic w. goudy

TYPEFACES

ANCIENT INSCRIPTIONS SAT MUTE OVER THE CENTURIES, PRESERVING THE DESIGN HERITAGE OF GREEK AND ROMAN CULTURE. PERIODICALLY THROUGHOUT HISTORY, THESE ELOQUENT FORMS HAVE BEEN CALLED FORTH TO BE UTILIZED AS A BASIS FOR LETTER-FORM DESIGN.

Photo © 1997 Corwin Low; courtesy Legacy of Letters.

Two thousand years ago, a series of military victories were recorded on the Column of Trajan in Rome (Fig. 1) in a detailed sculptural sequence that spirals up and around the column. What could not have been anticipated was the profound effect the relatively small inscriptions at the column's base would have on the future of type design. It is no coincidence that many modern roman letterforms resemble these ancient inscriptions, since over the centuries artists and craftsmen have returned to the monument for inspiration. In fact, these Roman capital letters have become arguably one of the single greatest influences on type design in Western civilization.

1

Column of Trajan, 105 A.D.

Environmental conditions influenced the design of the Trajan letterforms. Since the stone inscriptions were out of doors, weathering by rain and wind was inevitable. The sunlight and the shade also affected their appearance. Consequently, to maintain uniformity within the block of text, the letters were carved with these factors in mind. The horizontal strokes of the deeply cut letters not only reflected sunlight, but also collected debris as time passed, enhancing visual emphasis on the horizontals. Furthermore, the engravers often tinted their newly carved inscriptions with dye, which the rain would eventually wash away. The color tinting in the vertical grooves of the characters deteriorated before the horizontal grooves. The engravers made allowances for these circumstances by making vertical strokes wider than horizontal ones. A few exceptions were made in order to maintain the balance of certain letterforms such as the **N**. There is also a gradual and graceful transition in width between horizontal and vertical strokes in characters with curves such as **B**, **C**, and **D**, which enhances the beauty of the letterforms.

Modern stone carvers and calligraphers theorize that each inscription created by Roman craftsmen was carefully planned before carving began. Precise calculations were made, guidelines drawn, and each letter handpainted with a soft flat-tipped brush before the engraver began incising the stone. This technique resulted in characters with delicate and elegant contours. Fine serifs and asymmetric swelling of the stems evidenced the skilled chisel work by Roman craftsmen of this period.

The formal beauty of Roman inscriptions bespoke the power of the Empire at its peak. Because inscriptions were official state scripts, the government required stone carvers to adhere to strict rules of production so that each script maintained a uniform appearance wherever it represented Roman authority. The decline of the Empire was reflected in late inscriptions. Rules and patterns that were strictly adhered to for so long began to be disregarded and the classic forms deteriorated.

3

Book cover for publishers Hartley and Marks set in Trajan and Minion.
Designer: Robert Bringhurst.

"THE ROMANS MADE STONE SPEAK THROUGH THEIR INVENTION OF THE CAPITALIS MONUMENTALIS (MONUMENTAL CAPITALS) SCRIPT. A MODEL OF SOBRIETY AND GRAPHIC PURITY, THE BEAUTY OF THE LAPIDARY LETTER RESIDES IN A PRINCIPLE AS SIMPLE AS IT IS INSPIRED: A STROKE OF SHADE, A FLASH OF LIGHT. THE ROMAN CAPITAL IS AT THE SAME TIME THE HALLMARK OF A CIVILIZATION AND CONSEQUENCE OF TECHNIQUE."[1]

4

18-POINT CHARLEMAGNE

Fascination with ancient letterforms has resurfaced many times. During the Renaissance, interest in the Trajan inscriptions was part of the infatuation with Greco-Roman civilization and culture. Principles of balance, proportion, and harmony within letterforms intrigued the most acclaimed artist of the time, Leonardo da Vinci, who studied the Trajan inscriptions. Giovanni Francesco Cresci, a scribe in Rome during the late 1500s, developed lowercase script to accompany letterforms designed after ancient Roman capitals. He revered the classic Roman alphabet: "When a person addressed opens a letter and sees [that] the writing is beautiful and clear, he is attracted to it, and his mind is automatically disposed to agree with the author."[2] Printing presses of Cresci's time were still too crude and paper too irregular to use a typeface with the delicate lines of Cresci's lettering. Giovanni Francesco Cresci's work continues to influence type design today. In 1996, for instance, Garrett Boge introduced the Cresci typeface (Fig. 5). Boge used Cresci's writing book, *Il Perfetto Scrittore*, published in 1570, for his inspiration.

During the neoclassical movement in the United States in the 1700s, attention again focused on ancient accomplishments. Thomas Jefferson's architectural designs for his home at Monticello and his designs for the original campus buildings at the University of Virginia epitomized this revival. Inscriptions based on the classic

letterforms are found throughout the campus (Fig. 6). In the early 20th century, Edward Johnston, one of the founders of the Arts and Crafts movement, photographed and measured hundreds of Roman inscriptions. A book of Johnston's work, *Writing & Illuminating, & Lettering*, was published in 1906. (Reprinted in 1969 by Pitman Publishers).

In 1989, typeface designer Carol Twombly's digital typeface called Adobe Trajan was released (Fig. 2). Her work was carefully modeled after the inscriptions

Photo: Janet Horst.

ENTER
BY THIS GATEWAY
AND SEEK
THE WAY OF HONOR
THE LIGHT OF TRUTH
THE WILL TO WORK FOR MEN

6
Stone inscriptions, 1912. Sneff Memorial Gateway, University of Virginia, Charlottesville.

5
Poster for an art opening set in Cresci (large type) and Sabon (small type). Designer: Michael Skjei; client: College of Visual Arts Gallery, St. Paul.

A B C D E F G

Pen to Pixel: the Work of Paul Shaw and LetterPerfect. January 12th through February 6th, 1998 at the College of Visual Arts Gallery. Reception,

H I J K L M N

presentation and demonstration on Friday, January 16th, 5:30 to 8:30 with presentation and demonstration starting at 7:30. Gallery located at

O P Q R S T V

173 Western Avenue at Selby in St. Paul. Regular gallery hours are Monday through Friday, 8:30 am to 4:00 pm and Saturday 11:00 am to 6:00 pm.

W X Y & Z

I N S C

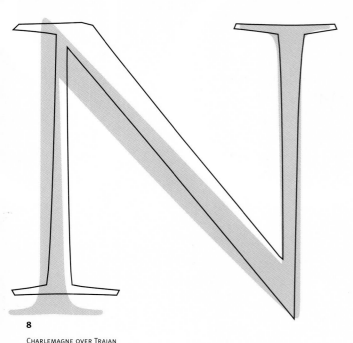

8

on the Trajan Column and is a fairly literal rendering of the original. When designing Trajan for Adobe, Twombly reworked several characteristics of the letterforms that seemed unsuitable for modern printing. For instance, while appearing perfectly balanced when carved very large and in stone, the Trajan **N** was too heavy and the **S** too light for printing at headline and poster sizes on paper. Twombly modified the weight of the serifs, which seemed too light. The bowl and stem weights were subtly adjusted for printing at various sizes and resolutions. The punctuation marks and numbers had to be carefully designed to maintain the personality of her letterform models. An all-capital typeface, Trajan is available in both bold and regular weights. It is formal, elegant, and highly legible when used as a display type in sizes of 18 points or larger. Trajan has been used in Isuzu Rodeo television advertisements, Microsoft ads, movie posters, and many book jacket designs (Fig. 3).

9

Base, Column of Trajan.

Adobe's Charlemagne typeface (Figs. 4, 7, 8, 10, and 11), designed by Twombly, is similarly inspired by classical lettering. It is a bit more spirited and dynamic than Trajan, with accentuated serifs, swelling stems, and large bowls. Charlemagne has roots dating back to the resurgence in learning initiated by the Emperor Charlemagne in the 8th century. Charlemagne, who was illiterate, assigned his scribes the task of designing a script that would facilitate efficient reproduction of text. His objectives were to produce more accurate copies of manuscripts, to standardize script, and to make the written word more widely available. Carolingian script was developed for this purpose. It was a minuscule style that could be written easily with a broad-edged pen. Carolingian script, with its fusion of beauty and legibility, prevailed in Europe for many centuries. To complement this script, scribes modified classical Roman-style capitals and created decorative capital versions called "square

1 2 3 4 5 6 7 8 9 0 ? !

ABCDEFGHIJK
LMNOPQRSTUVWXYZ

capitals" or "versals." The expressive versal capitals of this era inspired Twombly's all-capital Charlemagne typeface. Twombly studied examples of manuscripts written in 10th century Carolingian script and made sketches of the capital letterforms. Alterations were made to refine the shapes, but the spirit of the versal forms remains intact. Adobe's Charlemagne is popular as a display face in bold or regular weights. As with Trajan, optically spaced typesetting is recommended.

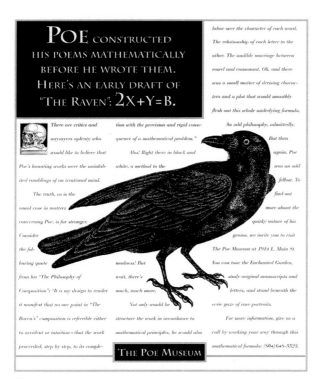

POE CONSTRUCTED HIS POEMS MATHEMATICALLY BEFORE HE WROTE THEM. HERE'S AN EARLY DRAFT OF "THE RAVEN": $2X+Y=B$.

THE POE MUSEUM

10

Charlemagne used as a headline typeface. Art director: Cliff Sorah; designer: Cliff Sorah; copywriter: Raymond McKinney; client: Poe Museum, Richmond, Virginia.

ABCDEFGHIJKLMNOPQRSTUVWXYZ

GREEK
INSPIR
GREEK
INSPIRE
GREEK
INSPIRE
GREEK
INSPIRE
GREEK
INSPIRED
GREEK
INSPIRED

12

Five weights of 18-point Lithos.

The predecessors to many modern sans-serif type designs were Greek inscriptions. Early Greeks had a more utilitarian view of script than the Romans and placed less importance on pristine letterform carving. The inscriptions were simple, rational, and ordered. "Many early Greek letterforms and inscriptions are very elegant, but often crudely carved," says Twombly. Geometric characters, free of adornment, were carved into stone with a constant line-width and were often aligned both vertically and horizontally (Fig. 13). The Lithos typeface, designed by Twombly in 1989, was modeled after these uncomplicated letterforms from the 4th century B.C. Five weights of Lithos are available, in capitals only, from very light to very bold, each weight having a different effect (Fig. 12). The type has a lighthearted, asymmetric quality that lends itself well to advertising. Even though it was modeled after an ancient classical script, Twombly gave the shapes a contemporary flair that can appear primitive, playful, or earthy. The typeface's flexibility has made it very popular since its release and it has appeared in advertisements for clients such as Taco Bell, McDonald's, and MTV.

Matthew Carter, formerly at Linotype and Bitstream and now at Carter and Cone Type Foundry, has designed a number of typefaces based on classic inscriptions. His typeface Mantinia (Fig. 14) is a display type inspired by the letterforms of Andrea Mantegna, one of the earliest Italian Renaissance artists to introduce letterforms based on Roman inscriptions into his paintings. The Mantinia typeface has several distinctive characteristics. Incorporated into the text type are small, raised capitals. Many of the letterforms can be joined at the serifs or overlapped on the vertical stroke to form ligatures. This is often seen on ancient stone inscriptions but is rare in printed letterforms. Small capitals are used in lieu of lowercase. Carter also designed the titling typeface Sophia (Fig. 15). Unlike Mantinia, Sophia ligatures are formed by extended strokes designed to fuse letters together. There are ten characters with this option. All letters have nearly uniform stroke width with a very pronounced serif. Alternate characters for many of the letters, such as the **A, I, M, X,** and **R,** along with the ligature options, provide considerable flexibility. Sophia was inspired by a blend of Roman capital alphabets, early uncials, and Greek letterforms.

13

76-point Adobe Lithos superimposed on Greek stone inscriptions.

Penumbra (Fig. 16) is a successful blending of Greek and Roman influences with modern geometric letterforms. This all-capital, multiple-master typeface was designed by Lance Hidy with the assistance of Gino Lee in 1994. Multiple-master technology allows for variations in character attributes such as weight and serif size. Designers can create infinite variations of Penumbra, including sans serif, full serif, flare serif, and half serif. "It is an 'androgynous' letterform which morphs seamlessly between the worlds of sans serif and serif. There is no other typeface that does this," explains Hidy. The hand-lettering on some of his poster designs is a hybrid of Futura and Trajan letterforms and was used as a basis for Penumbra. The multiple-master variations permit the whole range of stroke weights and serif variations found in Hidy's poster lettering.

Penumbra fills a void in contemporary type design: classically proportioned serif typefaces with a monoline stroke are very rare. By blending 20th-century geometric attributes with traditional humanistic qualities, Penumbra achieves a softer appearance than geometric sans-serif typefaces. Traditional humanist letterforms reflect the use of a broad-edged pen, modulating the stroke width. This thick-and-thin stroke contrast is present in humanist sans serifs (discussed on pages 146-153). Penumbra does the opposite; it combines geometric structure with serifs.

14

20-POINT MANTINIA

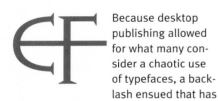

Because desktop publishing allowed for what many consider a chaotic use of typefaces, a backlash ensued that has led to a revival of simple and classic letterforms. This "new classicism," as designer Steven Heller has called it in his book *American Typeplay*, has fostered a genuine interest in classic typefaces such as Charlemagne and Trajan. Says Heller, "The new classicism is not a movement, nor a fashion, or yet another 'new wave.' But, it does suggest a new sobriety in the wake of what some have criticized as the wanton antics of postmodernism. Classic types are being appreciated anew in decidedly contemporary compositions. These derive from, but are not overly influenced by, the latest technologies." These sophisticated faces are not only pleasing to the eye, but also give credibility and an aura of stability to advertisers who choose to use them.

ABCDEFGHIJKL MN
QRSTUVWXY OŒP

15

24-POINT SOPHIA

1 2 3 4 5 6 7 8 9 0

PENUMBRA
VARIABLE SERIF & WEIGHT
RRRRRRRRRRR
RRRRRRRRRRR
ABCDEFGHIJ
KLMNOPQR
STUVWXY&Z
$1234567890

16

Penumbra variations, 1994. Designer: Lance Hidy.

TRAJAN
ABCDEFGHIJKLMNOPQ
RSTUVWXYZ1234567890

CHARLEMAGNE
ABCDEFGHIJKLMNOPQ
RSTUVWXYZ1234567890

LITHOS
ABCD
EFGH
IJKL
MNOP
QRST
UVWX
YZ12
3456
7890

ADOBE ORIGINALS DISPLAY TYPES
MODERN
ANCIENTS

17

Type specimen and poster demonstrating Adobe fonts.

ABCDEFGHIJKLMNOPQRSTUVWXYZ
ABCDEFGHIJKLMNOPQRSTUVWXYZ
ABCDEFGHIJKLMNOPQRSTUVWXYZ

24-POINT TRAJAN, CHARLEMAGNE, AND LITHOS REGULAR

8-POINT PENUMBRA MM 585 SEMIBOLD 150 FS

"IN CONTEMPORARY TIMES, WE ARE IN DANGER OF OVERLOOKING THE SIGNIFICANCE OF LETTERFORMS AND THE HISTORY INHERENT IN IT. THERE NOW EXISTS AN ENORMOUS GAP BETWEEN PRESENT TECHNOLOGY AND THE INHERITED AND HISTORICAL STANDARDS OF TYPOGRAPHIC ART. WE CAN COMPENSATE FOR SUCH SHORTCOMINGS THROUGH THE RENEWED EMPHASIS THAT WE ACCORD TO CULTURAL AND HISTORICAL ASPECTS OF LETTERFORMS."

—Steven Heller and Gail Anderson, *American Typeplay,* (Glen Cove, NY: PBC International, 1994).

NOTES

1 Rene Ponot, "Of Ink and Light," George Jean, *Writing, The Story of Alphabets and Scripts* (New York: Harry N. Abrams, 1992), 160.

2 Dave Frey, "By Way of Explanation, La Gioconda— A New Typeface" www.faces.co.uk/lagioconda.htm, June, 1998.

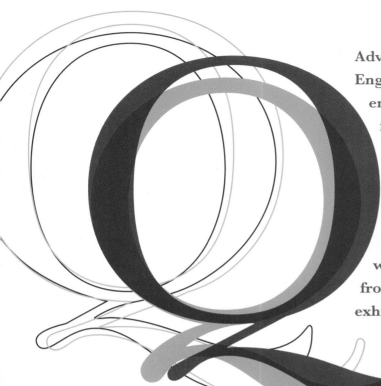

Advancements in printing technology made by
Englishman John Baskerville in the mid-1700s
enabled him to produce an innovative type-
face that emphasized the skills of the punch-
cutter and looked to the mechanical, rather
than to the handwritten, for inspiration.
Employing classical geometry as a model,
the Baskerville letterforms are rounded,
yet the angle of stress is closer to vertical
when compared to the same angle produced
from handwriting. The Baskerville face
exhibits an greater contrast between thick and
thin strokes than that found in
old-style faces. For its melding of
old-style and modern character-
istics, the Baskerville face is one
of the earliest to be classified
as transitional.

1

Preface to John Baskerville's edition of Milton, 1758.
In it he outlines his ambitions and preferences as a typographer.

When Baskerville began pursuing the hobby of typefounding in 1750, he had already accrued considerable wealth with a profitable business that manufactured tin household items called "japanned ware." Baskerville maintained this business until his death in 1775 to support the pursuit of his more passionate interests in typefounding, making paper and ink, and book design. Baskerville created an entire second profession from his personal ambition to improve on William Caslon's types. As Baskerville wrote in the preface to his edition of Milton, published in 1758, "I formed to my self Ideas of greater accuracy than had yet appeared, and have endeavoured to produce a *Sett* of *Types* according to what I conceived to be their true proportion (Fig. 1)."

Baskerville lived and worked in Birmingham, England, where he was regarded, according to type historian Daniel Berkeley Updike, as an "eccentric, vain and unattractive" man.[1] Baskerville's renown as a skilled printer and inventor, however, provoked both the respect and the envy of his fellow artisans. Baskerville's invention of hot-pressing (the technique of pressing each printed sheet though heated copper plates), his improved ink, and printing press innovations made him one of the most important figures in English printing, both during his own lifetime and after. Although Baskerville spent seven years perfecting his eponymous typeface, it is difficult to evaluate the face solely on its artistic merit, because Baskerville's printing innovations dramatically impacted the type's appearance and readability. It is safe to say, however, that as a type designer and printer, Baskerville consistently strove for clarity of message without ornament or complex type form. The Baskerville face was designed to be simple, yet visually eloquent.

Baskerville was used as a text type in books such as the Latin Virgil (1757) (Fig. 2), Milton (1758), and *The Spectator* (1761). But initially the designer's refined type and clarity in book design were not well received; in fact, it wasn't until 150 years after his death that the face again became popular. The font's alleged lack of readability was blamed on a number of factors including Baskerville's use of hot-pressing, which added a gloss to the pages. The delicate refinement of the Baskerville face, high contrast between strokes, and lack of a comforting calligraphic flow were also cited as factors disruptive to reading. Although rejected by his English contemporaries, Baskerville's type and page designs were welcomed in France and the U.S. Benjamin Franklin was a supporter and purchased many copies of the Latin Virgil (Fig.2), saying it "be the most curiously printed of any Book hitherto done in the World."[2] (Type historian Robert Bringhurst points out that the face's warm reception in the U.S. might be due to a shared neoclassical sensibility and the rise of the Federal architectural style in the late 1700s.[3])

PUBLII VIRGILII

MARONIS

BUCOLICA,

GEORGICA,

ET

AENEIS.

BIRMINGHAMIAE:
Typis JOHANNIS BASKERVILLE,
MDCCLVII.

2

Title page from the Latin Virgil, the first book printed with Baskerville type, 1757. The title's widely spaced capitals are characteristic of John Baskerville's esthetic.

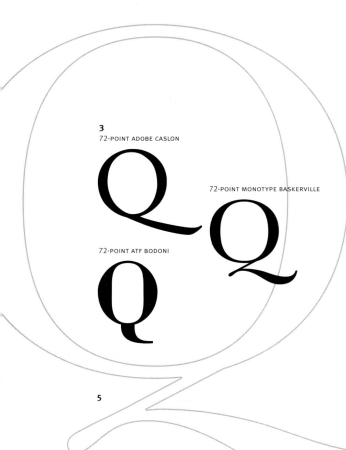

What distinguishes Baskerville type from old-style and modern faces? As noted above, Baskerville's type was criticized for its lack of convention, most notably for its contrast between thick and thin strokes. Baskerville's departure from traditional processes and accepted notions of readability made little sense to readers in the late 1700s. Today, conversely, we see considerable similarity between Baskerville type and the old-style faces, such as Caslon, at the same time recognizing more discrepancies between it and modern faces like Bodoni (Fig. 3).

Baskerville has many distinctive characteristics. The stress is almost vertical, eliminating the reclined axis of old-style type and its close association to handwriting. The open loop and the swashlike tapered tail of the **g** (Fig. 4) unmistakably identifies the letterform as Baskerville. A less obvious identifier is the flowing, swashlike tail of the **Q** (Fig. 5). This calligraphic feature varies in the different foundry versions, but it is always connected to the body of the letterform by a hairline.

Along with its unique identifiers, Baskerville has several additional nuances (Fig. 6). The **C** has serifs on both top and bottom, but a serif is not present on the central junction of the **W**. The spur of the **G** is slightly serifed from the concave joint. Other notable attributes of the upper-case include a high crossbar on the **A** and a long lower arm on the **E**. Because the lowercase counters have a large shape, the type has a full-bodied appearance. However, the **e** is slightly different from its lowercase siblings. The counter is smaller and restricts the type's flexibility in printing, creating the possibility of a closed counter. To meet modern type standards, Linotype's 1974 issue of New Baskerville (released by ITC in 1982) incorporated design changes to the **e**, including enlarging the counter to be more consistent with the other lowercase letterforms (Fig. 7).

6
Subtle nuances in the **C**, **G**, **W**, **A**, and **E** give Baskerville its particular identity.

7
The New Baskerville **e** is designed with a wider body and counter, making the letter more consistent with the other Baskerville lowercase.

Although Baskerville type has existed for over 240 years, there are few documented releases from the late 1700s to 1900. In the 20th century, however, at least eight foundries issued and reissued Baskerville with the advent of new technologies. The original design has been modified often to reflect contemporary type-design esthetics. Recently, however, the tide seems to have turned, with the designers of current releases making a tremendous effort to stay true to the personality of Baskerville's original.

The first two 20th-century versions of Baskerville were issued by Stephenson Blake in 1910 and the American Type Foundry (ATF) in 1915. Both were based, not on John Baskerville's types, but on a 1768 variation called Fry Baskerville (Fig. 8) that was cut by Isaac Moore and was an inexact copy of Baskerville's work. In 1919, Bruce Rogers encouraged the production of types using Baskerville's originals and advised Harvard University Press to purchase types cast from the original matrices. In 1923, Lanston Monotype produced the first version of Baskerville in the 20th century compliant with John Baskerville's original.

Baskerville was a controversial man in his time. As with his type, Baskerville seemed to be either loved or hated, and his social life was the talk of the town. The name of his mistress later inspired a late-20th century revival, Mrs Eaves, by Zuzana Licko. Initially serving as Baskerville's housekeeper, Sarah Eaves became his mistress after her estranged husband, Richard, left her and their five children. After many years of living together, Eaves and Baskerville were finally married a month after her first husband's death in 1764.[4] Licko, Emigre's principal type designer, reinterpreted Baskerville, she says, to challenge preconceived notions of reviving classic typefaces. Licko choose Baskerville because she "sympathized with the criticism the designer received during his lifetime." Licko incorporated less contrast throughout the type while pursuing, through digital means, Baskerville's quest for "perfect" printing.[5]

Metal Type
1757 John Baskerville uses his own typeface
1766 Joseph Fry and William Pine, Fry Baskerville
1910 Stephenson, Blake and Company, Baskerville Old Style
1915 American Type Foundry (ATF)
1923 Lanston Monotype
1926 Stempel
1929 Mergenthaler Linotype
1931 Intertype
1936 Deberny et Peignot
Phototype
1961 Berthold
1978 Linotype, New Baskerville
Digital Type
1982 International Typeface Corporation (ITC), New Baskerville designed by Matthew Carter
1983 Berthold, Baskerville Book designed by Günter Gerhard Lange
1995 Monotype
1996 Emigre, Mrs Eaves designed by Zuzana Licko

An aspect of Baskerville's type that I intended to retain is that of overall openness and lightness. To achieve this while reducing contrast. I have given the lowercase characters a wider proportion. In order to avoid increasing the set-width, I reduced the x-height, relative to the cap-height. Consequently, Mrs Eaves has the appearance of setting about one point size smaller than the average typeface in lowercase text sizes.

I realize that certain aspects of this revival probably contradict Baskerville's intentions, but my point in doing so is to take those elements from Baskerville that have become familiar, and thus highly legible, to today's reader, and to give these my own interpretation of a slightly loose Baskerville that may be reminiscent of a time past.

Zuzana Licko

8

Fry Baskerville is an inexact copy of John Baskerville's type. Made by Joseph Fry and William Pine in 1766, Fry Baskerville has greater contrast than the original. It also has a different tail connection in the **Q**.

Digital versions of Baskerville type are more uniform than phototype versions, but there are still significant variations between the digital faces. The following evaluation highlights specific letters from Monotype, Berthold, International Typeface Corporation (ITC), and Emigre.

Monotype Baskerville Regular (hereafter referred to as Monotype) bears the closest relationship to the original Baskerville. Overall, it has a greater contrast between the thick and thin strokes than does ITC New Baskerville (hereafter referred to as ITC), Berthold Baskerville Regular (hereafter referred to as Berthold), and certainly Emigre's Mrs Eaves (hereafter referred to as Emigre).

9

Berthold Baskerville Regular **C** is remarkable for its single serif.

72-POINT BERTHOLD BASKERVILLE REGULAR

72-POINT MONOTYPE BASKERVILLE

Berthold tends to be heavier than the other versions with less contrast between thick and thin strokes, a contrast most similar to that of Emigre. ITC distinguishes itself with slightly concave serifs. Most of the other differences between these versions lie in their serifs, bowls, loops, arms, and counters.

Alphabetically, the **C** of Berthold is the first letterform to offer significant contrast to the other versions (Fig. 9). Following its general characteristics, the serif of the Berthold **C** is heavier and bit wider. Whereas Monotype, ITC, and Emigre all have bracketed serifs on the top and bottom, Berthold employs only one serif on the top.

48-POINT ITC NEW BASKERVILLE

48-POINT MONOTYPE BASKERVILLE

48-POINT BERTHOLD BASKERVILLE REGULAR

48-POINT EMIGRE MRS EAVES

10

The body height of the **O** is quite different in the various versions of Baskerville. The counter of Mrs Eaves is the most circular.

One of the most structurally consistent Baskerville letterforms is the **O** (Fig. 10). The counter of ITC has a slightly more vertical oval, causing Monotype and Berthold to appear a bit rectangular in comparison. The Emigre **O** exhibits more geometry and less contrast. The one obvious difference between the forms lies in body height, with Berthold towering over the others.

As noted above, the **Q** has a tail that is easily identifiable as a Baskerville feature (Fig. 11). A shared element between versions of the **Q** is the equal ratio between the stroke width of the tail and the bowls. The swash tails are all long yet vary in each version. In Monotype, the hairline is attached to the bottom of the right side of the bowl, and the terminus is flat; it looks snipped off. ITC connects the tail at the bottom-center of the body via a shorter hairline. The terminus of its swash comes to a point in true calligraphic gesture. The tail of the Berthold version is the same as Monotype in swash stroke weight and connection point; the variation between Berthold and Monotype is

11

A comparative look at the tails of ITC, Monotype, Berthold, and Emigre shows variations in length, width, and terminus.

Berthold's slightly thicker hairline and rounded terminus. The tail of the Emigre **Q** is similar to that of Monotype and Berthold, but the connection is made at the center of the body form and is curved. Concerning the swash, the tear is more pronounced, and the terminus is flat like Monotype.

There are significant differences in serif treatment in the **d**, **h**, and **p** (Fig. 13A). The top and foot serifs of Monotype and Berthold are concave, but the Berthold version has a deeper curve. It is surprising to find the top serifs of ITC at a straight angle, unlike those of the uppercase. However, the lower serifs of the **h** and **p** echo the concave character of the uppercase. The letterforms **b**, **k**, **l**, and **q** also follow the aforementioned attributes. ITC also has a more obtuse angle in the foot serifs of the **d** and **u**. Emigre has straight angled top serifs while retaining flat descender serifs in the **h** and **p**.

72-POINT ITC
NEW BASKERVILLE

72-POINT
MRS EAVES

13A
Overlapping letterforms reveal nuances in both body height and serif style in all four versions: Monotype, ITC, Berthold, and Emigre.

13B
The terminus of the Berthold Baskerville Regular **g** almost closes the bowl.

The **e** and **g** are subtly yet distinctively different in each version (Fig. 13B). The small eye of the Monotype and Emigre **e** preserves Baskerville's original letterform. ITC and Berthold have made modifications to the eye so that it is larger and more proportional to the other letterforms; ITC has increased overall character width while Berthold has a lower bar. The open bowl of the **g** is different in three of the four versions. Monotype and Emigre share a similar terminus, coming to a slender point and leaving the openness of the bowl well defined. ITC brings the terminus inward slightly with a wider stroke and point. The terminus of Berthold almost closes the bowl with a broad stroke that comes to a sharp point.

Monotype Baskerville Italic is easy to distinguish from ITC, Berthold, and Emigre's italic versions. The **J**, **K**, **N**, **T**, **Y**, and **Z** employ cursive strokes unmistakable as ITC or Berthold (Fig. 14). The **J** and **Z** have swashes for crossbars while the **K**, **N**, **T**, and **Y** have tears on most of the termini. Emigre shares the cursive stroke faithfully with Monotype in the same uppercase letters except for the **T** and **J**. The **J** resembles ITC, and the **T** is characterized by serifs angled in opposite directions (Fig. 15). ITC distinguishes itself in its **W**, **w**, and **k** (Fig. 16). Radically breaking from the other faces, the arm of the **k** loops around to the leg to form a closed bowl. The **W** employs a center serif and the **w** does not loop at the apex, contrary to the other faces.

15
Emigre Mrs Eaves Italic differs significantly from Monotype Baskerville Italic in the **T** and **J**.

16
ITC New Baskerville Italic contains a looped arm on the **k** and center serif on the **W**.

36-POINT ITC NEW BASKERVILLE ITALIC

36-POINT MONOTYPE BASKERVILLE ITALIC

14
The cursive strokes of these Baskerville italic are unique to Monotype.

Baskerville type is familiar to designers as a body text and has been employed rarely above 18 point. However, with the invention of scalable digital fonts, today's designers are finding the type to be very useful in a varity of point sizes. Peter Martin's book *Atlas for a Typeface Exploration*, created in 1995, investigates ITC New Baskerville's visual agility by contrasting texture, rhythm, structure, kinetics, and tonality (Fig. 17). Ideas of point, line, and plane provide the guidelines for each exploration. Composing and crafting the single-copy book in graduate school at Viginia Commonwealth University, Martin was impressed by the type-

18
Web-site banner from RIT, 1995.
Design firm: Communications Office
of RIT, Rochester, NY.

Rochester Institute of Technology
R·I·T Today
Directory Search Calendar RIT News Web Help SIS

face's ability to remain legible in a variety of visual solutions. The selection of Baskerville for the project, he says, was out of "simple adoration for the type's distinct character."

How is the legibility of a finely crafted typeface like Baskerville affected by low resolutions and use on the Web? Rochester Institute of Technology utilizes ITC New Baskerville Roman for its logotype. It is used consistently in printed material and displayed on the school's Web site. The banner was designed by the Communications Office of Rochester Institute of Technology and instituted in 1995 (Fig. 18). Here, the logotype is set in a large point size, and does not suffer from too much degradation. The serifs do dither and fade out, which gives the logo a soft look, but concave serifs are still noticeable on the bottom of the **I** and the leg of the **R**. However, the integrity of the letterforms suffers immensely in the 16-point subhead that reads "Rochester Institute of Technology." Due to the screen's low resolution, it is difficult for the computer to render fine details.

A type solution, titled "EEEE," from Peter Martin's *Atlas for a Typeface Exploration*, 1995.

17

It is the spirit of one to remain as one...

It is the spirit of o ne tor ma as on e

The term "texture" signifies the manner in which the elements are externally combined with each other and with the basic plane.
— Wassily Kandinsky

DEAN'S MESSAGE

In 1997, Kinetik Communication Graphics produced a catalog for the School of the Arts at Virginia Commonwealth University (Fig. 19). Berthold Baskerville Book was used as the display font and within body copy for emphasis. Set in all uppercase roman and italic, at varying point sizes from letter to letter, this is a seldom seen treatment of Baskerville type. The combination of Berthold Baskerville Book faces, weights, and sizes gives an added tension to the type. It is noteworthy to recognize the italic face's similarity to Monotype Baskerville Italic. Scott Rier, senior project designer, agrees that Baskerville type has an association with tradition,

19
Three different uses of Berthold Baskerville Book from the VCU School of the Arts catalog, 1997. Design firm: Kinetik Communication Graphics, Washington, D.C.

but Rier also feels that the type is versatile enough to be used today over a wide range of applications. He suggests that the use of Baskerville in the catalog combines traditional values with open mindedness.

Regarded as the first transitional typeface, Baskerville has trod a rocky path over the past 240 years. The variety of digital versions offered today is a testament to John Baskerville's dedication and perfectionist philosophy in type design and printing techniques. Successful modern versions of Baskerville exemplify the challenge faced by all designers and typographers when reviving a classic face: to preserve a sense of tradition within a contemporary context.

NOTES

1 Daniel Berkeley Updike, *Printing Types: Their History, Forms, and Use. Vol. 2*
 (Cambridge: Harvard University Press, 1937), 113.

2 F.E. Pardoe, *John Baskerville of Birmingham: Letter-Founder & Printer*
 (London: Frederick Muller Limited, 1975), 58.

3 Robert Bringhurst, *The Elements of Typographic Style*
 (Vancouver: Hartley & Marks, 1992), 118.

4 F.E. Pardoe, *John Baskerville of Birmingham: Letter-Founder & Printer*
 (London: Frederick Muller Limited, 1975), 14.

5 Zuzana Licko, *Mrs Eaves* (Sacramento: Emigre, Inc, 1996), 2c-2d.

abcdefghijklmnopqrstuvwxyz
ABCDEFGHIJKLMNOPQRSTUVWXYZ
1234567890&!?.:;"

28-POINT MONOTYPE BASKERVILLE

British type designer and historian Stanley Morison called the 1496 types used by the famed Renaissance printer Aldus Manutius, on which the 1928 Monotype typeface Bembo is based, the beginning of "a new epoch in typography." Although Manutius considered his typeface a perfunctory and insignificant favor for a young friend, writer Pietro Bembo, it soon became Manutius's most lasting and important contribution to type design. Indeed, Bembo diverges from its predecessors by using a more articulated weight stress for each letter while retaining its calligraphic characteristics. For this reason, Manutius's types inspired the standard for European typeface throughout the 16th century. Even today, Bembo remains widely popular, and is commonly used as a text face in both conservative and progressive designs (Fig. 1).

corporate identity + communications

trade show + exhibition design

interactive media design

environmental design

strategic marketing

web site design

advertising

1

Bembo used on a business card for Informatics Studio, Pittsburgh. Art director: Todd Cavalier; designers: Todd Cavalier, Wendy Garfinkel; printer: New Image Press.

cnim (ut de me ipfo loquar) ; quibus ta-
men ; ex quo hanc uillam exaedificaui-
mus, iam inde ánte, q tu es natus, confu
mere hic nondum etiam licuit triginta in
tegros dies ; neq; quando licebit fcio , cu-
piam certe femper, et peroptabo ; uides
q multos tibi pofuerim ordines pulcher
rimarum arborum uel noftratium , uel
aduenarum:q fi etiam Platanos habuif-
fem ; nunq illae me uiuo periiffent ; et ha
beres tu quidem nunc, quo melius inuita
re poffes Faunum tuum ; et ille, quo li-
bentius accedere. B. F. Vellem equi
dem mi páter:fed(quando id effici nó po
teft) oblecta te populis tuis:tum etiam (fi

B

The history of Bembo originates in Venice, a typographic center of the 15th and 16th centuries. Many significant printers set up shop in Venice during this time, including Manutius, an influential scholar who founded the Aldine Press in 1490. About the time that Manutius began publishing in Venice, 25-year-old Pietro Bembo finished writing *De Aetna*, a personal account of his visit to the Mt. Etna volcano in Sicily. Bembo was eventually named a cardinal and became one of the most popular writers of the Renaissance. *De Aetna*, a precursor of 20th-century pocket books owing to its dramatic reduction in size, was a 60-page quarto published in February 1496. The Aldine Press printed *De Aetna* using a new roman typeface commonly known as *De Aetna* type. Although relatively unimportant as literature, *De Aetna* gave Pietro Bembo lasting renown after his name was attached to designs destined to become a type masterpiece.

2

Detail of Aldus Manutius's edition of *De Aetna*, 1496.

em adinuenit:quam animi a

ɔilemqʒ conuerſionem & uita

us:qua quidem ex uita amicii

amiciciam uero beatitudo illɛ

r:qui a ſuperioribus depend&

ırus eſt. Quid igitur hac intei

is atqʒ beatius excogitari pote

omniũ ipſe fons atqʒ largitoi

nt cauſam in ſe ipſo compleɛ

ā adeptus eſt.ʻqui reʒ omniũ

ui patrem atqʒ tutorem illum ſibi aſcrip

icere quin omnia quæ ad animam :quæ

ertineant optimé beatiſſimeqʒ is poſſide

actus:beatiſſimā eius amiciciā exacta exɛ

t.Hanc ergo ſalutaɾem hominum ad d

b omnipotenti deo miſſus deus uerbum

unctis annũciat.Non hinc aut alɪunde:f

d deum uerum:græcos ſimul et barbaro

3

Detail of Nicolas Jenson's edition of *De Evangelica Præparatione*, 1470.

Bembo has a calligraphic feel that is particularly evident in the serifs. Unlike the Jenson slablike serifs, Bembo's serifs have a delicate transitional curve that rises up into the stem of each letter. Top serifs on some of the lowercase letters are diagonally sloped toward the left, terminating just before the point. Many lowercase letters exhibit hints of sinuous curves reminiscent of those generated by hand-drawn letters; the termination of the arm of both the **r** and **e** flare slightly upward and outward. The lowercase **c** has a subtle forward slant, a reversal of the oblique stress of the **o**. Noteworthy also are the **h**, **m**, and **n**, which have a slightly returned curve on their final stem. All of these characteristics are minute and often overlooked, but they contribute considerably to the personality of the typeface. The Bembo majuscules retain many of the calligraphic elements of the lowercase. Particularly beautiful are the **J** with its elegantly curved descender, the very slightly curved strokes of the **K**, the barely detectable curve on the tail of the **Q**, and the flowing stroke of the **R**, which extends beyond the bowl with a delicate taper. The ampersand is a magnificent display of sweeping curves that change fluidly from concave to convex (Fig. 4).

BEMBO

The *De Aetna* type was cut by Francesco Griffo, a goldsmith-turned-punchcutter. He recognized the potential of metal type to achieve a precision and esthetic different from that of traditional ink-drawn characters. Griffo's genius as a craftsman and designer was matched only by Manutius's vision as an entrepreneur. Designed as roman text, these types had a lighter, more consistent weight stress and variation than their precedents. For this reason, they were appealing and easy to read. In his research on Griffo's punchcut types, Hans Mardersteig, the 20th-century scholar and printer, found that the first Griffo types were merely an extension of Nicolas Jenson's types. With each cut, however, Griffo gained new insight, allowing his letters to evolve. Finally, the masterful cut for *De Aetna* (Fig. 2) showed a significant departure from the design characteristics of Jenson (Fig. 3). This is evidenced by a marked difference between thick-and-thin strokes, with careful attention given to a more pronounced weight stress within each letterform. Delicate serifs further complement the sensitive cadence of Bembo. The initial design was produced only in lowercase, borrowing capitals from earlier roman faces. This was rectified three years later, in 1499, with the introduction of a companion capital set. Adding to Bembo's visual harmony, the height of the capitals falls slightly below the lowercase ascenders.

BEMBO

chrome Qn, JoKeR

4

By Julie L. Rabun

Bembo OLD STYLE Garamond

Bembo OLD STYLE Garamond

BEMBO

The *De Aetna* type, cited by Morison as the model and inspiration for Claude Garamond's types (Fig. 5), is often considered the prototype for old style. The Lanston Monotype Corporation, where Morison served as typographic advisor, was influential in resurrecting many historical typefaces during the 1920s. Monotype reintroduced Bembo in 1929. As with all old-style revivals, research proved difficult: poorly cast type, inconsistent ink squeeze, poor printing, and the age of the specimens made determining the exact shape of the letterforms an arduous task. Also, the designers at Monotype had to choose among as many as five alternate cuts for each letter. In fact, eight of the lowercase letters in Griffo's original set had variations. Nevertheless, Monotype created a beautifully rendered redesign named Bembo that approximately, albeit mechanically, represents the original cut.

During the production of Monotype Bembo, the design of a complementary italic to accompany the roman became a significant challenge. After an italic face cut by English calligrapher Alfred Fairbank was rejected as too divergent from the roman, Monotype staff designers created an italic based on works by the 16th-century Venetian writing master Giovanni Tagliente. This italic proved to be a more compatible companion to the roman.

More recently, several digital versions of Bembo have been produced. Modern examples include a Monotype PostScript set that closely resembles the 1929 release. Available as Monotype Bembo Expert, it contains the full Bembo family along with alternate characters such as the long-tailed uppercase **R**. While Monotype PostScript fonts often have an irregular appearance in low-resolution output, characteristic variations in stroke weight and delicate serifs are maintained at higher resolutions. Adobe produces a digital Type 1 version of Bembo. Unlike Monotype's fonts, Adobe's are hinted, which makes their screen appearance and low-resolution output more accurate. Adobe Bembo differs little from Monotype Bembo. Modeled after the 1960 Monotype design for phototypesetters, Adobe Bembo is more rounded and refined. Both digital releases enjoy continued popularity (Fig. 6), not unlike the success of their predecessors.

Comparable typefaces do exist. Many, including some Garamonds and Hans Mardersteig's 1929 typeface Griffo, were modeled after Bembo. In the 1960s, Jan Tschichold designed Sabon. Closely resembling Bembo, Sabon is a popular text typeface that was designed as a Garamond revival. A third comparison may be made with Minion, a contemporary digital type created by Robert Slimbach and released by Adobe in 1990. Slimbach attributes his inspiration to the Aldine typefaces. "I like to think of Minion as a synthesis of historical and contemporary elements," he says. "My intention with the design was to make a progressive Aldine style text family that is both stylistically distinctive and utilitarian. The design grew out of my formal calligraphy, written in the Aldine style. By adapting my hand lettering to the practical concerns of computer-aided text typeface design, I hoped to design a fresh interpretation of a classical alphabet."

MINION DISPLAY

12345

MINION EXPERT

Griffo and Manutius are believed to have
quarreled over proprietorship of typeface
designs, eventually ending their relationship.
However, Bembo remains a memorable
achievement of their partnership. Most type-
faces designed prior to and during the
Renaissance are attributed solely to the printer
or publisher, who was usually the same person.
There can be little doubt that Griffo's insightful
genius and skills as a punchcutter contributed
considerably to the creation of Bembo.
In the end, it seems unlikely that without this
brilliant, albeit tumultuous partnership with
Manutius, Bembo would not exist. Griffo left the
partnership in 1502, after which there were no
new typeface designs produced by the Aldine
Press.

MINION

abcdefghijklmnopqrstuvwxyz
ABCDEFGHIJKLMNOPQRSTUVWXYZ
1234567890&!?:;,""

28-POINT BEMBO

"Je ne veux que de magnifique et je ne travaille pas pour le vulgaire." [1]

"I wish only magnificence and I do not work for the vulgar."

Giambattista Bodoni chose the phrase above for his maxim. It clearly reflects the aristocratic foundations of a family of typefaces, categorized by Maximilien Vox as the "Didones," that forms one of the highest achievements of the modern typeface style. Emerging in the latter part of the 18th century, the typefaces of Bodoni and his French counterparts, the Didot family of Paris, embody the rationalist, noncalligraphic approach to typography begun a century earlier in the design of the *Romain du Roi* for Louis XIV and his court.

1

2
Construction diagram for the *Romain du Roi* **G** engraved by Louis Simmoneau in 1700. Simmoneau significantly softened the typeface's harsh geometries.

Often imitated and extended in countless revivals and redrawings over the last 200 years, the faces of Bodoni and the Didots continue to thrive, even if most versions, as noted by type historian Alexander S. Lawson (in the case of Bodoni), "tend to be more in the style of Bodoni than exact copies of his letterforms." [2]

Emerging at the height of the neoclassical era, the typefaces of Bodoni and Didot reflect a synthesis of 18th-century cultural and technological influences. The excavations of Herculaneum and Pompeii created a surge of interest in ancient culture, which was reflected in all of the plastic arts as well as in oratory and literature. It is for these latter purposes, as type historian Daniel Berkeley Updike suggests, that "it seemed necessary, in typography, to clothe new modes of expression in a new way, and new type forms were demanded to do it." [3]

Eighteenth-century type design was also heavily informed by the scientific precepts that had come to the fore during the Enlightenment. The *Romain du Roi*, which greatly influenced the development of both the transitional and the modern typeface style, is credited by most type historians as the progenitor of the new rationalist direction in letterform design. Based on a grid divided into 64 square units (which is in turn divided into 36 smaller units), the letters of the *Romain du Roi* were constructed mathematically (Fig. 2) with the elements of each letterform treated as components in an overall design system (Fig. 1). Development of the typeface was supervised by a committee of scholars led by the mathematician Nicolas Jaugeon and the initial printing of the letters was carried out in large copperplate prints by Louis Simmoneau in 1695, with the cutting of the actual types assigned to Phillipe Grandjean. The use of copperplate printing, along with the improved papers and inks of the period, dramatically impacted the future direction of letterform design throughout Europe.

Along with advancements in technology, the *Romain du Roi* introduced many specific design features that, in a more exaggerated form, would become the hallmarks of modern typeface design: a heightened contrast between thick and thin strokes, a shift of stress to the vertical, sharp horizontal serifs, and a move away from calligraphic letterforms toward those that reflected the tools and processes of the draftsman and engraver. The influence of the *Romain du Roi* would play out for the next 100 years, affecting the type designs of Fournier, Caslon, and Baskerville, and eventually culminating in the work of Bodoni and the Didots.

It is significant that, like their typographic ancestors, both the Bodoni and the Didot typefaces were created with the benefit of royal patronage. Giambattista Bodoni did the bulk of his work in the service of Ferdinand I, the Duke of Parma, who hired him in 1768 to run the *Stamperia Reale,* the Duke's personal press (Fig. 3). In France, Fermin Didot, the member of the Didot family most closely associated with the creation of the Didot style, was appointed director of the imperial foundry, the *Imprimerie Royale*, by Napoleon, a position Didot held until his death in 1836.

MANUALE

TIPOGRAFICO

DEL CAVALIERE

GIAMBATTISTA BODONI

VOLUME PRIMO.

PARMA

PRESSO LA VEDOVA

MDCCCXVIII.

3

Title page from the *Manuale Typografico*, a *tour-de-force* summation of Bodoni's typeface designs published by his wife five years after his death in 1813.

4

PIERRE & FIRMIN

5 | ABCDEFGHIJKLMNOPQRSTUVWXYZ
abcdefghijklmnopqrstuvwxyz
1234567890
ABCDEFGHIJKLMNOPQRSTUVWXY
abcdefghijklmnopqrstuvwxyz

THE BODONI FAMILY

BEAUTIFUL Printing is an educator, the same as is any art. The thoughts of an author take on added values by reason of it. The mind is always receptive in proportion as it is helped to comprehend the real meaning of the writer. Nothing will assist more than an effective page of type in enabling the reader to arrive at that meaning quickly and easily; for this purpose the members of the Bodoni Type Family are not surpassed for power and beauty

Tint: Jaquish Ornament Bodoni Mortised Ornament

6
Demonstration page of Morris F. Benton's ATF
Bodoni from the *American Type Founders
Specimen Book and Catalogue*, 1923.

While the clients of Bodoni and the Didots were not limited to their royal patrons, the work was nonetheless executed exclusively for the privileged. In an article on Bodoni, type historian Allan Haley notes that Bodoni's goal was "not to create type or typography to be appreciated by the masses. His books and other printing exercises were large, regal efforts meant to be looked upon and appreciated as works of art, rather than mere pieces of communication. His work was probably the most honored—and least read—printing of his time."[4]

Because of the similarity of their typefaces, and the fact that the Didots and Bodoni were contemporaries, much has been made of who deserves credit for the distinctly modern look of the faces. Were the Didots followers of Bodoni, or was it the other way around? Chronologically, the Didots produced the first typeface—in 1781— that we would identify today as being unmistakably modern. Bodoni, who most historians assert was well aware of the Didots, produced his first truly modern type design in 1790. However, it is also true that Bodoni's designs evolved throughout his lifetime and that he continually refined and extended his type to fit an increasingly wide range of languages and applications. The breadth and extent of this work was known in France and to the Didots. It is perhaps safe and probably more accurate to acknowledge the competition and mutual influence of these two giants of type design, and to think of them as researchers working on a common problem. (Understanding their mutual influence is helpful in evaluating later revivals of Bodoni and Didot, where features of both designs were sometimes intermixed.)

The fonts of Bodoni and the Didots were used off-and-on throughout the remainder of the 19th century, but with the exception of Walbaum (Fig. 5), a successful adaptation of Didot by J.E. Walbaum in Germany around 1800, it wasn't until the early 20th century that the faces gained major distribution outside of their respective countries. Interest in Bodoni was rekindled by a recutting of the face issued by the Nebiolo Type Foundry of Turin in 1901. A more influential revival, however, was Morris Benton's 1911 American Type Founders (ATF) version of the face (Fig. 6). According to Lawson, Benton "received guidance from Italian sources in his recutting," but "did not attempt an exact copy of the original Bodoni type."[5] The result was a typeface that drew liberally from both Didot and Bodoni models and included what appear to be some features of Benton's own invention. The most notable departure from the Bodoni face is the use of flat, unbracketed serifs in the uppercase letters and in the bottom serifs of the lowercase ones. Benton's typeface also included a rather oversimplified and overly symmetric geometry which resulted in some rather un-Bodoni-like features as in the joinery of the finials in the **C** and **G** (Fig. 7).

Benton's 1911 Bodoni was subsequently copied by the Monotype, Haas, Intertype and Ludlow foundries, and is still widely used, especially in Europe (Fig. 8).

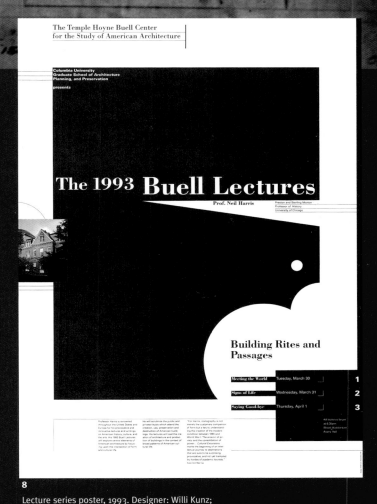

7

Digital versions of Bodoni's types, like their phototype predecessors, are based on idealized renderings, averaging the letterforms to reflect features from a range of the original metal types. ATF Bodoni may reduce the original forms a bit too far.

8

Lecture series poster, 1993. Designer: Willi Kunz; client: Columbia University Graduate School of Architecture, Planning and Preservation.

ORIGINAL BODONI MAJUSCULE 113 — **CG**

ATF BODONI — **CG**

BAUER BODONI — **CG**

ITC BODONI SEVENTY TWO — **CG**

48-POINT BAUER BODONI ROMAN

COGNOSCENTI

48-POINT ATF BODONI REGULAR

COGNOSCENTI

9

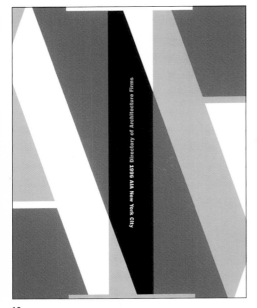

10

Directory cover, 1996. Design Firm:
Pentagram, New York City; designer:
Michael Gericke; client: American
Institute of Architects.

The next important moment in the 20th-century revival of Bodoni came in 1923 when Hans Mardersteig, an expatriate German living in Switzerland, opened the *Officina Bodoni*, a private press dedicated to the use of classic type. Mardersteig convinced authorities in Italy to allow him to make new castings of the original Bodoni matrices stored in Parma. Mardersteig's production of fine books using the original Bodoni led to a heightened interest in Bodoni's output, and was particularly influential in the development of the Bauer type foundry version of Bodoni (Fig. 9) in 1926. Designed by Heinrich Jost and punchcutter Louis Höll, Bauer Bodoni was a markedly more refined representation of the Bodoni style. The proportions of the letterforms far better matched the stateliness of Bodoni's originals, and the stroke weights were adjusted to achieve more accurately the much admired "sparkle" of Bodoni's types. The Bauer Bodoni design also restored important details including the pointed apex of the **A**, the slight bracketing of the serifs, the distinctive nick in the upper- and lowercase **J**, curved brackets on the finials, and more graceful concavities in the ascenders (Fig. 11).

In contrast to the Bodonis of the time, Bauer Bodoni was hailed as the most accurate rendering of the Bodoni style. In retrospect, and in light of a recent Bodoni revival by Inter-

national Typeface Corporation (ITC), it is clear that, while undeniably improving upon the Benton version, Bauer Bodoni may have depended on features as much akin to Didot as to Bodoni. Regardless, Bauer remains the Bodoni of choice for many contemporary designers (Figs. 10, 16).

The success of ATF and Bauer Bodoni led to a number of interesting but decidedly ahistoric additions to the Bodoni/Didot family. In 1930, the Berthold Type Foundry released Bodoni Antiqua, which was modeled closely on the Benton face, but was extended to include a condensed version. Bodoni Antiqua featured a reduced contrast between thick and thin strokes to improve legibility when used for running text, and shortened ascenders and descenders. An immediate success, the face was adopted and is still used as IBM's corporate typeface (Fig. 13). Bodoni and Didot also served as the inspiration for a wide variety of display fonts including Benton's Ultra Bodoni (1928), Chauncey Griffith's Poster Bodoni (1929) and Gary Powell's Onyx (1937) (Fig. 12).

A more recent descendant of Berthold Bodoni Antiqua is "Our Bodoni" (Fig. 15), drawn by Tom Carnase for the Vignelli office in 1989. This decidedly modernist take on the Bodoni family was motivated by Massimo Vignelli's frequent pairing of serif and sans-serif faces. Carnase adjusted the x-heights, shortened the ascenders and descenders to match the ratios found in Helvetica, and developed a set of four weights to allow for maximum control of contrast.

65-POINT BAUER BODONI

11 # CAJUN fiddle

24-POINT MONOTYPE ULTRA BODONI

ABC123

24-POINT ITC POSTER BODONI

ABC123

24-POINT ONYX

ABC123

12

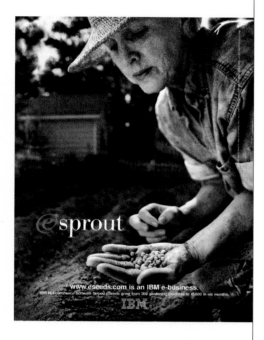

13

Magazine advertisement applying Bodoni Antiqua to an e-commerce theme, 1999. Agency: Ogilvy & Mather, New York City; art directors: John McNeil, Mark Graham; copywriters: Josh Tavlin, Kristen Steele: photographer: Robert Lewis; client: IBM E-Business Solutions.

Typefaces revived under the Didot name have not had anywhere near the currency of Bodoni releases. Jaspert, Berry, and Johnson's *Encyclopedia of Type Faces* lists four entries under "Didot," but the only version widely available outside of France is Monotype's Neo Didot (designed by the Monotype staff in 1904). Because of its similarity to Bodoni, and because of the liberal intermixing of features in early Bodoni revivals, it seems that Didot has become relegated to use mostly as display type. For this purpose, its highly etched hairlines create a distinctive identity and a ready-made air of sophistication. One of the most successful translations of Didot into a digital form was carried out by Adrian Frutiger for Linotype-Hell in 1992 (Fig. 4, page 55).

14

In addition to developing his variations on Roman letterforms, Bodoni directed his attention to other alphabets such as Greek and Arabic. A version of Cyrillic Poster Bodoni inspired by Bodoni's experiments is used above to advertise a lecture series. Designers: Bruno Monguzzi, Alberto Bianda/Meride, Switzerland; clients: Museo Cantonale d'Arte, Lugano; Galleria Gottardo, Lugano; Museo del Malcantone, Curio.

Our Bodoni

Our Bodoni

15

Tom Carnase's Our Bodoni, shown here above Bauer Bodoni, adjusts the proportion of upper- and lowercase letters of Bodoni to equal those of Helvetica. This results in an increased x-height and markedly reduced ascenders and descenders.

40-POINT ITC BODONI SEVENTY TWO

Manuale

40-POINT ITC BODONI TWELVE

Manuale

40-POINT ITC BODONI SIX

17

Manuale

16

Most digital versions of fonts are based on a single outline description, such as the Bauer Bodoni used in this opera poster, 1998. Linear scaling by layout software provides a range of sizes. Design firm: CYAN, Berlin; client: Berlin State Opera.

Like Caslon, and Garamond, Bodoni has been the subject of a major recent digital revival. In 1991, International Typeface Corporation (ITC) sent a team of type designers on a pilgrimage to the *Museo Bodoniana* in Parma. The museum is housed in the Biblioteca Palatina, its collection including thousands of printed volumes from Bodoni's presses, as well as large numbers of metal punches from Bodoni's 400-plus fonts: 146 sizes of his roman types (with 146 accompanying italics), 115 titling and script fonts, and numerous nonlatin scripts.[6] The design team, consisting of Holly Goldsmith, Janice Prescott Fishman, Allan Haley, Ilene Strizver, and Sumner Stone, carefully examined the collection to determine which of the Bodoni fonts were most suitable to combine into a scalable set of digital fonts. This proved a difficult task because, unlike many contemporary type designers who might work on several distinctly different type designs over the course of a career, Bodoni spent his entire life refining and expanding the range of a single face. The research team found that individual cuttings included slight variations in serif structure, adjustments to the shape of counterforms, and other idiosyncratic details. These variations became more obvious as the fonts evolved from very small sizes to larger majuscules. To try to capture the subtle variations between cuttings, the ITC team decided to create three separate sets of fonts. The first was a large display face optimized for a 72-point setting. The smaller faces were opti-

mized for 6- and 12-point text (Fig. 19). For the large face (later named ITC Bodoni Seventy Two), the team chose Bodoni's Papale, or "the Pope's type" (Fig. 18), as its model. The small face was modeled after Bodoni's elegant text face Filosofia Bassano. In a daring experiment, the 12-point face was created by the process of computer-aided interpolation. The success of this middle synthesized version, according to Stone, is a testimony to the "precise visual image of [Bodoni's] type which he developed and maintained over many years."[7] The need for three sizes of the typeface is quite evident when each is brought up to a common size (Fig. 17). One of the biggest difficulties faced in creating both the phototype and the digital versions of Bodoni has been the face's resistance to linear scaling. In the original metal versions, great care was taken to adjust the stroke-weight ratios so that even at the smallest size there would be no loss of legibility. The three sizes of ITC Bodoni follow this example to ensure that hairline strokes are not fragmented when printed small.

The idea of issuing a set of fonts for different point-size ranges is a fairly recent development in digital font design and distribution, although it was common in metal type cut for letterpress. This feature allows for increased fidelity to classic metal types.

Quousq;
tandem
abutêre,
Catilina,

18

Quousq;
tandem
abutêre,
Catilina,

Quousq;
tandem
abutêre,
Catilina,

Unlike the early Bodoni revivals that tended to oversimplify the geometry of the characters, the ITC versions strove to preserve the variety and unique characteristics of actual Bodoni type without resorting to photo-realistic interpretations. For an example of the team's remarkable success in this area, compare a resetting of the Papale specimen sheet from Bodoni's *Manuale Tipografico* set in ITC Seventy Two, a digital Bauer Bodoni, and the original (Fig. 18). The Bauer version betrays a significant exaggeration of stroke contrast (note the **n, d, b,** and **m**) and a rather formulaic approach to the geometry of the serifs (quite evident in the run of baseline serifs across the middle of the fourth word, *Catilina*.) The ITC version captures quite convincingly the often ignored organic properties of Bodoni's type, evidenced particularly in the rounded serifs and the less rigid shape of the counterforms.

Each size of the ITC Bodoni includes a roman, an italic, a boldface, and a boldface italic, and each weight includes a set of old-style figures and small caps. A very recent addition to the family is a set of capitals based on Bodoni's swash majuscules, the *Majuscole Cancelleresche* (Fig. 20).

Largo
Adagio
Moderato
Allegro
Prestissimo

19 6-POINT ITC BODONI SIX

"Exaggerated by the brilliance of his ink, the sharpness of his impression and the luxury of his paper, the total effect was such as to seduce every European typographer and all the fashionable amateurs."

12-POINT ITC BODONI TWELVE

"Exaggerated by the brilliance of his ink, the sharpness of his impression and the luxury of his paper, the total effect was such as to seduce every European typographer and all the fashionable amateurs."

—Stanley Morison, on Bodoni's influence, from *The Typographic Book, 1450–1935.*

20

The ITC Seventy Two Swash Book Italic is based on the 17th entry in the *Majuscole Cancelleresche,* one of the most elaborate fonts presented in Bodoni's *Manuale Tipografico.*

18-POINT FILOSOFIA REGULAR

ABCDEFGabcdefg12345

18-POINT FILOSOFIA ITALIC

ABCDEFGabcdefg12345

18-POINT FILOSOFIA BOLD

ABCDEFGabcdefg12345

18-POINT FILOSOFIA SMALL CAPS

ABCDEFG12345

18-POINT FILOSOFIA UNICASE

21 aBCDeFG12345

A comparison of **Filosofia Grand** with ITC Bodoni Seventy Two (both are set at 60 point). In addition to its condensed forms, Filosofia exhibits a markedly smaller cap height.

FILOSOFIA

Another addition to the Bodoni family is Zuzana Licko's Filosofia. Introduced in 1996, Filosofia expresses Licko's preference for a "geometric Bodoni." It incorporates features such as the "slightly bulging round serif endings that often appeared in printed samples of Bodoni's work."[8] Filosofia comes in two sizes—a regular size for text (Fig. 21) and a grand size for display (Fig. 23). The regular face features reduced stroke contrast to allow for a very comfortable optical effect when set in running text, while Filosofia Grand adopts the more conventional proportions associated with Bodoni display types. The face has a strong vertical feel due to its slightly condensed letterforms and strong vertical symmetry. Filosofia offers an interesting contrast to the ITC Bodoni family (Fig. 22). While the latter revival does a remarkable job of restoring to contemporary use the look and feel of Bodoni's pages, Filosofia draws from the originals in a distinctly postmodern way—creating a new face by repurposing admirable features from the past.

A very fine digital revival of Didot was introduced in 1992 by the Hoefler Type Foundry in New York. Commissioned by *Harper's Bazaar* as the cornerstone of a new visual identity, HTF Didot expresses the Didot style with remarkable elegance and grace (Fig. 24). Like ITC Bodoni, HTF Didot provides a set of fonts designed for use at very specific ranges of point size. Because of the razor-sharp strokes and serifs, a fully scalable HTF Didot requires seven separate sizes—below 10 point, 11–15, 16–23, 24–41, 42–63, 64–95, and 96 and above.

The designer, Jonathan Hoefler, explains the historical precedent for this approach in the 1999 HTF catalog: "Before the development of the pantographic punchcutter at the end of the 19th century, it was impossible to duplicate the design of a typeface in multiple sizes. As a result, types often varied wildly from size to size, but the need to handcraft each particular size allowed punchcutters to imbue each design with characteristics which were suitable to its size. HTF Didot is designed in this tradition, with individually tuned designs each for use at specific sizes."[9] HTF Didot includes light, medium, and bold weights, each with an accompanying italic (Fig. 25).

The various fonts that are today known simply as "Bodoni" or "Didot" usually adopt one consistent set of characters for each and every size. The many fonts of Bodoni and the Didots however contained a rich set of variants on certain letterforms from font to font, and even included alternate versions of some characters within the same font. The wishbone **v** and **w**, and the splayed **y** found in Linotype Didot, for example (Fig. 26), are among many variants of these forms in the Didot specimens. The HTF Didot adopts rounder forms (from the *corps dix-huit* of Didot le Jeune, which appear in the *Specimen des Caracteres* of 1819) which, to a modern eye, results in a more regularized face with a pleasing formal rhythm. HTF Didot does, however, retain the stark exaggerated slant typical of Didot's italic majuscules.

36-POINT FILOSOFIA GRAND

ABCDEFGabcdefg12345

36-POINT FILOSOFIA GRAND BOLD

ABCDEFGabcdefg12345

18-POINT FILOSOFIA GRAND CAPS

23 ABCDEFG12345

gathering
MOSS

Understanding the conundrums designed by L.A.'s
unpredictable architect Eric Owen Moss isn't always
easy—but what works by an enfant terrible are?

By Joseph Giovannini

24

Opening page of an article set in HTF Didot, 1992. Designer: Fabien Baron; client: *Harper's Bazaar*.

25

16-POINT HTF DIDOT 16 LIGHT
ABCDEFGabcdefg12345

16-POINT HTF DIDOT 16 LIGHT ITALIC
ABCDEFGabcdefg12345

16-POINT HTF DIDOT 16 MEDIUM
ABCDEFGabcdefg12345

16-POINT HTF DIDOT 16 MEDIUM ITALIC
ABCDEFGabcdefg12345

16-POINT HTF DIDOT 16 BOLD
ABCDEFGabcdefg12345

16-POINT HTF DIDOT 16 BOLD ITALIC
ABCDEFGabcdefg12345

26

48-POINT LINOTYPE DIDOT ITALIC
vwyAVW

48-POINT HTF DIDOT 42-ITALIC
vwyAVW

NOTES

1 Bodoni's maxim, stated in French, the *lingua franca* of Europe in the 1700s,
reflects Bodoni's widespread influence throughout the continent.

2 Alexander S. Lawson, *Anatomy of a Typeface* (Boston: Godine, 1990), 196.

3 Daniel Berkeley Updike, *Printing Types: Their History, Form and Use, Volume II*
(Cambridge: Harvard University Press 1937), 163.

4 Allan Haley, "Giambattista Bodoni," *U&lc* 14 (November 1987): 14.

5 Alexander S. Lawson, op. cit., 205.

6 Sumner Stone, "Notes from Parma," *U&lc* 21 (Fall 1994): 8.

7 ibid., 11.

8 Zuzana Licko, Filosofia specimen page in *Emigre Catalog* (1998): 15.

9 Jonathan Hoefler, HTF Didot specimen page in *Catalogue of Types, Third Edition* (1999): 16.

28-POINT BODONI SEVENTY TWO

abcdefghijklmnopqrstuvwxyz
ABCDEFGHIJKLMNOPQRSTUVWXYZ
1234567890&!?.:;""

28-POINT HTF 24 MEDIUM DIDOT

abcdefghijklmnopqrstuvwxyz
ABCDEFGHIJKLMNOPQRSTUVWXYZ
1234567890&!?.:;""

"When in doubt, use Caslon," is an old adage often repeated to honor William Caslon's readable and familiar fonts, whose pleasing appearance makes them among the most widely used typefaces. According to a 1923 American Type Founders catalog, "The opinion of many printers is that one never makes a mistake by composing the job in Caslon."[1]

The enduring popularity of types based on designs by William Caslon—the English type designer who cut his earliest roman types around 1725—is attributed to the warmth and legibility of his designs, as well as the vigorous energy generated by their sturdy and varied letter shapes. Design inconsistencies and a few eccentric letters, especially in the larger sizes, give Caslon a lively rhythm.

The enduring popularity of types based on designs by William Caslon—the English type designer who cut his earliest roman types around 1725—is attributed to the warmth and legibility of his designs, as well as the vigorous energy generated by their sturdy and varied letter shapes. Design inconsistencies and a few eccentric letters, especially in the larger sizes, give Caslon a lively rhythm. Its letter shapes and weight contrast warrant classification as an old-style face rather than a transitional style, as are other 18th-century fonts such as Baskerville's.

Before Caslon began to design type, English type founding was almost nonexistent; most printers were importing type from Holland. Caslon was influenced by Dutch fonts from the 1600s, but he made significant improvements that resulted in a wide demand for his work. As the British empire spread around the world, Caslon types developed an international following. The first printed version of the American Declaration of Independence was set in Caslon.

Not more than *one man* in a Thousand can tell·you WHY he *smiles* when he is *pleased*, or WHY he *frowns* when *displeased*. The other *Nine Hundred and Ninety-nine* say it is the natural thing to do and *let it go at the*

ATF CASLON NO. 471

134 ROSA BORDER

1
This handset sample from the 1923 American Type Founders *Specimen Book and Catalogue* shows the mixing of roman, italic, small capitals, and swash initials using several sizes of type.

THESE pages which you ar
themselves the most conv
the fact that Linotype Cas
and faithful reproduction
letter, for while most of these two pag
Linotype, several of the lines are hand
from matrices still in the possession of H

2

Caslon's specific characteristics are exempli-
fied in an actual-size reproduction from a 1924
specimen book (Fig. 3) issued by the H. W.
Caslon & Co. Ltd. type foundry to celebrate the
200th anniversary of its inception. Caslon's
sinuous italic ampersands (Fig. 4) are distinc-
tive and reflect the designer's background as
an engraver of ornate gun locks and barrels.

Twentieth-century revivals of Caslon encom-
pass two distinct approaches. Some attempt
to replicate the master's work as closely as
possible, while others deliberately depart from
the originals. ATF's handset Caslon No. 471
(Fig. 1) was cast from original Caslon matrices.
Linotype's Caslon Old Style is also very accu-
rate. In the 1930s, an 18-point Linotype speci-
men (Fig. 2) mixed several handset lines using
types cast from William Caslon's original matri-
ces with Linotype output. Only the most astute
typographic connoisseur can identify the hand-
set lines.

& &

AT the beginning of the 18th century tl
Foundry, which contained material pro
Worde, Day, the London Polyglot Four
and many others, was procuring types f
and an account of Thomas James's negoti
1710, when he went to procure a supply
his foundry, is given in a series of interesti
seriously humorous letters in Rowe Mores
The Dutch type-founders from whom Ja
were Athias, Voskens, Cupi, and Rolu. I

3

In this actual-size reproduction from a 1924 H. W. Caslon & Co.
Ltd. specimen book, thin strokes are fairly thick, and serifs
are stubby. Some letters, such as **O** and **S**, are lighter than
others. The **A** has a concave dip at the apex. The **C** has two full
serifs. Caslon's old style numerals have ascenders and
descenders. Like many other 16th- and 17th-century old style
fonts, the zero is a perfect circle to differentiate it from the
letter **o**. Capitals are wide and prominent; the **M** is square.

4

G ⁵ Quo Usque

ADOBE CASLON

Quo Usque

BIG CASLON CC

Fonts deviating from the originals include ATF's Caslon 540 (Fig. 8). Its very short descenders enable designers to set advertising headlines with tighter line spacing. Weights and characters are somewhat regularized in comparison to the original. During the phototype era, International Typeface Corporation issued ITC Caslon No. 224—designed by Ed Benguiat in 1983—which freely departs from William Caslon's designs. It has a larger x-height (Fig. 6), expanded italic letters, and flamboyant, exaggerated serifs. Many purists reject these phototype fonts because of the liberties taken with the letterforms. Ilene Strizver, director of typeface development at ITC, says, "I admire ITC Caslon No. 224 as a clean, elegant expression of the 1970s sensibilities." During that decade, she says, "many typeface designers were less concerned with authenticity and more concerned with exploiting phototype's expanded range of possibilities." ITC Caslon No. 224's large x-height make ascenders and descenders appear short by comparison. The exaggerated serifs on the **T** and the sinuous flow of the **x**'s thinner strokes reflect the 1970s design ethos, as do the exaggerated **F** and **c**. The flattened **f** and placement of the ear of the **g** on top of the letter are anomalies that prevent these outcroppings from jamming into other letters when tightly spaced. Four weights are available in roman and italic fonts.

Three Caslon families designed in the 1990s provide exceptional digital interpretations of Caslon. Each brings unique attributes to the typographic palette. These are Adobe Caslon, designed by Carol Twombly and released in 1990; Big Caslon CC (Carter and Cone Type Foundry) designed by Matthew Carter in 1994; and ITC Founder's Caslon, created by Justin Howes in 1998.

T

⁶ TxFcfg

EeEeEeEeEeEeEeEe

Twombly's Adobe Caslon is a serious effort to create a digital text face based on careful studies of Caslon's meticulously printed 1734 and 1786 type proofs (Fig. 7). Twombly made drawings of each letter from enlargements of the various text sizes and created an archetypal version of each character. Each single punch for every size and style of William Caslon's types had been designed and cut by hand over a period of two decades. Careful study revealed a wide range of design variations. Twombly made careful drawings from photographic enlargements of Caslon's five text sizes. Using characteristics from all five sizes, she designed a master letter that captures the essence of each Caslon character.

PICA ROMAN.

Melium, novis rebus ftudentem, manu fua occîdit. Fuit, fuit ifta quondam in hac repub. virtus, ut viri fortes acrioribus fuppliciis civem perniciofum, quam acerbiffimum hoftem coërcerent. Habemus enim fe-natufconfultum in te, Catilina, vehemens, & grave: non deeft reip. confilium, neque autoritas hujus or-dinis : nos, nos, dico aperte, confules defumus. De-ABCDEFGHIJKLMNOPQRSTVUWX

ADOBE CASLON.

Melium, novis rebus ftudentem, manu fua occîdit. Fuit, fuit ifta quondam in hac repub. virtus, ut viri fortes acrioribus fuppliciis civem perniciofum, quam acerbiffimum hoftem coërcerent. Habemus enim fe-natufconfultum in te, Catilina, vehemens, & grave: non deeft reip. confilium, neque autoritas hujus or-dinis : nos, nos, dico aperte, confules defumus. De-ABCDEFGHIJKLMNOPQRSTUVWX

7

Among digital Caslons, Adobe Caslon is quite faithful to Caslon's text typefaces and is favored by many designers. The overall color is slightly lighter than some letterpress specimens from the Caslon foundry, and some inconsistent letters are regularized.

Adobe Caslon is not recommended for display settings for an important reason: Although its weights, forms, and proportions mimic William Caslon's text types quite well, when Adobe Caslon is enlarged to display sizes it appears totally different from Caslon's originals. Adobe Caslon is crisp and refined; the letters are regularized; and serifs are more slablike in design. At text type sizes, the color and texture are remarkably expressive of the look and feel of Caslon's original types. When the text face Adobe Caslon is enlarged to display size, and display face Big Caslon CC (discussed on the following page) is reduced to text size for comparison, the impact of scale upon letterform perception is revealed (Fig. 5).

Adobe Caslon's expert fonts and ornaments enable a designer to achieve a stunning range of typographic detail and subtlety. The variety of characters and alternate characters available make possible a high level of discriminating and elegant typography.

Fall 1989

8
Cover for *Type Talks* magazine, 1989. Designer: Paul Rand; client: Advertising Typographers of America.

Quo Usque Tandem Abutere, Catilina Pati Nostra? Quam Diu Etiam Furor Iste Tuus Nos Finem

Quo Usque Tandem Abutere, Catilina Pati Nostra? Quam Diu Etiam Furor Iste Tuus Nos Finem

Quo Usque Tandem Abutere, Catilina Pati Nostra? Quam Diu Etiam Furor Iste Tu

Quo Usque Tandem Abutere, Catilina Patu Nostra? Quam Diu Etiam Furor Iste Tu

Quo Usque Tandem Abutere, Catilina Pati Nostra? Quam Diu Etiam Fu

Quo Usque Tandem Abutere, Catilina Pati Nostra? Quam Diu Etiam Fu

1387564726IO

A digitized display Caslon to accompany the superb text versions available was lacking; in 1994, the release of Big Caslon CC filled this void. It is based on 60- and 72-point titling capitals from the upper left-hand corner of William Caslon's famous 1734 specimen sheet. (Later, the Caslon foundry added lowercase letters, but who designed them, or when this occurred, is unknown.) The contrast between thick and thin strokes is exaggerated in the original letterforms. There is a forceful, even eccentric, variety to the letters. Serifs are sharp and pointed; thin strokes are exaggerated to achieve a lively sparkle. William Caslon's large fonts have many eccentric letters. Carter made his version less extreme while maintaining the spirit of the originals.

Big Caslon CC capitals are somewhat expanded (Fig. 9), while many lowercase letters are slightly condensed. Three sets of thin brackets, based on Caslon's lighter versions, contrast with the vigorous letters. Because some contemporary designers object to the use of a perfect circle as a zero, Carter made the lowercase **o** the same height so it can be substituted if desired. The lowercase letters have a dazzling vitality created by the position of weights and quick tapers from thick to thin strokes. A wonderful ampersand, long- and short-tailed versions of the capital **Q**, and exquisite ligatures—including over two dozen designed to solve problems caused by the lowercase **f** overhang—are available. Big Caslon isn't recommended for text, because serifs and thin strokes appear weak at small sizes. Display sizes below 24 point are discouraged.

Big Caslon is an important addition to the digital type library because it interprets William Caslon's large display fonts, whose letters are quite different from the smaller fonts that usually serve as a model for Caslon revivals. Its vigorous presence in display settings is seen in a page from *Rolling Stone* magazine (Fig. 10).

Hh Pp
OO
Q fft

9

BIG CASLON CC

ITC Founder's Caslon reproduces the original Caslon fonts as accurately as modern scanning and printing technology will allow. Justin Howes, an English typographer and printing scholar, was dissatisfied with the Caslon fonts available on his computer. His issues involved having only one alphabet for all sizes and the presence of characters altered from the originals. (Even metal types that were cast by the Caslon foundry contain characters reworked as much as a century after William Caslon created the originals.) Howes actually had metal types handset for some of his projects; this compounded his dissatisfaction with the digital versions. His next step was to scan and digitize authentic William Caslon characters printed from letterpress types.

One of the world's premier letterpress printers, Alan Dodson, prepared meticulous proofs on a variety of papers using genuine roman and italic metal types cast from Caslon's original 18th-century matrices. A series of four type sizes (12, 30, 42, and 96 point) were selected to capture the texture and detail found in text-, medium-, and large-size fonts (Fig. 11). Roman, italic and small-capital alphabets were digitized in the three smaller sizes, but only a roman font is available in Caslon's 96-point poster size. Howes selected what he considered the best impressions on Dodson's press proofs and made direct computer scans from the characters to create fonts as close as possible to Caslon's intent. Generally, the types became cleaner, sharper, and more accurate as Caslon cut larger punches. Anomalies that were clearly errors in cutting the original punches, such as significant differences in character height or letter spacing, were corrected. The series comes very close to the look and feel of type printed by letterpress, for the irregularity and warmth of handcast types is captured.

10
Page from *Rolling Stone* magazine using Big Caslon CC, 1999. Art director: Fred Woodward; designer: Siung Tjia.

{ SPECIAL REPORT }
BY PAUL ALEXANDER

All Hat, No Cattle

GEORGE W. BUSH was head cheerleader in prep school, a hard-partying frat rat and mediocre student at Yale. After skirting the draft in 1968, he failed at business three times, got bailed out by powerful friends, made a fortune at taxpayer expense and became the popular but weak governor of Texas, an evangelical Christian who preaches morality but ducks questions about his own past. And now he might be president?

BIG CASLON CC

Ee	Ee	Ee	Ee	12-POINT
Ee	Ee	Ee	Ee	30-POINT
Ee	Ee	Ee	Ee	42-POINT
Ee	Ee	Ee	Ee	96-POINT

ITC FOUNDER'S CASLON TWELVE ITC FOUNDER'S CASLON THIRTY ITC FOUNDER'S CASLON FORTY-TWO ITC FOUNDER'S CASLON POSTER

12

Caslon Antique specimen from
the Barnhart Brothers and Spindler
Catalog 25, undated.

13

Annual report cover design proposal using
Big Caslon CC numerals with Caslon 224 Bold
and Bold Italic title, 1996. Designer: Philip B.
Meggs; client: VCU School of the Arts.

A comparison of the original handset Caslon Old Style with two contemporary digital versions of the face, Founder's Caslon and Adobe Caslon, shows the options available today (Fig. 14). (Founder's is somewhat closer to the original than the "original," for this specimen is inked a bit too heavily and has characters revised by later Caslon foundry designers.) Founder's Caslon captures the warmth and irregularity of metal type, while Adobe Caslon provides the tailored uniformity of a new digital rendition. Founder's Caslon has one weight in four size variants, while Adobe Caslon has three weights. Each serves a different role in a designer's type library. The message, paper, color, and expression of a given project might make one or the other more appropriate.

One curious footnote to the story of Caslon is a crude font named Caslon Antique (Fig. 12). Originally called Fifteenth Century when first released by the Barnhart Brothers & Spindler type foundry in the 1890s, it was seldom used until the name was changed to Caslon Antique in 1918. After the name change, this pitted and deformed face became wildly popular, even though it bears little resemblance to Caslon. In a strange bit of marketing copy, the foundry's specimen book proclaims, "Art of ye XV century endures . . .Though created with crude tools our modern art printer will welcome this good old typeface so characteristic of the period . . . Belongs in the Caslon family because it enableth ye modern printer man to produce effects resembling ye printing of Caslon's time."[2]

After 275 years, Caslon type is still widely used in publications (Fig. 13), environmental graphics, and posters (Fig. 15).

"Why are William Caslon's types so excellent and so famous? To explain this and make it really clear, is difficult," wrote the eminent historian of printing, Daniel B. Updike. "While he modelled his letters on Dutch types, they were much better; for he introduced into his fonts a quality of interest, a variety of design, and a delicacy of modelling, which few Dutch types possessed. Dutch fonts were so monotonous, but Caslon's fonts were not so. His letters when analyzed, especially in the small sizes, are not perfect individually; but in mass their effect is agreeable. That is, I think, their secret—a perfection of the whole, derived from harmonious but not necessarily perfect individual letters. To say precisely how Caslon arrived at his effects is not simple; but he did so because he was an artist. He knew how to make types, if ever a man did, that were 'friendly to the eye,' or 'comfortable.'"[3]

14

CASLON OLD STYLE

Although, as Professor A. W. Pollard has pointed out in a masterly sketch, to which the reader is referred, "throughout

ADOBE CASLON

Although, as Professor A. W. Pollard has pointed out in a masterly sketch to which the reader is referred, "throughout

FOUNDER'S CASLON

Although, as Professor A. W. Pollard has pointed out in a masterly sketch to which the reader is referred, "throughout

MILLERCOMM93

Cheo Hurtado
David Peña
Cristobal Soto
Luis Julio Toro

8 OCT

Thursday 4:00pm *lecture/demonstration*

Room 25, lower level, Smith Music Hall
805 South Mathews Avenue, Urbana
University of Illinois at Urbana-Champaign

Thursday 8:00pm *concert* 1992

Auditorium, Smith Music Hall
805 South Mathews Avenue, Urbana
University of Illinois at Urbana-Champaign

Ensamble
Gurrufio
de Venezuela

There are few aspects of Latin American life that articulate the coming together of the Native American, African, and European heritages as clearly and as forcefully as music.

Venezuelan based Ensamble Gurrufio has delighted audiences around the world with their unique style and interpretation of the *joropos, merengues,* and *valses* of their native land "infusing the songs and dances with all the joy, imagination, and excitement humanly allowable." Gurrufio is a production of the Music of the Americas Program, a presentation of the Sante Fe Chamber Music Festival 1992.

Office of the Chancellor
Office of the Vice Chancellor for
Academic Affairs
College of Communications
School of Music
Department of Anthropology
Department of Political Science
Department of Spanish, Italian and Portuguese
Center for Latin American and
Caribbean Studies
Krannert Art Museum

World Heritage Museum
La Casa Cultural Latina
University YMCA
Center for Advanced Study
George A. Miller Endowment
George A. Miller Committee

Printed on paper that may be recycled.

15
Caslon 540 is used on a lecture series poster for Millercomm93.
Designer: David Colley; client: University of Illinois, Champaign-Urbana.

28-POINT BIG CASLON CC

abcdefghijklmnopqrstuvwxyz
ABCDEFGHIJKLMNOPQRSTUVWXYZ
1234567890&!?:;"

70 **71**

NOTES

1 *Specimen Book and Catalogue* (Jersey City, NJ: American Type Founders Company, 1923), 142.

2 *Catalogue 25 Type Faces . . .* (Chicago: Barnhart Brothers and Spindler, undated) 55.

3 Daniel Berkeley Updike, *Printing Types: Their History, Form, and Use.* 2nd Edition, Volume II (Cambridge: Harvard, 1937), 105–106.

Albert Bruce Rogers, called "B.R." by friends, was "one of the greatest artificers of the book who ever lived,"[1] according to Francis Meynell, founder of the Nonesuch Press. Rogers, born in Lafayette, Indiana, in 1870, created the typefaces Montaigne and Centaur.

He designed some of the finest books ever made, such as the Oxford Lectern Bible, *The Centaur*, T. E. Lawrence's famous translation of *The Odyssey of Homer*, and *Fra Luca de Pacioli.*

Rogers's interest in typeface and book design formed in his early years. When he was 12, a cousin gave him a copy of John Ruskin's *Elements of Drawing*, which fired Rogers's curiosity about typeface design. Other crucial influences that fed his fascination were *Forest Hymn* by William Cullen Bryant and *The Poems of Sappho*. In a revealing recollection in *The Art of the Printed Book*, Rogers explained, "[My] early attempts at book decoration, though childish and commonplace, will doubtless furnish, to those who like to account for things, an indication of what my later endeavors might be expected to be, but they were hidden from me then, as it was my ambition to become a painter of landscape, or at least, a cabinet maker or a ship builder."[2]

At 16, Rogers entered Purdue University, where he studied illustration and joined the staff of the university publications office. His talents were quickly recognized and he created lettering for the yearbook, university catalogs, and the *College Quarterly* magazine. His longtime friend Frederic Warde recalled Rogers's early passion for letterforms: "Even at that time the arrangement of type on paper was of strong interest to him. He [brought] home from the library several volumes of the works of the earliest and most interminable American novelist Charles Brockden Brown simply because the printing and binding of that particular edition seemed so pleasant to him."[3]

The Centaur lowercase letterforms have a modulated stroke and humanist axes, as indicated by the black rule to the left. These design elements are unique to Renaissance letterforms, which derive from the calligraphic handwriting of the 14th century, prior to the invention of movable type. The Bembo and Jenson chapters offer further comparisons for analysis.

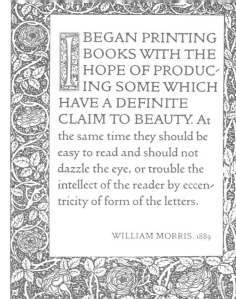

1

Page from William Morris's *Poems by the Way*, 1891. Publisher: Kelmscott Press.

I BEGAN PRINTING BOOKS WITH THE HOPE OF PRODUCING SOME WHICH HAVE A DEFINITE CLAIM TO BEAUTY. At the same time they should be easy to read and should not dazzle the eye, or trouble the intellect of the reader by eccentricity of form of the letters.

WILLIAM MORRIS. 1889

After graduating from college in 1891, Rogers held various jobs such as creating illustrations for the *Indianapolis News*, clerking in a railroad office, and working as a general draftsman for the Indiana Illustration Company. In 1893, Joseph Bowles, an enterprising salesman in an Indianapolis art store, founded a magazine called *Modern Art*. Bowles, aware of the Arts and Crafts Movement, imported limited-edition books printed by William Morris's Kelmscott Press, including *Poems by the Way* (Fig. 1). When Rogers saw this particular book, he was struck by a revelation. As Warde explained, "His whole interest in book-production became rationalized and intensified. He abandoned the prevalent idea that a book could be made beautiful through the work of an illustrator alone, and determined instead to use that curiosity he had always felt as to type and paper, toward a study of the physical form of printed books."4

From 1896 through 1900, Rogers worked as a book designer at Houghton Mifflin in Boston.

There he developed his hallmark style, which, according to his biographer, was characterized by a "direct and forthright approach, a subtle lightness in the seemingly easy placement of words on a page, and, above all, a sense of order. In later years of wider scope, Rogers's work showed greater audacity and subtlety, but even in these useful books one may see a certain grace, not easily defined, that was an integral part of both the man and his work throughout a long and productive life. Rogers believed that books were meant to be read; his were rarely precious or flamboyant; never *objects d' art* to be preserved behind glass."5

In 1900, Houghton Mifflin created a Department of Special Collections and Rogers was placed in charge of the design and production of limited-edition books. The projects produced by the department were printed exclusively with metal type and not electrotype plates. In his new position, Rogers had complete freedom of conception, design, use of materials, and choice of printing and binding methods.

Rogers's first attempt at type design, around 1903, resulted in the Montaigne face. Rogers was inspired by Nicolas Jenson's 15th-century types (Fig. 2). "At an exhibition of books at the Boston Public Library, I saw for the first time a copy of Nicolas Jenson's *Eusebius* of 1470," he

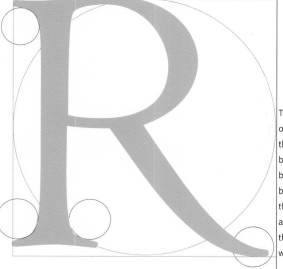

The Centaur capital **R** is based on the capital **B**. The top bowl of the **B** is smaller than the bottom bowl to create an optically balanced letter. Rogers made the bowl of the **R** the same size as the lower bowl of the **B**, then achieved balance by extending the leg outward to the right, where it drops below the baseline.

uideo quomodo aer folis & lunæ mī appellari poffit: quom ipfe ma,
gis a luminaribus fiat & tranfmutetur q̄ ab ipfo luminaria. Paululum
uero pgreffus telluris uirtutem ueftam appellat:cuius uirginale fimu,
lacrum in foco ignis ftatuitur:quæ uirtus quoniam ferax eft:mulieris
eam fpecie denotarūt.Rhea uero quā opé latine appellamus lapidofæ
atq; mótanæ terræ uirtuté defignat.Ceres feracis & planæ:differt enim
a Rhea quoniam bonam ioui peperit deam: ac ideo imago eius fpicis
coronatur & papauera quæ fertilitatis fymbolum funt circa imaginem
ponuntur.hic diligenter aīaduerte quomodo deorum ipfiufque Iouis
matrem quæ Rhea dicitur ad terram & lapides detraxit & eandem effe
cereri ait quibus adiecit.Quoniam aūt quædam uirtus etiam proiecti
feminis in terram eft:quam fol ī hyemali folftitio fouet. Bona qdem
dea quam & perfephonem uocant uirtus feminum eft:pluto uero fol
qui tempore hyemis remoti opé mūdi parté perluftrat:iccirco raptam
ab eo proferpinā dicunt:quā ceres fub terra latenté quæritat. Plantaꝗ
autem omniū uirtus Dionyfus nuncupatur:& bonæ qdem deæ imago
germina quædam quafi fui fymbola protédit. Dionyfus uero cornua
hab& et muliebriformis eft ‚pmifcuā uirtutem generationis plantarū
fignificans. Plutonis autem raptoris galea caput tegitur quod occulti
uerticis fymbolum eft.Sceptrū uero breue quod ten& inferioris regni
fymbolum eft. Canis autem eius frugum a terra partium tripartito in
proiectionem orationem germinatioém diuidi notat.Atys porro atq;
adonis ad fruges ac fructus pertinere uidentur.Sed atys flores maxime
defignat qui ante q̄ ad fructum ueniant defluūt.Quapropter pudéda
ei fuiffe incifa dicūtur:quoniam flores defluxi femina non ‚pduxerūt.
Adonis pfectos fructus fignificat . Silenus uero fpiritalis motus fym,
bolū eft:qui non parū uniuerfo conducit: cuius caput candore fulgés
cæleftis motus. Cefaries uero quæ iferioribus imaginis partibus appo,
nitur craffitudinem terreftris aeris fignificat. Verū quoniā uaticinādi
etiā quædā uirtus eft themis ideft latine carméta uocitata eft:eo ꝗ fta,
tuta unicuiꝗ præcinat:qbus oībus uirtus hæc inferior colitur ut uefta

later recalled. "I was at once impressed by the
loveliness of its pages, indifferently printed
though as they were. The early judgment was
confirmed for me many years later (though by
then it needed no confirmation) when Berkeley
Updike wrote of them: 'to look at the work of
Jenson is to think but of its beauty, and almost
to forget that it was made with hands.'"[6]
Locating a collector who owned an *Eusebius,*
Rogers also found a *Suetonius*, which was
printed by Jenson, at the Harvard College
Library. In addition to these, Rogers used
Ongania's *Early Venetian Printing* to acquaint
himself with early Venetian typefaces. He
made photographic enlargements of the type
from the pages of each book, and began the
process of creating Montaigne. The first
appearance of the face in print was the three-
volume, 1500-page *Essays of Montaigne.*

An excerpt from a letter by Rogers to Carl
Purington Rollins of Montague Press reveals
Rogers's attention to detail: "There are some
minor differences between the type to be used

in the *Montaigne* and that of the *Revenge* [a
Riverside Press book printed in a test of
Montaigne]—the latter being really
a trial stage of the finally accepted type.
Several letters were recut after the *Revenge*
was printed, notably the lowercase **o** which
was made rounder and the lowercase **g** which
was lightened; the **g** has since been still
further modified and will require one more
recutting before meeting my final approval. In
addition to these modifications the whole
fount was given a wider set, $1/3000$ of an inch
being added to the body of each letter to open
up the page a little more. The effect is hardly
discernible even when attention is called to it
but the improvement is there."[7]

In hindsight, it was Rogers's belief that the
Montaigne typeface was not entirely satisfac-
tory. It did, however, pave the way for his next
typeface design, produced between 1912 and
1914 and ultimately named Centaur (Fig. 3).
Rogers thought the design of Centaur to be of
historic importance because it exemplified "an
original design of rare cultivation and grace.
Because of its classical elegance and its aristo-
cratic Renaissance ancestry, the type calls for
special handling. On the other hand, among
devotees of fine printing, it has been accepted
as one of the great type designs, and once the
cutting was completed for the Monotype
machine, it was welcomed by sensitive design-
ers and printers for many of their best books
and ephemera."[8] In creating Centaur, Rogers

3

Centaur
ABCDEFGHIKLM
NOPQRSTU
VWXYZ
abcdefghijklmnopqrst
uvwxyzäöü
1234567890
ff fi fl &
Rotunda, omnium
scripturarum nobilissima,
vocatur etiam mater
et regina aliarum

BOOK I

By now the other warriors, those that had escaped headlong ruin by sea or in battle, were safely home. Only Odysseus tarried, shut up by Lady Calypso, a nymph and very Goddess, in her hewn-out caves. She craved him for her bed-mate : while he was longing for his house and his wife. Of a truth the rolling seasons had at last brought up the year marked by the Gods for his return to Ithaca ; but not even there among his loved things would he escape further conflict. Yet had all the Gods with lapse of time grown compassionate towards Odysseus—all but Poseidon, whose enmity flamed ever against him till he had reached his home. Poseidon, however, was for the moment far away among the Aethiopians, that last race of men, whose dispersion across the world's end is so broad that some of them can see the Sun-God rise while others see him set.

4
Page from *The Odyssey of Homer*, 1932.
Designer: Bruce Rogers; printer: Emory Walker;
publisher: Oxford University Press.

once again turned to the work of Jenson and the *De Evangelica Præparatione* for inspiration.

Rogers made pale impressions, called fugitive prints, from photographic enlargements of the typeface and then wrote over the lowercase letters with a broad pen. The best drawings of each character were selected from a series of hand-drawn pages and "the obvious imperfections were touched up with a brush and white [paint]."[9] The Centaur matrices were made on a pantograph machine by Robert Wiebking in Chicago. Rogers wrote, "The result was a closer approximation to the original Jenson than the Montaigne type had been. It was not, however, a facsimile, for I had purposely altered some of the details in a few letters, and Wiebking had made slight alterations, for practical reasons, in others, but they were always improvements over my designs."[10]

Early uses of Centaur were exclusively for the signage and titling work produced at the Metropolitan Museum in New York as well as for Rogers's personal book projects. It wasn't until 15 years later in 1929 that a commercial version of Centaur was made available for machine composition by the English Monotype Company. The first Monotype specimens were completed in 1929 and displayed in a pamphlet called *The Trained Printer and the Amateur* by Alfred W. Pollard, then the keeper of printed books at the British Museum.

Rogers, who had left Boston in 1912 to travel and freelance, spent considerable time working in England. He spoke at a 1931 luncheon at the Savoy Hotel in London by invitation from W. I. Burch, managing director of the Monotype Corporation. Rogers said at one point in the speech, "Last year, at a dinner in this very hostelry, one of the directors of the American Monotype Company said that 'typographic cranks' like Morison, Goudy, and Rogers were called 'damn nuisances' by the practical men at the head of great businesses—but he had the grace to add that they had all come to recognize that we were more or less necessary nuisances, and, on better acquaintance, even sometimes rather agreeable ones. I hope I may be included with the latter ones."[11]

In 1932, the Monotype version of Centaur first appeared in the book *The Odyssey of Homer* (Fig. 4). This is one of Rogers's most beautifully crafted books. Other outstanding printed

examples of Monotype Centaur include the *Fra Luca de Pacioli* (Fig. 5), designed in 1933, and the Oxford Lectern Bible, published in 1935 by the Oxford University Press (Fig. 6). This Bible was the last book Rogers would make in England, a country he frequented and spoke of with fond regard throughout his life.

Stanley Morison commented in No. 7 of *The Fleuron*, "The most notable difference, however, between the original Jenson and the Centaur Founts is in the distribution of weight. When Mr. Rogers began to make enlargements of the original he was at once struck by the penlike character of the lowercase. A character indeed, which has been strengthened rather than weakened in his own drawings.

a | e | j | o | r | y

pen-formed terminal

rising crossbar, perpendicular to the stroke axis

calligraphic pen-formed terminal

axis inclined to left

splayed, bilateral foot

flat-foot serif

7

Identifying characteristics of the Centaur typeface.

The calligraphic basis of the design which evades the eye in the smaller sizes is beautifully seen in the 72 point In the book sizes of the type, i.e., 18 point and below, the face disposes itself on the page with a unique grace, carrying the sense of the text with an easy and modest individuality."[12]

In a small book, *The Centaur Types,* Rogers evaluates the typeface he designed: "I have often been asked what I think of Centaur, and although one usually has a bias in favor of his own productions the whole matter is now so far in the past that I believe I can view it without prejudice. My opinion, then, is whatever its intrinsic merits may be, it is too definitely an Italian Renaissance letter which I have tried to suggest by the classic column in my initial drawing. It is a little too elegant and thin for our modern papers and methods of printing, and is seen at its best when printed on dampened hand-made or other antique papers, and with more impressions than you can ordinarily get a pressman to put on it. He, and most of us, want printing as well as many of our other outlines in life to be as sharp and hard and definite as possible. I rather think that, in printing, Bodoni inaugurated this fashion, and thus [was] as 'modern' as his types. The three qualities named sharp, hard, and definite, are no doubt admirable ones in their place; but Centaur does not take them too readily and naturally, and profits most when somewhat carelessly printed on paper that wouldn't be passed as perfect in any modern paper mill. It

looks surprisingly well on news stock, but we can't make books of that. It is what might be called a 'cool' type unless humored in the composition and press-work."[13]

Rogers called upon the expertise of Frederic Warde in 1925 to devise a suitable italic letter as a companion to the roman version of Centaur. Warde made modifications to 15th-century chancery letters by a calligrapher, Ludovico degli Arrighi. After several revisions, the reinterpreted italic (Fig. 8) inspired by Arrighi and Centaur was used by Rogers in appropriate pieces to summon the spirit of the Venetian Renaissance.

After completion of the Oxford Lectern Bible, Rogers returned to the U.S. and spent the next 22 years at his residence, October House, in Connecticut. Occasionally, he traveled tô Europe to visit friends and old haunts. Until his death in 1957, Rogers was committed to the beauty and clarity of the printed page. In his own words regarding books and the printed word, "They prove my contention that the finest products of bookmaking may not be books but friendships."[14]

a b c d e f
g h i j k l
m n o p q
r s t u v w
x y z

8 24-POINT MONOTYPE CENTAUR ITALIC

CENTAUR ITALIC ALTERNATE

9
Book cover for Little Brown & Co., New York. Designer: Bruce Campbell; photographer: Ansel Adams. Copyright © 1999 by the trustees of the Ansel Adams Publishing Rights Trust. All Rights Reserved.

ANSEL ADAMS

IN COLOR

Spread from *Paper* magazine using Centaur Swash Italic on the floor and Centaur Roman in the text, 1997. Art director: Bridget de Socio; designer: Ninja von Oertzen; photographer: Norma Zuniga.

10

Today, the only digital version of Centaur available is produced by Monotype but is licensed and distributed through other companies, such as Adobe Systems. Captured eloquently in the digital version are the face's signature features: the diagonal slant of the crossbar in the lowercase **e**, the bracketed serifs of the **r**, and the inclined axis of the **o** (Fig. 7). These nuances are descendants of the calligraphic forms of the Jenson typeface.

Centaur continues to be used in limited-edition fine-art books and professional design work. In recent years, it has regained popularity among designers who admire and appreciate the elegant forms inherent in the face (Figs. 9-12).

11

Exhibition graphics for the National Gallery of Art in Washington, DC, 1999. Designer: Barbara Keyes; photographer: Rob Shelley.

Over The Top.
The Fordham University
Campaign – Page 5

12
Cover of *Fordham University Newsletter*, 1998. Design firm: Liska + Associates, Chicago; art director: Susanna Barrett; designer: Al Cristancho.

NOTES

1 Joseph Blumenthal, *Art of the Printed Book 1455–1955* (New York: Pierpont Morgan Library, 1973), 48.

2 Joseph Blumenthal, *Bruce Rogers: A Life in Letters, 1870–1957* (Austin: W.T. Taylor, 1989), 3.

3 Ibid, 4.

4 Ibid, 5.

5 Ibid, 10.

6 Ibid, 13.

7 Ibid, 15.

8 Ibid, 33.

9 Ibid, 32.

10 Ibid, 32.

11 Ibid, 122.

12 Stanley Morison, *The Fleuron Vol. 7* (Cambridge: Cambridge University Press, 1930), 171.

13 Bruce Rogers, *The Centaur Types* (Chicago: October House, 1949), 13.

14 Joseph Blumenthal, op. cit., 125.

abcdefghijklmnopqrstuvwxyz
ABCDEFGHIJKLMNOPQRSTUVWXYZ
1234567890&!?:;,"

28-POINT MONOTYPE CENTAUR

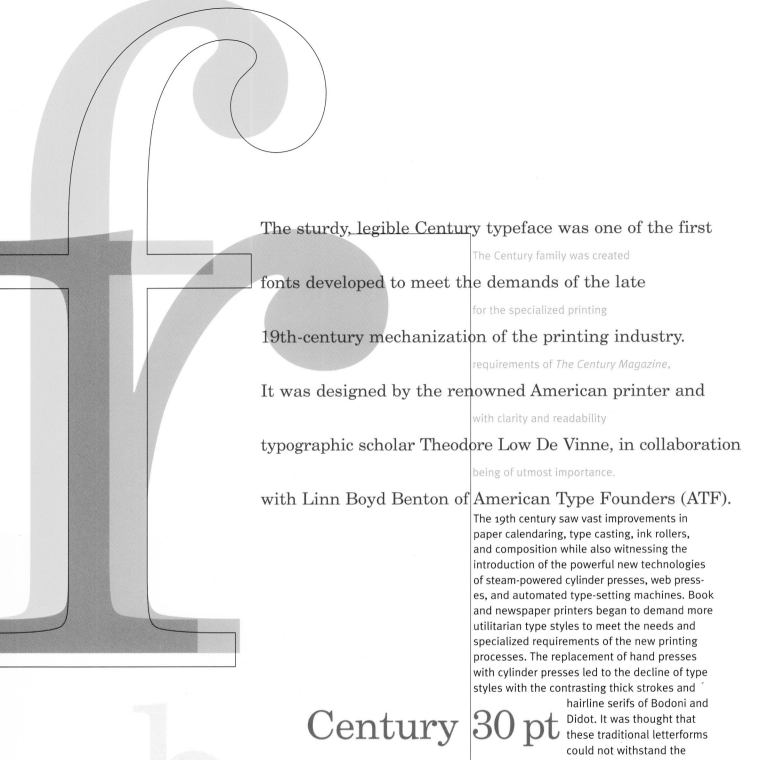

The sturdy, legible Century typeface was one of the first

The Century family was created

fonts developed to meet the demands of the late

for the specialized printing

19th-century mechanization of the printing industry.

requirements of *The Century Magazine*,

It was designed by the renowned American printer and

with clarity and readability

typographic scholar Theodore Low De Vinne, in collaboration

being of utmost importance.

with Linn Boyd Benton of American Type Founders (ATF).

The 19th century saw vast improvements in paper calendaring, type casting, ink rollers, and composition while also witnessing the introduction of the powerful new technologies of steam-powered cylinder presses, web presses, and automated type-setting machines. Book and newspaper printers began to demand more utilitarian type styles to meet the needs and specialized requirements of the new printing processes. The replacement of hand presses with cylinder presses led to the decline of type styles with the contrasting thick strokes and hairline serifs of Bodoni and Didot. It was thought that these traditional letterforms could not withstand the force applied by the new printing equipment. Type designers developed dull, lifeless letterforms intended to avoid complications in printing, such as when ink flooded the counter spaces at high speeds during print production. Unfortunately, these lackluster typefaces became somewhat standard for text type by the mid-19th century. Display types became characteristic of the age, while the design of text type was largely neglected.

Century 30 pt

Century Roman was designed to be a black, readable face with thicker thin strokes than those of Bodoni and Didot.

THE CENTURY MAGAZINE

Vol. LVI. JUNE, 1898. No. 2.

TOLEDO, THE IMPERIAL CITY OF SPAIN.

BY STEPHEN BONSAL.

WITH PICTURES BY JOSEPH PENNELL.

WE left Madrid a little before midday; and had we carried the king's signet, or had the thought of some fair one in distress spurred us on, before the last gentle echo of the vesper bell had died away we might have demanded admittance at the iron-bound gates of the Imperial City. But we knew no such sweet necessity, so we rode with little haste, and in Illescas tarried long enough to walk through the lonely barrack in which Francis I of France pined and moaned when the conquering Charles presented to him the alternative of perpetual captivity in this dungeon, or liberty chained to a woman not of his choosing. When the shadows of evening overtook us by Ollias, we decided to spend the night there. The *venta*, or inn, with its many rambling courtyards and stables, proved not unlike every other venta in Spain. The *ventero* bids you welcome right heartily, and assures you, in his hospitable way, that for supper you may enjoy anything you may have brought with you in your saddle-bags, and some nice white beans beside. And then he

guest-chambers, so we chose a corner of the courtyard in which to enjoy our ease; and, with some straw for bedding, a saddle for a pillow, and a rough Asturian mantle as protection against the chill air, we hoped to pass a pleasant night under the starry heavens. But we counted without our four-footed companions; all night long cavalcades of sleep-walking mules wandered round our bower, now and again even trespassing, to our alarm, upon our very beds. But at last the day dawned.

For another short hour we galloped again across the dreary Sagra. Then there burst upon our expectant gaze a yellow mass of ruins that glistened weirdly in the glorious sunshine; and round about the scene of picturesque desolation, and almost encircling it as a ring, flowed the silvery waters of the Tagus. Unmistakable in its grim and gaunt outlines, there loomed up before us the citadel rock and the great square tower whence so many a human eagle has soared to pounce down upon the world with sword and

1

Original page setting from *The Century Magazine*, 1898. Century type was designed specifically for the publication.

In response to the growing production of feeble typefaces, De Vinne, printer of *The Century Magazine*, convinced the magazine's publishers to support the design of a new typeface. De Vinne was dissatisfied with the thin modern faces being used in publications at the time. He was quoted as saying, "Readers of failing eyesight rightfully ask for types that are plain and unequivocal, that reveal the entire character at a glance, and are not discerned with difficulty by body marks joined to hairlines and serifs that are all but half seen or not at all."[1]

De Vinne, an innovative printer and typographer, set out to design a blacker, more readable face, slightly extended, with thicker thin strokes and short serifs for greater clarity. An increased x-height provided improved readability and gave the illusion of tighter fitting copy. (De Vinne made the curious claim in advertising Century that its vertical expansion enabled one "to get much matter in a small space.") De Vinne knew that these characteristics would both improve legibility and hold up under the stress of the new mechanized presses. He commissioned Benton of ATF to draw and cut the design. The punches were cut on Benton's newly invented matrix cutting machine, and Century Roman made its first appearance in *The Century Magazine* in November 1896 (Fig. 1).

The magazine's publishers were extremely pleased with the new Century Roman face, and its acceptance led to the development of many versions. Benton soon created a companion to Century Roman, called Century Broadface, for ATF. It became the basis for Century Expanded, designed under the direction of Morris Fuller Benton, Linn Boyd Benton's son. Morris Benton, as head of ATF's Department of Typographic Development, created 18 different variations of the basic Century face between 1900 and 1928.

The original Century Roman face was thought by some printers to appear too narrow. Morris Benton modified the set width of the original designs with drawings of Century Expanded and Century Expanded Italic, completed in 1900. These are vigorous faces with large x-heights and, despite being called expanded faces, they sit fairly tight. Due to the enlarged x-height they lack the elegance of some modern faces, but what they lack in elegance they make up for in warmth and readability. The expanded typefaces were followed by Century Bold in 1904 and Century Bold Italic in 1905. These styles were essentially bold versions of the Century Expanded face.

ABCDEFGHIJKLM
NOPQRSTUVWXYZ
abcdefghijklmnopqrstuvwxyz
1234567890

18-POINT CENTURY EXPANDED

*ABCDEFGHIJKLM
NOPQRSTUVWXYZ
abcdefghijklmnopqrstuvwxyz
1234567890*

18-POINT CENTURY EXPANDED ITALIC

abc

abcdefghijklm

abcdefghijklm

abcdefghijklm

2

3

Century Oldstyle's top serifs are angled, as in the capital **T** and **F**. The apex of the **A** is angled as shown, in contrast to the square apex of Century Roman.

Century Expanded and its companion styles have been copied extensively by Monotype, Linotype, and Ludlow. Ludlow called its version Century Modern, which it introduced in 1964. All of these versions have largely preserved the design of the original Century.[2]

In 1908, Morris Benton began plans for an entirely new series of the Century family called Century Oldstyle. While the appearance of Century Roman and Century Expanded was inspired by Bodoni and Didot, Century Oldstyle seems to have been derived from Caslon. The top serifs are angled, like those of the capital **T** and **F**, and the apex of the **A** is angled (Figs. 3, 4). The stress of the curved strokes is diagonal, and many traces of the original letterforms have been dropped. The result is a blacker, sturdier face than the original Century. Three variants of Century Oldstyle were produced by ATF: Century Oldstyle Bold in 1909, Century Oldstyle Bold Italic in 1910, and Century Oldstyle Bold Condensed in 1910 (Fig. 2).

4

A phototypeset version of Century Oldstyle is used in the Nature Company logo, 1984. Design firm: Pentagram, San Francisco; art director/designer: Kit Hinrichs.

THE NATURE COMPANY

Monotype's version of Century Oldstyle varies considerably from the original. The capitals are somewhat wider and the fitting is looser throughout. Another distinction is the alternate long descenders, the **g**, **p**, and **q** (Fig. 5), as well as alternate long ascenders, as in the **b**, **f**, and **h**. Linotype's version of Century Oldstyle, later renamed Century Oldstyle No. 74, was more faithful to the original than Monotype's version.

The digital version of Adobe's Century Oldstyle remains true to the ATF version designed under Linn Benton. While an effort was made to maintain the integrity of the original design, some alterations have been made. The most obvious are the slightly thicker strokes and the large serifs, which are cut more squarely. Some of the delicacy of the face has been lost and it appears more condensed. Regardless of these slight alterations, the Adobe version of Century Oldstyle preserves the simplicity and timelessness of the original cutting (Fig. 6).

5

LONG ASCENDERS AND DESCENDERS FOR CENTURY
OLDSTYLE, No. 157E (Shown with Regular)

CHARACTERS IN FONTS

8 Point: g g j j p p q q y y

10 Point: g g j j p p q q y y

11 Point: g g j j p p q q y y

12 Point: b b d d f f g g h h j j k k l l p p
q q y y fi fi fl fl ff ff ffi ffi ffl ffl

6

Adobe Century Oldstyle features slightly thicker strokes and wider serifs than does the original Century.

Century Schoolbook was designed to meet the requirements
In making these types, every detail has been considered and a great deal of labor,
of colleges and boards of education, at the same time taking into
experimenting, and calculations have been required to make them as perfect as possible.
consideration the conclusions arrived at by the other authorities.[3]

Another version of the face, called Century Oldstyle No. 3, was released by ATF in 1912 and was later reworked and renamed Century Catalogue. Although still an old-style face, it is slightly wider than Century Oldstyle. As its design reached completion, textbook publishers Ginn & Company approached ATF with an interest in a new type design for use in school textbooks (Fig. 7). Morris Benton began the project by reviewing research on the relationship of type and children's eyesight, notably the *Report of the Influence of School Books Upon Eyesight* written for the British Association for the Advancement of Science.[4]

A RIDE IN THE CARS

Evelyn cars ride one these ticket two aboard New York all Donald

Characters. MAY, GRACE, EVELYN, GEORGE, DONALD, JACK, WILL, FRANK, TICKET MAN

(Arrange chairs for a train of cars, and have one chair with a table or a desk for a ticket office. Let the children make tickets for busy work)

DONALD. Do you wish to ride in my cars?

7

A page of *Cyr's New Primer*, reset in Century Schoolbook, displays caps, small caps, lowercase, and italic, with wide spacing between words.

qn

a

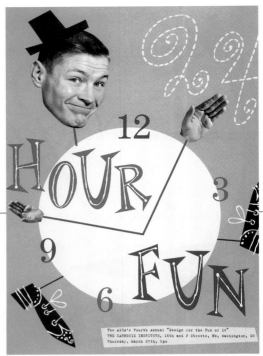

Designer Melinda Beck juxtaposes numbers and text set in Century Schoolbook with hand-drawn letters and illustrations to create a playful contrast in AIGA's "24 Hours of Fun" brochure, 1997. Client: AIGA (see also Fig. 11).

Research indicated that children respond better to large, clear typefaces. In his design of Century Schoolbook, Benton increased the letter spacing, the x-height, and the weight of each stroke. He opened up the interior spaces of the letters, seen clearly in the lowercase **a**, **q**, and **n** (Figs. 8, 9), to make them more readable and user friendly. Another distinctive identifying feature is the loop on the **Q**, which is more exaggerated than in other Century versions. Century Schoolbook was completed in 1919, and it is probably the most popular of the entire family of Century types. Its heavy weight, large x-height, and strengthened serifs make it easy to set and read. It reproduces well in both direct and reverse printing.

A very legible and practical typeface, Century Schoolbook has become a standard in textbook, magazine, and newspaper publishing. The simplicity and friendly characteristics of the face make it an obvious choice for design jobs directed toward children and for educational purposes. It is also used widely in advertising and corporate design (Fig. 13).

The original ATF Century Schoolbook version did not have italics, but since the face proved to be so popular, subsequent versions from Mergenthaler Linotype, Monotype, and other manufacturers were expanded. These later versions include a full range of weights and companion italics, including a black version.

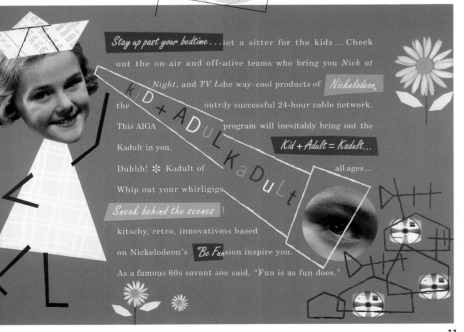

26 good reasons to use Century Bold

12

The half serif on the lowercase **h**, **m**, and **n** gives ITC Century a slightly more economical character fit.

ATF licensed the name "Century" to the International Typeface Corporation (ITC) in 1975 for the release of their own version of the face, ITC Century. The design of ITC Century is a melding of the proportions and characteristics of three fonts: the original Century, Century Expanded, and Century Schoolbook. Its designer, Tony Stan, based the majority of his work on Century Expanded. However, he made his design less delicate and more flexible by adopting the stronger character stroke, serifs, and bracketing of Century Schoolbook.

The interior spaces of ITC Century are larger, and its character shapes are well defined. Both of these qualities enhance the readability of this already accessible typeface. ITC Century also has modified character proportions, which make it slightly more condensed than the original ATF version, thus granting the designer the benefit of a more economical character fit.

Another trait that distinguishes ITC Century from other Century variations is the half serif on the lower case **h**, **m**, and **n** (Fig. 12). This simple adjustment gives the overall setting a consistent value and provides harmony in text composition. ITC Century was originally released in light and ultra weights; then additional weights were added to the family to expand its expressive range.

The Century family of types has endured 100 years of technological changes and design variations. Throughout its history, it has maintained the integrity of De Vinne's original concept. Century's simplicity, clarity, and straightforwardness continue to make it a favorite among designers, typographers, and most importantly, readers.

NOTES

1 Alexander Lawson, *Anatomy of a Typeface*, (Boston: David R. Godine, 1990), 278.

2 Mac McGrew, *American Metal Typefaces of the Twentieth Century*, (New Castle, DE: Oak Knoll Books, 1986).

3 This statement is used in a printed sample from the 1923 ATF Catalog. *Specimen Book and Catalogue 1923*, (Jersey City, NJ: American Type Founders Company, 1923) 205.

4 As above, Ibid., 205.

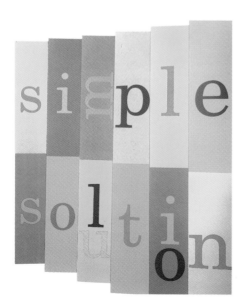

13

This colorful poster shows the clarity and simplicity of the Century Schoolbook letterforms, 1996. Design firm: Cahan & Associates, San Francisco; art director: Bill Cahan; designer: Sharrie Brooks; client: San Francisco Creative Alliance.

abcdefghijklmnopqrstuvwxyz
ABCDEFGHIJKLMNOPQRSTUVWXYZ
1234567890&!?:;"

28-POINT MT CENTURY ROMAN

"The most useful Founts that a Printer can have in his Office are Clarendons: make a striking Word or Line either in a Hand Bill or a Title Page, and do not overwhelm the other lines: they have been made with great care, so that while they are distinct and striking they possess a graceful outline, avoiding on the one hand, the clumsy inelegance of the Antique or Egyptian Character, and on the other, the appearance of an ordinary Roman Letter thickened by long use."[1]

Robert Besley, designer of the Clarendon typeface, made the above statement in 1850, five years after his influential font was released and became a huge commercial success.

Besley designed the original Clarendon in 1845 while working on the design staff of the Fann Street Foundry in London. Besley had joined William Thorowgood, owner of the firm, in 1838. After Thorowgood retired in 1849, Besley took over the firm and renamed it Besley & Co. Besley's partner was the skilled punchcutter Benjamin Fox who had assisted him in creating Clarendon.

In 1845, Clarendon was the first typeface registered under a new English law that permitted type designs to be copyrighted for a three-year period. However, despite the legal protection, the face soon became one of the most plagiarized typefaces of the late 18th and early 19th centuries.

design

The name Clarendon came to refer not only to

a specific face, but also to a subcategory of slab-

or square-serif typefaces with bracketed serifs.

Some of the later faces that belong to this subcat-

egory include Consort, Egizio, Fortune, and

Playbill. In England, Clarendon became synony-

mous with the term boldface as a description of

weight, and the face is still used in the *Oxford*

English Dictionary to offset entries from their

definitions.

SERIFA ROMAN

design

MONOTYPE CLARENDON

The original Clarendon was modeled after the Egyptian faces, with bracketed serifs replacing the Egyptian square serifs (Fig.1). Unlike its progenitors, which were used only as display types, Clarendon was designed to serve as a condensed text type. Overall, Clarendons have the structure of romans, but lack the thin strokes typical of those faces. In fact, Clarendons often accompanied roman types, playing a role similar to contemporary boldface. (Type families containing both roman and boldface were not common until later in the century.) The bracketing of the serifs and an increased thick-and-thin stroke contrast allowed Clarendon to blend harmoniously with roman type. The intermixing of Clarendon with roman types represents one of the first instances when boldface was used instead of italics as a means of indicating emphasis—a practice that continues to this day.

Clarendons sit midway between the severe blockiness of the Egyptian slab serifs and later bracketed slab serifs such as Century Schoolbook (Fig. 2). The serifs of 19th-century Clarendons (Fig. 3) are not as thick as those of most Egyptians and the tapering provided by the brackets softens the harsh angularity typical of slab-serif faces.

The original Clarendon was a bold, condensed face, but Besley later released a slightly expanded version. This version became popular in the printing business as a display face and later its pleasing proportions made it the model for most Clarendon revivals.

SERIFA ROMAN
MONOTYPE CLARENDON
CENTURY SCHOOLBOOK

2

3

CLARENDON NO. 40

Specimen from ATF's *Specimen Book and Catalogue 1896.*

1

SERIFA ROMAN
MONOTYPE CLARENDON

Signage for the National Park Service. The alphabet is a modified Haas Clarendon. Design firm: Chermayeff & Geismar, New York City; designer: Tom Geismar.

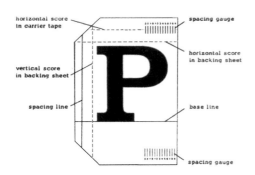

TYPOGRA-
PHY
typography

A B C D E
a b c d e

C E G

E F L

K

M W

Q R

The structure of most Clarendon capitals suggests a self-sufficient compactness, each letter sitting solidly within its own prescribed area. These thick-and-thin letters have a well-modulated weight contrast between elements. The lowercase letters reflect a similar compactness and rectangular proportion. Clarendon has a large x-height with short and stocky extenders.

The Clarendons have many remarkable features (Fig. 5). The counters are usually narrow with small apertures as seen in the **C**, **E**, and **G**. The **G** has a pronounced spur. The **E**, **F**, and **L** have rather long serifs. The **K** has a stepped leg instead of a single junction. The flat junction of the **M** rests on the baseline and the junction of the **W** includes a serif, making it a three-top-serif letterform. The unique tail of the **Q** creates a secondary counter where the swash nestles in the counter of the letterform. The end of the tail is turned upward, resembling the upturned leg of the **R**.

Exhibition brochure. Designer: J. Abbott Miller.

"VizAbility" CD-ROM and booklet. Design firm: Meta Design, San Francisco; art director: Terry Irwin; designer: Jeff Zwerner; authors: Kristina Hooper Woolsey, Scott Kim, Gayle Curtis; client: PWS Publishers.

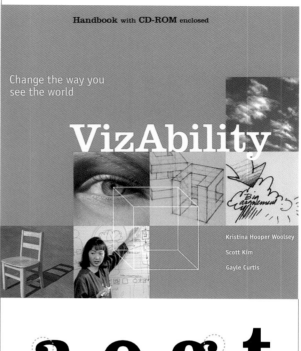

Handbook with CD-ROM enclosed

Change the way you
see the world

VizAbility

Kristina Hooper Woolsey
Scott Kim
Gayle Curtis

Carefully considered relationships exist between the upper- and lower-case letters. The upturned feature seen in the tail of the **Q** also appears in the hooked tail of the double-storied lowercase **a** as well as the **t** (Fig. 6). The structures of the **a**, **e**, **g**, and **t** are based on the roman model rather than the Egyptian. The unique rounded serifs of the **a**, **c**, **f**, and **r** can also be found in the down-turned ear of the double-storied **g**, the loop of the **j**, and the hook-curl descender of the **y**. The **p** and **q**, which have flat, bracketed, serifed descenders, are mirror opposites. Usually this mirror-opposite quality would be preserved between the **b** and the **d**, but this is not the case in Clarendon. Unlike the **d**, which has a flat serif like that of the **u**, the **b** has an angle spur at the foot of the stroke. The shoulders of the lowercase letters are thin, and the dots of the **i**, **j**, and all punctuation marks are rounded.

6

a e g t

c f r j y

p q

b d

d u i j

M

Detail from *Westvaco Inspirations 210*, 1958. Designer: Bradbury Thompson. © Westvaco Corporation. Reprinted with permission.

E

There were many versions of Clarendons produced during the 19th century but the most influential versions were created in the 1950s. The two most important revivals from that time, and still popular today, are Haas Clarendon and Craw Clarendon. In 1951, Hermann Eidenbenz designed Haas Clarendon, which was issued by the Haas'sche foundry in Basel, Switzerland. A lightweight version of Haas Clarendon was added in 1962 to complete the series. Haas Clarendon was released by Linotype in 1966, in both light and bold weights.

American Type Founders (ATF) commissioned Freeman Craw to develop a new typeface based on the Besley Clarendon model. Called Craw Clarendon, it was released in 1955. Craw Clarendon Book, a lighter weight, was released the next year, followed by Craw Clarendon Condensed, released in 1960. The normal widths were also produced by Monotype. Freeman Craw has commented that as a designer of type he faced different problems than as a designer with type. In spite of criticism that some sizes were too small for the body and had excess shoulder, the Craw Clarendons are excellent and deservedly popular faces.

From 1955 to 1958, the Nebiolo Foundry issued a Clarendon type family, Egizio, designed by Aldo Novarese (Fig. 9). Although Clarendons usually do not have italic versions because these fonts' designs have little relationship to script, Egizio is the first Clarendon series with an italic.

In the late 1980s, David Berlow began to develop a family of fonts based on Egizio called Belizio (Fig. 8). "When I created Belizio, New Century Schoolbook was about the only square-serif font available in digital form," Berlow recalls. "I wanted to do something with a strong Clarendon feel that was as far away from Century Schoolbook as possible."

"At the time," says Berlow, "no one believed that a typeface could be designed and delivered on the Mac with proper spacing and fit. People were astounded by how good it looked." One of the first typefaces released by Font Bureau, Belizio was initially available in bold and bold italic. Today the series includes four romans and four italics, and Berlow continues to expand on it. "A custom client wants condensed roman and italic versions," he says.

E E

E

& E

EGIZIO is the only Clarendon series offering medium, medium italic, bold, bold italic and condensed letters. Designed for the Nebiolo foundry by Novarese and Butti, it was introduced at the Milan Fair in 1953. Specimen sheets are available from:
AMSTERDAM CONTINENTAL TYPES
and Graphic Equipment, Inc.
276 Park Ave. So., New York 10 SP 7-4980

36 BELIZIO BOLD ITALIC

8

9
Egizio advertisement from *Art Direction* magazine, 1960.

Editorial spread from *Raygun*. Art director: David Carson; design firm: Stoltze Design, Boston; designers: Clifford Stoltze, Peter Farrell; photographer: Russ Quackenbush; copywriter: Gabriella Marks.

Today, digital versions of Clarendon are available from Adobe, Agfa, Linotype, and Monotype, among others. Linotype's version, Craw Clarendon, is available in five different weights: light, medium, bold, extra bold, and bold expanded. Linotype also issued Haas Clarendon, which is available only in regular weight. Revival fonts often deviate from the original Clarendon, losing some of the properties created by Besley. A frequent alteration lies in the junction of the **M**. In the original, the junction is pointed, but in most of the revival and digital versions, the junction of the **M** is flattened (Fig. 7).

Digital versions of Clarendon have the flexibility for either text or display. They are often specified for magazine and newspaper design, package design, signage, and broadcast graphics. Designers find Clarendon to be a useful typeface because of its bold and distinctive character that has stood out from more conventional roman and sans-serif fonts for over 150 years.

NOTES

1 Alexander Lawson, *Anatomy of a Typeface*, (Boston: Godine, 1992), 315.

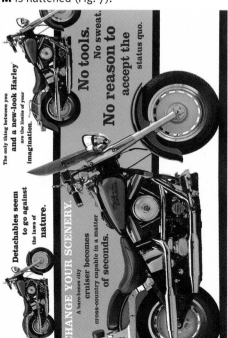

Clarendon Bold from Bitstream is used on a product catalog, 1997. Design firm: VSA Partners, Chicago; photographer: Mid Coast Studio; client: Harley-Davidson Motor Company.

abcdefghijklmnopqrstuvwxyz
ABCDEFGHIJKLMNOPQRSTUVWXYZ
1234567890&!?:;""

28-POINT MONOTYPE CLARENDON

Cheltenham is a notoriously controversial typeface. Appearing at the end of a prolific period of Victorian type design, it satisfied a demand for new advertising display faces and gained immediate, far-reaching popularity after releases by Mergenthaler Linotype in 1896 and American Type Founders (ATF) in 1903. By 1915, Cheltenham boasted one of the most extensive type families known at that time, with nearly 21 cut variations of the original face. Variants were produced by every major type company, including Monotype, Ludlow, and Intertype. By 1929, Cheltenham was one of the top advertising typefaces in the United Kingdom according to *Advertiser's Weekly*,[1] but its popularity wasn't universal; even during the period of its greatest use, Cheltenham was carefully scrutinized. The very properties that won it commercial success—legibility, flexibility, and ruggedness—were criticized by influential designers. Bias against it was evident decades after its inception: it was described by the authors of a 1953 publication on typography as "an unattractive type [that] became strangely popular."[2]

Cheltenham was originally designed by Bertram Goodhue in 1896. Intended for use by the Cheltenham Press of New York, the typeface was the result of a collaboration between Goodhue, an architect by trade, and Ingalls Kimball. Goodhue's foray into the realm of type design was made possible by certain technological developments: at the end of the 19th century, type punches could be cut by machines from drawings and did not require the manual skill of a punchcutter. As a result, nonspecialists and amateur designers like Goodhue began to design type.

Goodhue sold Cheltenham to the Mergenthaler Corporation soon after its creation. ATF, the original cutter of the handset version for Cheltenham Press, purchased the design around 1901. Cheltenham was an immediate success when released by ATF in 1903. New leadership at ATF recognized the potential of the typeface and devised marketing strategies to meet commercial demand. Goodhue's original drawings of Cheltenham Oldstyle were modified.[3] Following this, the design was developed further by Morris Fuller Benton, who is credited with drawing a family of 18 weights and variants between 1904 and 1911.

1

An advertisement from the American Type Founders *Specimen Book and Catalogue* showing use of alternate capitals **T, N, M, B, R, Q,** and **A**, 1923.

2
Handset example of
Cheltenham Oldstyle used
as book type, 1910s.

3
Ad from ATF *Specimen
Book and Catalogue*, 1923.

Other companies had previously explored the
idea of the type family, but with 18 versions
of Cheltenham, ATF set a new standard. Success
fostered competition in the printing trade, and
in 1904 Linotype introduced ten Cheltenham
variations plus advertising figures. Following
this, multiple versions of the face were produced
nationally and abroad by Monotype, Ludlow,
and Intertype under different names including
Gloucester (Monotype), Winchester (Stephenson
and Blake), and Cheltonian (Intertype). By 1920,
most American suppliers of printing types were
producing a version of Cheltenham.

Why all the fuss? Cheltenham was unremarkable
in concept: it was initially conceived as a book
type in which legibility was the dominant ele-
ment (Figs. 2, 3). Goodhue believed the upper
half of letterforms to be more important for char-
acter recognition than the lower half; to this end,
he lengthened the face's ascenders and short-
ened its descenders. Small counters were a
result of the low x-height. Goodhue's original
design showed variation in stroke width but min-
imal contrast overall. Although the elements of
characters are both thick and thin, the first
impression of the face is one of consistency
throughout. Cheltenham is classified as a new
transitional face. Its thick terminals are neither
strictly ball- nor teardrop-shaped. Its bracketed

slab serifs—criticized by some as being
flat and stubby—reference the Clarendons
of the mid-19th century.

In spite of the designer's intention,
Cheltenham became popular not as book
type but as a display face in advertising
and job printing. This was due largely to
ATF's expansion of Goodhue's design into
an extensive family. By 1913, the family
included Cheltenham Oldstyle, Italic,
Condensed, Extra Condensed, Inline,
Medium Expanded, and Wide. Each of
these variants afforded different degrees
of emphasis for headings or displays. ATF
Cheltenham Oldstyle included eight liga-
tures, two **C**s, and an alternate **r**. Intended
for use only when found at the end of a
word, this **r** had a thickened ear projecting
above the top of the letter. In addition
to the standard lower- and uppercase
alphabets, alternate characters were
designed for Cheltenham Italic, including
11 capital letters, six lowercase letters,
and one ligature (**Qu**). These decorative
characters show more contrast between
thick and thin strokes than their standard
italic counterparts. Terminals are pear-
shaped, and finials on some of the alter-
nate character capitals, including **B, N, R,
Q**, and **A**, dip below the baseline (Fig. 1).

LETTERS ARE SYMBOLS WHICH TURN MATTER INTO SPIRIT.

ALPHONSE DE LAMARTINE

Architecture began like all scripts. First there was the alphabet. A stone was laid and that was a letter, and each letter was a hieroglyph, and on each hieroglyph there rested a group of ideas, like the capital on a column. Thus, until Gutenberg architecture is the chief and universal "writing." This granite book, begun in the East, continued by the Greeks and Romans—its last page was written by the Middle Ages. Until the fifteenth century, architecture was the great exponent and recorder of mankind. In the 15th century everything changed. Human thought discovered a means of perpetuating itself which was not only more lasting and resilient than architecture, but also simpler and more straightforward. Architecture is superseded. The stone letters of Orpheus have been succeeded by the leaden ones of Gutenberg. The book will destroy the edifice. The invention of printing is the greatest event in history. It is the fundamental revolution. Under the printing form, thought becomes more imperishable than ever; it is volatile, elusive and indestructible. It mingles with the very air. Thought derives new life from this concrete form. It passes from a life-span into immortality. One can destroy something concrete, but who can eradicate what is omnipresent? *VICTOR HUGO*

Whence did the wondrous, mystic art arise of painting speech, and speaking to the eyes? That we, by tracing magic lines are taught how to embody, and to colour thought?
WILLIAM MASSEY

THE TRADITION OF TYPE MUST BE CONSIDERED THE MOST ENDURING, QUIET AND EFFECTIVE INSTITUTION OF DIVINE GRACE, INFLUENCING ALL NATIONS THROUGH THE CENTURIES, AND PERHAPS IN TIME FORGING A CHAIN TO LINK ALL MANKIND IN BROTHERHOOD JOHANN GOTTFRIED HERDER

"If there is nothing for dinner but beans, one may hunt for an onion, some pepper, salt, cilantro and sour cream to enliven the dish, but it is generally no help to pretend that the beans are really shrimp or chanterelles(.)... When the only font available is Cheltenham... the typographer
5 must make the most of its virtues, limited though they may be."⁵

"By any name, Chelt is going to be around for a long time(.)... Undoubtedly, given typography's addiction to type trends, Cheltenham will have its ups and downs, but whenever a vigorous, legible display face is needed, this type will prove as useful as ever."⁶

GAUGE

6

Cheltenham's design was criticized early in its career. Douglas C. Murtrie, an early-20th century typographer, said, "The appearance of most magazine and commercial printing will be improved by the simple expedient of denying any variants of the Cheltenham design to compositors."⁴ The most idiosyncratic Cheltenham character is the lowercase **g** (Fig. 10). The link and lower loop are not rendered as continuous organic lines; instead, they meet at an angular joint and read as distinct shapes. The unclosed tail ends in a marked thickening. The uppercase **G** has a spur at the base of the stem; a counterpart to this occurs in the right stem of the **A**, which projects

beyond the left stem (Fig. 6). The serifed center stems of the roman **W** do not meet at an apex but overlap (Fig. 11); as a result, the width-to-height ratio of this capital remains consistent with that of the others. The Cheltenham Italic **p** and **q** have no foot serifs. The bowls of the italic **e** and **p** are unclosed; additionally, the bowl of the **p** extends beyond its stem to form a spur. These features were carried into subsequent digital revivals (Fig. 14, page 96).

A significant shift in Cheltenham's design occurred several decades after its introduction. In 1975, International Typeface Corporation (ITC) commissioned designer Tony Stan to restyle the typeface. Stan was initially commissioned to create an extra bold weight to supplement the existing family. In the process, and perhaps in response to contemporary film typesetting technology, he shortened the unusually long ascenders of Goodhue's Cheltenham Oldstyle and enlarged the x-height. With these modifications came a clear change in overall character of the face (Fig. 4). Recognizing that change, ITC commissioned Stan to redraw the entire family. By 1978, the ITC Cheltenham family included roman and italic fonts in four weights: light, book, bold, and ultra. ITC Cheltenham Condensed and ITC Cheltenham Condensed Italic were also released in the above four weights. The final introductions to the series included ITC Cheltenham Outline, Contour, and Outline Shadow. Just as Cheltenham had been the first extensive family of metal types in the early-20th century, it also became one of the largest families available for photographic and electronic typesetting.

Some metal types required thickening for phototypesetting and offset printing in order to achieve the same appearance as letterpress printing. This did not apply to Cheltenham; its original design had moderate, not extreme, differentiation between thick and thin strokes. In his design of ITC Cheltenham, Stan made only subtle variations to stroke weight in response to phototype technology. More visibly, Stan adjusted the proportions of Bertram Goodhue's original design and enlarged the x-

7 ITC CHELTENHAM BOOK
CHELTENHAM BT ROMAN

9
ITC CHELTENHAM BOOK
CHELTENHAM BT ROMAN

CHELTENHAM BT ROMAN

10

CHELTENHAM BT ROMAN
11

8 ITC CHELTENHAM LIGHT

CHELTENHAM BT ROMAN

ITC CHELTENHAM BOOK

ITC CHELTENHAM BOLD

ITC CHELTENHAM ULTRA

height significantly (Fig. 7). Were Stan's decisions esthetic or pragmatic? The editors of *U&lc* addressed this question in the magazine's September 1978 issue: "In designing the [ITC Cheltenham] extra bold weights, Tony Stan drew the characters with the eyes of a '70s designer, and with the freedom of modern film typesetting at his disposal." [7] Stan's adjustments might be considered necessary since phototypesetting machines often used only one master film image carrier to achieve a range of point sizes. More likely, ITC Cheltenham represented a revival of a historic typeface restyled for contemporary usage and audiences.

The ITC redesign process dramatically altered Cheltenham's look and story. In addition to proportional changes made by Stan to Cheltenham's body size, adjustments were made to individual characters. The Cheltenham Oldstyle **q** had a unilateral foot serif. In contrast, the ITC Cheltenham **q** has a bilateral foot serif (Fig. 12). While the **G** and **A** in this font retain the spurs found in Cheltenham Oldstyle, the ITC Cheltenham **W** is modified: the center stems do not overlap. The ITC Cheltenham **f** and **j** have exaggerated notches before their thickened terminals (Fig. 8). The bowls of the ITC Cheltenham Italic **e** and **p** are closed. The alternate **r** of ATF Cheltenham is not present in ITC Cheltenham. (Originally designed for use only at the end of words, the alternate character had been frequently misused and placed awkwardly between letters.) The capitals of ITC Cheltenham are narrower in width-to-height ratio than those of Cheltenham Oldstyle (Fig. 9). The most significant characteristic of the ITC Cheltenham series is the enlarged x-height; the subsequent loss in ascender height and expanded counter affects body type, color, and texture (Fig. 12).

ITC CHELTENHAM BOOK

CHELTENHAM BT ROMAN

12
The **q** of ITC Cheltenham has a bilateral foot serif. The x-height is enlarged. The foot serif of the Cheltenham Oldstyle **q** is unilateral. The ascenders are greater in length than the descenders.

The Chair Fair

14

The **e** of Cheltenham BT Italic has an open bowl. The leg of the **k** dips below the baseline. The aperture of ITC Cheltenham Italic is wider. The bowl of the **e** is closed. The leg of the **k** rests on the baseline.

24-POINT CHELTENHAM BT ROMAN
24-POINT CHELTENHAM BT BOLD

1 2 3 4 5 6 7 8 9 0
1 2 3 4 5 6 7 8 9 0 **17**

Bitstream is a modified series based on the ATF Cheltenham family. This family comprises seven variants, rather than upwards of 21, including Cheltenham BT Roman, Bold, Bold Headline, Italic, Bold Italic, Bold Italic Headline, and BT Bold Extra Condensed. This series is characterized by the long ascenders and short descenders that were hallmarks of Goodhue's 1896 design. The original character body size has been maintained, as have the treatments of slab serifs and terminals.

However, slightly sharper contrast between thick and thin strokes distinguishes Cheltenham BT from its predecessor. Cheltenham BT Italic retains the ornamental flair of the original ATF Cheltenham Italic (Fig. 15). The bowls of the **e** and **p** are unclosed. The leg of the **k** dips below the baseline (Fig. 14). The return stems of the **v** and **w** extend above the meanline. The **f** has a lower loop and spur. Within the Cheltenham BT family, there is a significant difference between the roman and the bold numerals: the numerals in the roman font do not end in thickened terminals; **1** and **4** do not have foot serifs; and numerals **2**, **3**, **5**, and **7** have oblique stress, rather than vertical (Fig. 17).

15 *"[My father] took me aside, presented me with Updike's **Printing Types**, and read me a solemn lecture on the iniquities of the Cheltenham family which I have never forgotten"*

Attributed to Roy Lewis at the Keepsake Press, Hammersmith, England. [8]

Digital revivals of Cheltenham are numerous and widely available. A digital version of ITC Cheltenham is available directly from ITC as well as from other vendors including Adobe Systems and Linotype Library. Variations on this font include light, book, bold, and ultra weights in roman, italic, condensed, and condensed italic fonts. ITC Cheltenham Handtooled Bold and Bold Italic, designed by Edward Benguiat for ITC in 1993, extend the range of this type family.

Other type foundries have released digital designs that follow the tradition of Cheltenham Oldstyle. Cheltenham BT by

Another digital derivative of the early-20th century Cheltenham family is FB Cheltenham (Fig. 18), designed by Jane Patterson for Font Bureau. Like Cheltenham BT Bold Extra Condensed, this single font is based on Cheltenham Bold Extra Condensed as drawn by Morris Fuller Benton for ATF in 1906.

Both ITC Cheltenham and the digital versions of Cheltenham Oldstyle have unique, if vernacular, voices in the vast community of serif typefaces. Given competition from old-style garaldes and transitional typefaces, it is doubtful that Bertram Goodhue's wish for

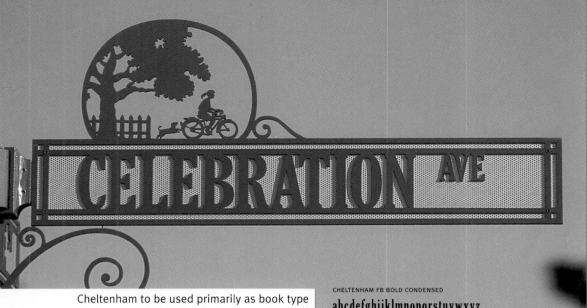

Cheltenham to be used primarily as book type will ever be fully realized. As demonstrated in the early part of the 20th century, its effectiveness may be best realized as display type. Cheltenham has seen practical, common usage in the face of subjective criticism. Designers in need of a period typeface find advantages in its gentle modulation, sturdy serifs, and playful terminals. Although it is in sharp contrast to contemporary type designs, Cheltenham has personality, flexibility, and proven longevity. Occasionally maligned but never forgotten, it may easily see a second century of controversy as well as success.

NOTES

1 Lewis Blackwell, *20th Century Type: remix* (Corte Madera, CA: Gingko Press, 1998), 92.

2 W. Turner Berry, A. F. Johnson, and W. P. Jaspert, *The Encyclopedia of Type Faces, 2nd Edition* (London: Blandford Press, Ltd., 1958), 120.

3 Mac McGrew, "The Bentons, Father & Son," *Typographici*, 10 (March 1978): 3.

6 Alexander Lawson, *Anatomy of a Typeface* (Boston: Godine, 1953), 255.

5 Robert Bringhurst, *The Elements of Typographic Style* (Pointe Roberts, WA: Hartley & Marks, 1992), 92.

6 Alexander Lawson. op. cit., p. 255.

7 "What's New from ITC", *U&lc* 5 (September 1978): 27.

8 Roderick Cave, *The Private Press* (New York: Watson-Guptill, 1971), 251.

9 J. I. Biegeleisen, *Classic Typefaces and How to Use Them* (New York: Dover Publications, 1995), 68.

CHELTENHAM FB BOLD CONDENSED

abcdefghijklmnopqrstuvwxyz
ABCDEFGHIJKLMNOPQRSTUVWXYZ
1234567890&!?:;"

18

"Cheltenham is a traditional face among traditional printers. It is strong, reliable and can pull a load; it is a veritable workhorse in the stable of American alphabets." [9]

CHELTENHAM FB BOLD CONDENSED

28-POINT CHELTENHAM BT ROMAN

abcdefghijklmnopqrstuvwxyz
ABCDEFGHIJKLMNOPQRSTUVWXYZ
1234567890&!?:;"

The Egyptians, also called slab- or square-serif types, are characterized by heavy square-cornered serifs, usually without brackets, and little contrast between thick and thin strokes. In many slab-serif typefaces, the strokes are all the same weight.

The first Egyptians were designed early in the 19th century to meet the demands of a newly industrialized society. Egyptians evolved from the fat-face types, which achieved maximum boldness with thickened main stems and reduced serif weight. Early square-serif type first appeared in 1815 under the name Antique by the English type founder Vincent Figgins (Fig. 1). Responding to a popular interest in Egypt following the Napoleon's conquest of that country, Robert Thorne, whose Fann Street Foundry in London specialized in the production of display types, used the term Egyptian to describe slab-serif types. By the time of Thorne's death in 1820, the Fann Street Foundry had produced six Egyptians. These types were exhibited in a specimen book issued by William Thorowgood that same year, after he purchased Thorne's foundry. In 1821, Thorowgood issued his second specimen book, *New Specimen of Printing Types*, in which he kept much of the contents of Thorne's foundry and also made some additions, such as the Six Lines Pica Egyptian (Fig. 2). With bold and strong square strokes, these slab-serif types could effectively command readers' attention and became standard for display during the Industrial Revolution. They were employed for advertising on posters, handbills, flyers, and broadsides (Figs. 3, 4). Napoleon reportedly used square-serif characters in message relays, since his soldiers could see them through telescopes over long distances on large signboards.

ABCDEFGHIJ KLMNOPQR STUVWXYZ&,:;.- £1234567890

1

Two Lines Pica Antique (shown reduced) from Vincent Figgins's specimen book, 1815.

R.THORNE ashbourn &. £126780

2

William Thorowgood's Six Lines Pica Egyptian (shown reduced) from *New Specimen of Printing Types*, 1821.

Next **FRIDAY,** July 15,
ALL IN ONE DAY,
4 of **£21,000**
AND MANY OTHER CAPITALS; TOGETHER WITH
64 Pipes of Old Port Gratis !
Presented by HAZARD & Co. as an addition to the Four Prizes of One Thousand Guineas—being SIXTEEN PIPES for EACH TICKET, Share in Proportion, so that EACH SIXTEENTH will receive ONE PIPE.
NO BLANKS! As every Number is sure of £5.
HAZARD & Cº
STOCK-BROKERS,
AT THEIR OLD-ESTABLISHED AND FORTUNATE OFFICES,
Royal Exchange Gate ; 26, Cornhill ; and 324, Oxford Street, end of Regent Street :
Who Shared and Sold on the 31st of last May,
No. 1,804......£30,000 | No. 3,627............£5,000
Also in the Last Year's Lotteries since FIVE Prizes of £30,000 and £90,000; and the following Prizes drawn on the 12th of April last,
8,135, £90,100—9,579, £3,000, and Eight other Capitals.

3

Early 19th-century lottery bill that mixed fat-face and slab-serif types.

4
Astley's show bill, 1845.

Slab-serif typefaces with serifs thicker than their main strokes are called reversed Egyptians. Originally referred to as Italian or French Antiques, this group includes P. T. Barnum, Figaro, Hidalgo, Italiana Cursiva, Italienne, Playbill, and Pro Arte. Another variation on the Egyptians is the addition of curved bracketing, resulting in a softening of the style's abrupt geometries. Clarendon, Century, and Cheltenham all apply this approach and are discussed separately in this book. In the 1920s and '30s, the fasci-nation with revivals of classic typefaces resulted in new versions of Egyptian type-faces with geometric forms, including Memphis, Beton, Cairo, Karnak, Rockwell, and Stymie. These were designed by adding square serifs to geometric sans-serif type families like Futura. Likewise in 1974, ITC Lubalin Graph was created by adding square serifs to Avant Garde Gothic.

Generally, slab-serif faces are hard to read when set too tightly in text because letters tend to run together where serifs touch. Legibility and harmony between strokes and serifs become degraded. In addition, mixing one slab-serif family with another can result in a clash between two faces, but mixing a sans serif with a slab serif often creates an effective weight and texture contrast between the two styles.

ABCDEFGHIJKLMNOPQRSTUVWXYZ

FURNITURE

MAIDSTONE

MANKIND

EGYPTIAN BOLD CONDENSED

6

EGYPTIAN BOLD EXTENDED

Vincent Figgins's 1817 catalog introduced many innovative typefaces including four slab-serif faces (two of these, Antique and Nonpareil Antique, are shown in Fig. 5). The catalog included a range of outline, incised, and shadow fonts as well, including In Shade and Open (also shown above). The four slab-serif fonts had only capital letters, three of which were of monotone construction, with unbracketed serifs the same weight as the stems. Later variations (Fig. 7) included condensed Egyptians such as Antique No. 3 (c. 1860), a revival of an early design; lighter faces of the same basic design, including Antique No. 5; and fat Egyptian capitals and figures like Antique No. 6 (c. 1880). These forms are un-modified originals from Figgins's foundry, and were later acquired by Steven Shanks.

As demand for the Egyptians increased, foundries introduced new fonts with subtle changes in letter structure. By the 1830s, some Egyptians had appeared with a slight hint of bracketed serifs. Fifteen years later, varieties named Clarendon and Ionics emerged with fully bracketed serifs and contrast-ing stroke widths. (These fonts are discussed in the Clarendon chapter.)

EGYPTIAN BOLD EXPANDED

While the Egyptian style has been quite influential, there are only a few faces that fall specifically under the name Egyptian (Fig. 6). Egyptian Bold Condensed is based on an anonymous 19th-century design with very short descenders, while Egyptian Bold Extended is a modern design from 1955 by Walter H. McKay. Both typefaces have bracketed serifs. Egyptian Expanded is a 19th-century design by Miller & Richard and is currently available in digital form from Monotype. It is an extra extended bold face with very pronounced serifs. A new face with a name similar to Egyptian, Egyptienne F (Fig. 9), was designed by Adrian Frutiger in 1956. This was one of the first Egyptian text typefaces creat-ed expressly for photocomposition and printing by offset lithography. Egyptian 505 (Fig. 8) was a student entry in an international type design competition organized by the Visual Graphics Corporation. The first-prize winner for 1966, this flexible face was designed for use in all com-position and printing processes. Led by Andre Gurtler, the project was named after the lettering classroom's number (505) at the Kunstgewerbeschule in Basel, Switzerland. Although Egyptian in name, both Egyptienne F and Egyptian 505 have slightly bracketed serifs.

EN

ANTIQUE NO. 3

7

ANTIQUE NO. 5

ANTIQUE NO. 6

9

egyptians

24-POINT BETON LIGHT

24-POINT ROCKWELL REGULAR & EXTRA BOLD

Square-serif typefaces played a dominant role in everyday life from about 1820 to 1870. They were seen on buildings, street signs, legal injunctions, broadsheet titles, theater bills, circus and auction notices, and advertisements. The popularity of square-serifs declined rapidly at the beginning of the 20th century. This disuse continued for almost 30 years, until around 1930 when square-serif faces were revived as text types by several German typefounders. These revivals followed a renewed interest in sans serifs in the 1920s, when the geometric fonts reemerged under the influence of the Bauhaus. Most of the early Egyptian revivals appear to be little more than contemporary sans serifs with added serifs. They usually have geometric forms, unbracketed square serifs, monoline strokes, and a range of stroke weights from light to very bold (Fig. 10). Examples from this period include Memphis, released from the Stempel foundry in 1929 (the earliest of the Egyptian revivals), followed by Beton and City in Germany, and by Rockwell and Scarab in Britain. Many of these European types were imported to the U.S. In response to the influx in 1931, ATF released its own square-serif revival, called Stymie, to "stymie" the flow of European typefaces into America.

The geometric structure of these 20th-century Egyptians made them ideal for use in compositions combining type with images featuring similar shapes. In a book jacket for Harmony Books, for example, the **O**s of Eric Gill's square-serifed roman Joanna become a pair of colored circular eyeglasses (Fig. 11).

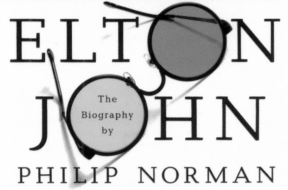

Memphis (Fig. 12) was originally designed by Rudolf Wolf for the Stempel foundry in Germany about 1929, and first imported into the U.S. as Girder. In the 1930s, Linotype introduced different roman weights and variations, including Memphis Light (1933), Medium (1935), Bold (1933), Italics (1934), and Unique Caps (1934). The **A** has two versions: one has a top serif and the other has a rounded top (not shown). The **G** has a spur. The middle strokes of the **M** stop short of the line. The lowercase **a** is one-storied, with top and foot serifs on the right. The **g** has an open tail and a top serif instead of an ear. Memphis—first of the popular 20th-century square serifs based on sans-serif typefaces—can be casually described as a Futura with serifs. Like the geometric sans serifs, it appears monoweight with optically identical strokes. On both coarse and coated papers, it maintains a high level of legibility. With the clarity of a sans serif and the readability of a serif, Memphis is suitable for use in both display and text situations.

12

11
Book jacket for *Elton John: The Biography*, 1992. Art director: John Fontana; designer: Henry Sene Yee; photography: London Features International, P. Ollern Shaw, Katherine McGlynn; publisher: Harmony Books, a division of Crown Publishers.

Stymie (Figs. 14, 15) is another geometric typeface that can be described as Futura with serifs. Designed by Morris F. Benton for ATF, it was released in 1931. Its round characters, **C**, **O**, and **Q** for example, are based on a perfect circle. The **A** has a top serif that extends horizontally to both sides. The **G** has a straight vertical spur. The **e** is a perfect circle with a very small aperture and crossbar. Originally, Stymie had four weights (light, medium, bold, and black) and a compressed version, which were produced by ATF. In 1934, when the Monotype Corporation produced its version of Rockwell, some of the literature erroneously called the face Stymie Bold; this has resulted in confusion between the two faces. Monotype later expanded the Stymie family by producing Stymie Extra Bold and some condensed faces from 1934 to 1936. Stymie also has extra-large sizes, produced by ATF as early as 1932. Some of the Stymies were cast up to 144-point. Stymie Compressed was cast in 288-point from the drawings by Wadsworth A. Parker of ATF (Fig. 13).

Serifa (Fig. 17) was designed in 1967 for the Bauer foundry by Adrian Frutiger, who based the font on his earlier sans-serif design, Univers. At its most basic, Serifa is Univers with serifs. But a fundamental difference between the two lies in the width of the letters: Serifa's letters are more extended and open than those of Univers. The serifs of Serifa are the same thickness as the main strokes, and the face has an unusually tall x-height. The **C** does not have a bottom serif; the **G** has a vertical spur; the tail of the **Q** extends horizontally along the baseline; and the **W** does not have a middle serif. Unlike most of the Egyptians, Serifa has humanist forms that are highly legible for both text and display, such as headlines, captions, or corporate logos. Serifa is available from several digital foundries including Adobe, Berthold, Bitstream, Agfa, and Linotype.

ITC Lubalin Graph (Fig. 16) was designed by Herb Lubalin for International Typeface Corporation (ITC) in 1974 and is based on his earlier design of ITC Avant Garde Gothic. ITC Lubalin Graph has oblique versions to accompany its five weights (extra light, book, medium, demi, and bold). Small caps are available for the roman, book, and medium versions. This type family was designed to meet the requirements of contemporary graphic designers for a more flexible Egyptian alphabet that worked well with new photographic typesetting technologies.

14

30-POINT BITSTREAM STYMIE

COQ
AG e

15

Spread from promotional book using quotations from well-known designers to demonstrate 2-color printing and binding capabilities, 1995. Design Firm: Hutchinson Associates Inc, Chicago; designers: David Colley, Jerry Hutchinson; client: Dupli-Graphic.

17

30-POINT BITSTREAM STYMIE

ABCDEFG
HIJKLMNOPQR
STUVWXYZ

16

18 ABCDEFG
HIJKLMNOPQR
STUVWXYZ

®
19

Some Egyptian typefaces such as Berthold City and Playbill have more expressive and decorative qualities. City was designed by Georg Trump for Berthold in 1930. It is a rectangular Egyptian face: all of its round letters have been squared off (Fig. 18). The **O**, for instance, is a rectangle with rounded corners. This typeface has three weights (light, medium, and bold). The current IBM logotype (Fig. 19), Paul Rand's 1970s revision of his original 1966 design, features a redrawing of City Medium. ATF's Tower is a very similar typeface. Playbill (Fig. 21) was released by Stephenson Blake in 1938. It is a condensed reversed Egyptian, and is characterized by serifs thicker than its main strokes. Other reversed Egyptians include Amsterdam's Hidalgo and Monotype's Figaro. These typefaces are so visually distinctive that they are more suitable for display than for text setting. They have a strong presence and give their messages graphic impact.

fghijklmn
opqrstuvwxyz
21

When the digital age arrived in the 1980s, many designers and type foundries embraced electronic design. Jonathan Hoefler's Hoefler Type Foundry in New York has specialized in custom and original typeface design since 1991, with many of its faces inspired by historical examples (Fig. 20). In a 1998 interview with the editors of this book, Hoefler pointed out that type-design innovations are led by the need for innovations in usage. When the Industrial Revolution brought about the need for advertising, he maintained, that inspired the creation of such attention getting types as the Egyptians. Looking to 19th-century type achievements, Hoefler developed his Proteus Project, a group of four subfamilies and their italics, for *Rolling Stone*. While one face in the group, HTF Ziggurat, is a slab-serif (Egyptian) typeface, HTF Acropolis is a Chamfered (Grecian) face, in which the curved parts of letters are drawn at a 45-degree angle (Fig. 22). This structure can be seen as a variation of the Egyptians. In fact, as early as 1828, a similar typeface appeared in William Thorowgood's *Specimen of Printing* (Fig. 23).

ABCD
Good LETTERING *requires as much skill as good painting or good sculpture.*
EFGHI
Although it serves a definite purpose and not necessarily eternity, good lettering
JKLM
is equal to the fine arts. The designer of letters, whether he be a sign painter, a
NOPQR
graphic artist or in the service of a type foundry, participates just as creatively
STUV
in shaping the style of his time as the architect or poet. – JAN TSCHICHOLD
WXYZ

20 Egiziano Filigree designed by Jonathan Hoefler for *Rolling Stone*, 1989.

HTF ACROPOLIS

22

HOMERTON
MOLDER
23
SIX LINE REVERSED EGYPTIAN ITALIC

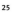

Like Hoefler's HTF Ziggurat, Font Bureau's Giza is another digital Egyptian revival. It was designed by David Berlow and based on the original Egyptians in Vincent Figgins's specimens of 1845. This typeface consists of 16 styles,[3] adding variety to the use of Egyptian letterforms. Nine One, for example, has main strokes heavier than serifs and an apparent contrast between strokes (Fig. 24). Like Playbill, it has a strong visual impact.

25
Book jacket for *The Rolling Stone Illustrated History of Rock & Roll* featuring HTF Ziggurat, 1992. Art director/designer: Fred Woodward; publisher: Random House.

26
Spread from *Rolling Stone* using HTF Acropolis, 1993 Art director: Fred Woodward; designers: Fred Woodward and Gail Anderson; photographer: Mark Seliger; publisher: Wenner Media.

When Egyptians are used for text settings, tight letterspacing can reduce their legibility, but when used for display, they create an unusual visual language. Two examples from *Rolling Stone* (Figs. 25, 26) employ positive space (the letterforms themselves) and negative space (the counters and spaces between letters) to create a dynamic energy. The combination of type and color further animates the design. Egyptians are also widely used in vernacular design, such as in the logotypes of sports teams and university sportswear (Fig. 27). The bold quality of Egyptians always provides an expressive communication vehicle.

27 Sportswear from Ohio University.

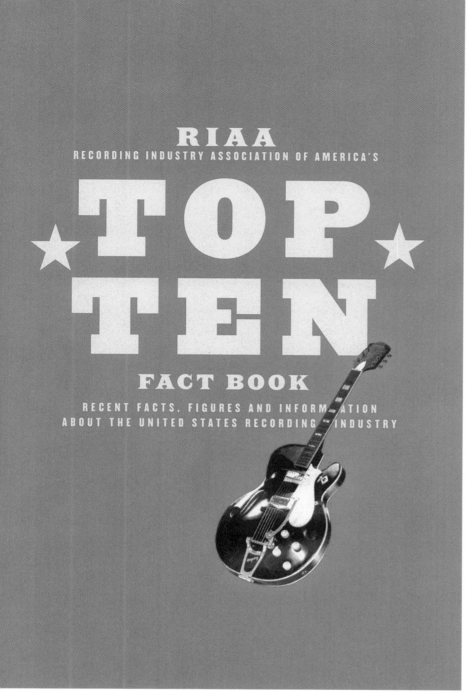

28

Institutional brochure for the Recording Industry Association of America featuring HTF Ziggurat and HTF Champion Gothic, 1997. Art director/designer: Neal Ashby; illustrator: John Moore.

NOTES

1 Sol Hess and Monotype produced Stymie Extra Bold in 1934, and Stymie Light Condensed, Medium Condensed, and Extra Bold Condensed in 1935–1936.

2 This project, originally designed for *Rolling Stone*, consists of four type families—Egyptian, Gothic, Grecian, and Latin. The design is inspired by 19th-century styles and, for purposes of interchangeability, the character widths, size, and spacing are set in common.

3 The 16 styles are One One, One Three, One Five, Three One, Three Three, Three Five, Five Three, Five Five, Five Seven, Seven Three, Seven Five, Seven Seven, Seven Nine, Nine One, Nine Three, and Nine Five.

abcdefghijklmnopqrstuvwxyz
ABCDEFGHIJKLMNOPQRSTUVWXYZ
1234567890&!:;"

"While types come and go, Franklin Gothic goes on forever."[1] **So spoke Steven Watts, a type-foundry manager at American Type Founders (ATF). Successful display faces command readers' attention. Franklin Gothic doesn't waiver.**

Several misapprehensions surround the Franklin Gothic face. There is no evidence to support the assumption that Franklin Gothic was named for Benjamin Franklin, nor is it truly a gothic face. In America, the term "gothic" is an eccentric way of referring to a sans-serif typeface. Gothic, when used in Europe, actually denotes a blackletter face. Gothic was probably first used by the Boston Type and Stereotype Foundry to describe a sans serif, and the name stuck. Franklin Gothic is most appropriately defined as a 19th-century American grotesque. It was originally designed as a display face with few weight and width variations. Early in the 20th century, it became common practice at the major type foundries to design typefaces with several variations and to convince printers of the necessity to purchase a range of weights and widths. Franklin Gothic's regular weight is "extra-bold," as were many other gothic faces of that time. Additional members of the ATF gothic family included News Gothic (Fig. 1) and Alternate Gothic, both of which are available in digital form. Franklin Gothic successfully combines a range of attributes: subtle irregularities, tapering of strokes near junctions, and respect for the roman form.

Designed and released in the period 1902–1912, Franklin Gothic was one of over 200 typefaces designed by Morris Fuller Benton and produced by ATF. The creation of this new sans serif, intended to compete with the 19th-century European sans serifs (e.g., Akzidenz Grotesk), was one of Morris Benton's first tasks at ATF. The result was a dramatic success. Franklin Gothic sold well immediately following its release, and continues to be popular today. Over the years, it has held its ground against the European sans serifs and other American gothics, and has also stood firm against the more geometric sans serifs, like Futura, that arrived in later years.

1
18-POINT ADOBE NEWS GOTHIC

LARGE LETTERFORM SAMPLES ARE
SET IN ITC FRANKLIN GOTHIC HEAVY
THROUGHOUT THIS CHAPTER.

2
18-POINT ITC FRANKLIN GOTHIC DEMI

Do you **think** an advertisement can sell if nobody can **read it?** You can not **save** souls in an **empty** church.

David Ogilvy, 1983

Franklin Gothic's heavy strokes and unadorned forms ensure legibility and drive home the formal dynamic of this asymmetric composition. Design firm/client: Shay, Shea, Hsieh and Skjei, Minneapolis; designer: Michael Skjei.

abcdefghijklmnopqrstuvwxyz 1234567890
ABCDEFGHIJKLMNOPQRSTUVWXYZ

4
18-POINT ITC FRANKLIN GOTHIC
EXTRA CONDENSED

His father's type founding business evolved into ATF about the time Benton started college. After graduation from Cornwallis University in 1896 with a degree in mechanical engineering, Benton moved back home and went to work at the foundry.[3] In a short time, he became ATF's chief type designer. Benton made extensive use of ATF's library and museum, always preferring to research an idea thoroughly before beginning the design of a new typeface. As head type designer, Benton did more than design his own typefaces for the foundry. He was also responsible for the translation of sketches by other designers into usable typeface drawings and for the reinterpretation of classic faces into designs compatible with new printing technologies.

Benton's background in engineering gave him a ferocious eye for detail, and he spent much of his time reviewing typeface drawings before they were approved for the making of matrices. Benton, like many type designers, was obsessive about detail, sometimes bordering on the compulsive. This character trait can be found in many aspects of his personal life as well. Benton was passionate about music and had a piano in his house for himself and his daughters. His daughter Caroline recalled, "He had the theory that every individual piano had certain tonal areas which needed to be balanced with extra care during the tuning. Morris would often retune the piano himself after the regular piano tuner had left the house."[4] A similar attitude informs the design of Franklin

Gothic. Franklin Gothic's well-considered details and quirky personality are what give it such a strong presence.

Franklin Gothic could be found everywhere in the early part of the 20th century. It was used by many newspapers for headlines and advertisements. Franklin Gothic's success was so great that ATF quickly licensed it to the major manufacturers of mechanical typesetting machines (Monotype and Linotype) to prevent it from being copied. In the 1970s, the International Typeface Corporation (ITC) licensed rights to Franklin Gothic from ATF for development as phototype. In 1980, as ITC prepared a digital version, it commissioned Victor Caruso to develop four new weights in roman and italic to expand the face's range. Caruso's redrawing of Franklin Gothic for ITC incorporates a slightly enlarged x-height and a moderately condensed lowercase alphabet. In 1991, David Berlow at Boston's Font Bureau was commissioned by ITC to design condensed, compressed, and extra-compressed versions of Franklin Gothic, which expanded the face into a very well-rounded family of fonts.[5] (Figs. 2, 4) The condensed book and medium fonts include small caps and old-style figures.

Franklin Gothic is found in the catalogs of many font suppliers under one of two names. The first, referred to plainly as "Franklin Gothic" (sometimes with a few weight and width variations), almost always indicates a version of the face originally made available by Linotype. The Franklin Gothic listed in Adobe's type catalog is a typical example. This face with its limited expressive range is useful primarily for display settings. The second is ITC Franklin Gothic, which includes the extensions that were added later by ITC. In the ITC family, the regular weight most closely resembles Benton's original design. Many foundries and suppliers have licensed the ITC version, selling it alongside their own versions. Strengthened by the additions made by ITC over the years, including the text face, Franklin Gothic continues to maintain a high profile, appearing in a variety of media from books to billboards (Figs. 6, 8).

5

6

This 1995 corporate invitation demonstrates ITC Franklin Gothic's no-nonsense appeal and its ability to mix well with other typefaces. Design firm: Werner Design Werks, Minneapolis; designer: Sharon Werner; client: Target Stores.

7

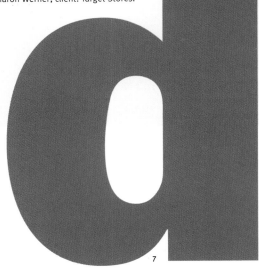

CONSIDERING THE PRICKS YOU DEAL WITH IN ADVERTISING, GIVING BLOOD SHOULD BE NO PROBLEM.

THE J. WALTER THOMPSON BLOOD DRIVE
January 23-24 · 2nd Floor Theatre · 8:30am-4:45pm

8

Franklin Gothic, here set in all caps, superbly conveys the irony of this 1992 poster for the J. Walter Thompson Blood Drive. Agency: J. Walter Thompson, New York; art director: Greg Cerny; copywriter: Greg Cerny; client: The Greater New York Blood Program.

From the modulation of its stroke weight to the tapering of strokes near junctions (Figs. 5, 7), ITC Franklin Gothic possesses many subtle, organic features that distinguish it from geometric sans serifs like Futura. It is not a humanist sans serif like Optima, nor is it infused with the finer characteristics of Univers or Helvetica. Its forms are a bit rougher, having more in common with 19-century European grotesques.

Two distinguishing characteristics of ITC Franklin Gothic are the tail of the **Q** and the ear of the **g** (Figs. 9, 11). The tail of the **Q** curls downward from just off the bottom center of the letterform in the book weight and shifts slightly to the right in the bolder fonts. The **g** is especially remarkable in certain weights for the way its ear juts above the x-height line. The **g**, **a** (Fig. 13), and **k** (Fig. 12) are notable for their roman heritage: the **g** has a bowl and loop like many serif faces, the **a** is two-storied, unlike most sans serifs, and the **k** has an angled junction. The **t** possesses a short tail (Fig. 10).

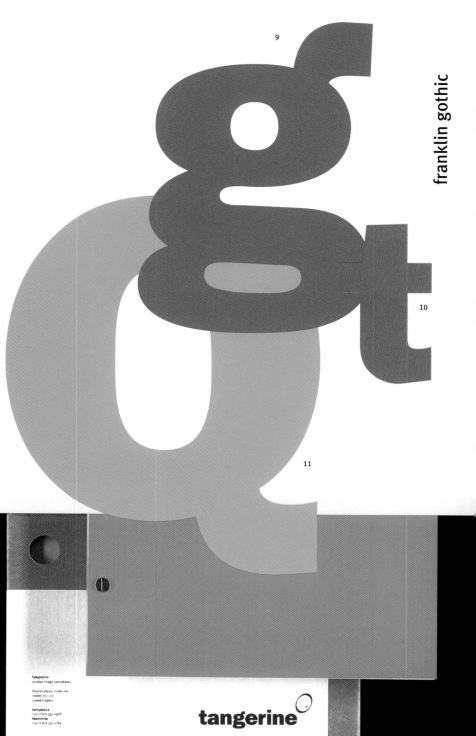

9

10

11

12

13

14

This clean, bright 1995 promotional booklet for Tangerine Product Design Consultants demonstrates ITC Franklin Gothic's strength in minimal compositions. Design firm: Metadesign, London; design directors: Tim Fendley, Robin Richmond; designers/illustrators: Tim Fendley, Roger Fawcett-Tang; copywriter: Hugh Aldersey-Williams.

15

Many of its letterforms have terminals that end at an angle, typifying the quirkiness that makes ITC Franklin Gothic so enjoyable. These angled terminals, in combination with the modulation of the stroke weight, give Franklin Gothic a very lively rhythm when it is set in lines of text. The angled terminals and modulated stroke also lend a sensuous quality to the lowercase **s** (Fig. 15). Another character with unique attributes is the numeral **1**, with its slab serif-style base (Fig. 16).

ITC Franklin Gothic is an extremely efficient face—a benefit of its large x-height and slightly condensed lowercase alphabet. Typical of many work-horse sans serifs, the face holds up well at low resolutions. Franklin Gothic readily takes to tight letter spacing, but one should always pay careful attention to word shapes when pursuing this approach. Allan Haley, a typographic historian, recommends keeping word spacing tight and line lengths short. He also recommends that designers using Franklin Gothic should not mix different designs of Franklin Gothic from different foundries; the effect can seem rather clumsy, like colors that don't quite match.[6] He also urges caution against the use Franklin Gothic in combination with other sans serifs such as Univers or Helvetica—there is not enough difference between the designs to provide good contrast. However, mixing works well with many serif faces as well as sans serifs that are sufficiently different in design (Fig. 18).

Franklin Gothic's ability to tackle tough briefs while still maintaining a lively personality and refined character makes it the right choice for many jobs. The additions and adjustments made by ITC over the years have served to enhance its flexibility. Franklin Gothic is a sans serif like few others: it is sturdy yet subtle and avoids plainness, never becoming stiff or stuffy. In business and in play, Franklin Gothic mingles well.

17

This 1994 annual report for Expeditors International of Washington shows how Franklin Gothic makes a statement in large sizes. The generous leading in the text setting gives the face necessary breathing room. Design firm: Leimer Cross Design, Seattle; art director: Kerry Leimer; photographer: Tyler Boley.

18

This 1989 poster for AIGA New Directions shows how Franklin Gothic can work well with a variety of typefaces in a dense composition. Design firm: Stoltze Design, Boston; designers: Clifford Stoltze, Terry Swack; art director: Clifford Stoltze; client: AIGA, Boston.

NOTES

1 Alexander Lawson, *Anatomy of a Typeface* (Boston: Godine, 1990), 295.

2 Ibid., 298.

3 Patricia A. Cost, "Linn Boyd Benton, Morris Fuller Benton, and Typemaking at ATF," *Printing History 31/32* (1994): 32.

4 Ibid., 31.

5 "What's new from ITC," *U&lc,* 18 (Winter 1991): 17.

6 Allan Haley, "Franklin Gothic: Making a Comeback," *Step by Step Graphics* (January/February 1992): 112/113.

28-POINT ITC FRANKLIN GOTHIC BOOK

abcdefghijklmnopqrstuvwxyz
ABCDEFGHIJKLMNOPQRSTUVWXYZ
1234567890&!?:;,"

A resurgence of interest in French Renaissance typefaces, whose varied designs bespeak stately elegance and rhythm, can be attributed to the superior type designs of Claude Garamond and Robert Granjon. These distinctive old-style designs—inspired by the types cut by Francesco Griffo for Aldus Manutius in Venice—were used to print exquisite books now regarded as some of the finest examples of French typography. Garamond and Granjon produced the majority of their work during the 16th century, a time considered by many to be the golden age of French typography. Their designs, now available in digital form, are among the most notable typographic achievements of the era.

Even the informed designer may be unaware that many types bearing the name of Claude Garamond are distinctively different. The Garamond fonts and their variations are marked by a rather intriguing history, with some mystery surrounding the location and authorship of several influential specimens.

Claude Garamond apprenticed as a punch-cutter under the tutelage of Antoine Augereau and, after developing his craft, he was approached by Robert Estienne, the Parisian scholar-printer. This encounter proved most fruitful, as Estienne subsequently commissioned Garamond to cut punches for a new series of roman type (Fig. 2). These delectable designs won praise from numerous book printers and soon gained widespread acclaim. The harmonious relationships between the letterforms is immediately obvious when seen in body text (Fig. 1).

These original Garamond letterforms, as well as many other roman types of the 16th century, are classified as Garalde or old style. A horizontal bar on the **e**, bracketed serifs, axis curves that are inclined to the left, and notable contrast between thick and thin strokes are all typical features of this style. Traits particular to Garamond include the small bowl of the **a** and small eye of the **e**, the downward slope of most top serifs, and the long extenders. These attributes are fairly consistent among all variations.

Oguans donc en ceſte maniere, non pas de la bor de ou artimó,mais auec les aëlles de cupido,qu'il auoit eſtendues au vent, comme dict eſt. Polia & moy conformes en voluntez , tous deux deſirans paruenir au lieu determiné pour noſtre beatitude au plus grand aiſe qu'onǵs ſens humain peuſt ſen tir,& langue dire , ſouſpirans de doulceur par a-

1 | Printed by Jacques Kerver, 1561.

Alphabetum

Græcum

2 | A detail of one of the type fonts cut by Garamond, from a book printed by Robert Estienne, 1550.

4 TYPES CUT BY JEAN JANNON

ABCDEFGHIJKLMN
OPQRSTUVWXY&Z

abcdefghijklmnopqrstuvwxyz

1 2 3 4 5 6 7 8 9 0

3

CHARACTERVM SEV
TYPORVM PROBATISSIMORVM,
INCONDITE QVIDEM, SED SECVN-
DVM SVAS TAMEN DIFFERENTIAS PRO-
POSITVM, TAM IPSIS LIBRORVM AVTORIBVS,
QVAM TYPOGRAPHII AEPRIME VTILE

Quis credidit Auditui nostro: & brachium Iehouæ cui Re-
uelatum est, Et ascendit sicut virgultum C O R A M eo, & velut
radix de terra deserti: Non erat forma ei, neque decor. ☙ Æ.Œ.

Aspeximus autem eum, & non erat aspectus, & Non desiderauimus eum videre. Despe
ctus fuit & Reiectus inter viros vir dolorum, & expertus Infirmitatem, & veluti absconso
faciei Ab eo, despectus inquam, & non putauimus eum. Verè languores nostros ipse tulit,
& dolores nostros portauit, nos Autem reputauimus Eum plagis affectum, Percussum à
Deo & HVMILIATVM. W. H. S. G.

When Garamond died in 1561, his punches and matrices were sold to the printer Christopher Plantin, whose independent press was located in Antwerp. Curiously, the types soon appeared on a broadside (Fig. 3) printed by the type foundry Egenolff-Berner. This broadside, which is often used as a reference for contemporary renditions, has several Garamond faces paired with italics designed by Robert Granjon. The punchcutter Jacob Sabon apparently acquired the matrices and punches while working with Plantin, and it was through Sabon that the types arrived at the Egenolff-Berner foundry. The specimens printed by this foundry established a high standard in typography, and subsequently Garamond fonts came to influence a huge number of type designs.

Another moment in history that had great impact on the future of Garamond occurred during the 17th century when the French printer Jean Jannon designed a typeface with very similar attributes. To Jannon's misfortune, the punches and matrices were confiscated and stored for centuries at the royal printing office. In 1825, these fonts reemerged in a fortuitous discovery at the vaults of the French national printing office, but they were mistakenly attributed to Claude Garamond. Many designs based on Jannon's work (Fig. 4) are thus named Garamond, even though Jannon's face has several unique characteristics. (Jannon's originals seem disorderly when compared to Garamond's types, as the letterforms vary in axis and slope.) Since the uncovering of this case of mistaken identity in 1927 by historian Beatrice Warde, erroneously named revivals and variations have retained the Garamond name, contributing to confusion regarding the Garamond family.

In 1917, Morris F. Benton and T. M. Cleland of American Type Founders designed ATF Garamond (Fig. 5), which is based on Jannon's roman and italic type designs. The ATF Garamond letterforms are slightly baroque with a gracefully disheveled appearance. The face has numerous characteristics that distinguish it from Garamond's forms, such as the large, angled serifs on the letters **s**, **m**, **n**, **p**, and **r** (Fig. 6). The introduction of ATF Garamond spawned an international revival of Garamond type.

A further adaptation of ATF Garamond, Garamond No. 3, was designed for the Linotype machine and later revised for digital use. The digital version, known simply as Garamond 3, maintains its fidelity to the Linotype version. Garamond 3 is primarily used as a text face, as it is less graceful at display sizes than many other renditions.

TYPOGRAPHY IS THE
MOST INFLUENTIAL OF
ALL THE ARTS: IT SENDS
KNOWLEDGE ABROAD
AS HEAVEN SENDS THE
RAIN · ONE FRUCTIFIES
THE SOIL, THE OTHER
MAN'S INTELLIGENCE

BRASS RULE FRAME MITERS

5 ATF GARAMOND BOLD

6 ATF GARAMOND

Frederic Goudy's Monotype version named Garamont, a Latin word for Garamond, followed the release of ATF Garamond. This typeface was also based on Jannon's work, but differs surprisingly from ATF Garamond. Monotype Garamond, issued by Monotype in 1922 (and also available in digital form), remains closer to Jannon's rambunctious italic types than do earlier Garamond revivals. The extreme slope of the capitals and varying axes are clearly baroque and have little semblance to Garamond's and Granjon's italic types. Simoncini Garamond, issued in metal by the Simoncini Foundry in 1958, is another notable derivation of Jannon's work. This typeface, designed by Francesco Simoncini and W. Bilz, is lighter in color and more delicate than most other Garamonds. It is highly versatile as a display or text face. The phototype incarnation of Jannon's type is ITC Garamond, designed by Tony Stan in the 1970s for International Typeface Corporation (ITC). This face, a radical departure from the work of Garamond and Jannon, is offered in digital formats with numerous weights and condensed versions.

The version of Garamond most faithful to the original arrived in 1924 when the Stempel Foundry in Germany issued its Stempel Garamond (Fig. 7). Both the roman and italic types are based on the original Garamond designs, while most other Garamond italics are based on the designs of Granjon or Jannon. The proportions of the italics have been altered slightly, thus a subtle variation in rhythm is evident. An angularity is apparent in the romans, as well as a slightly heavier weight, that is unlike most other Garamonds. This adaptation of the original Garamond was faithfully digitized by Linotype.

The digital Stempel Garamond italic has a different rhythm than does its model, the Garamond *Gros Romain* italic (c. 1539) (Fig. 8). The digital italic appears more uniform and orderly and, like the original Garamond italic, the letterforms slant at varying degrees. As for the roman styles, Stempel Garamond is uncannily close to the original Garamond. The calligraphic nuances that characterize the original are integral to the Stempel family. The angular head and bowl of the **a** and the oblique apex of the **A** are fine calligraphic qualities that are less pronounced in other Garamond versions, but are clearly accentuated in the Stempel types.

18-POINT DIGITAL STEMPEL GARAMOND

A B C D E F G H I J K L M N O P Q R S T U V W X Y & Z
abcdefghijklmnopqrstuvwxyz
1 2 3 4 5 6 7 8 9 0

7

Dicendum eſt igitur de iure priuato, quòd

Dicendum est igitur de iure priuato, quod

8

Gros Romain italic is shown above digital Stempel Garamond Italic.

9 18-POINT ADOBE DIGITAL SABON

ABCDEFGHIJKLMN
OPQRSTUVWXY&Z
abcdefghijklmnopqrstuvwxyz
1234567890

ch *Aaek*
ch *Aaek*

10

Jan Tschichold's original drawings are shown below their digital counterparts.

Another notable derivation of Claude Garamond's work is the typeface Sabon (Fig. 9) designed by Jan Tschichold. This typeface arose from a problem posed by a group of German master printers in the early '60s. They sought a versatile face that could be set by hand from foundry type or machine-set by either Linotype or Monotype, and yet provide no perceptible difference in the final printed piece. Problems such as varying point-bodies, kerning restrictions, and different unit systems had to be considered.[1] Tschichold was commissioned to contend with these difficult issues, and he successfully resolved them in the design of Sabon. This beautiful and versatile typeface is loosely patterned on the roman Garamond as well as Granjon's italic specimens from the previously mentioned Egenolff-Berner broadsheet. Considered by many as Tschichold's typographic apotheosis, Sabon was later digitized, easily acclimating itself to yet another technology. The digital rendition is available in roman, italic, semibold, semibold italic, and small caps. The digital forms appear almost as facsimiles of the prototype, although a slight difference in modularity is apparent (Fig. 10).

Sabon deviates from most other variations of Garamond in its heavier stroke weight, taller x-height, and shorter descenders. The typeface was intended for use as a all-purpose book face and thus has a larger eye, which increases readability when it is set in small body text. Sabon appears less elegant in larger sizes.

The serifs of Sabon are flat and almost slab-like, differing greatly from the scooped and rounded serifs of Stempel and most other Garamond versions (Fig. 11). This anomaly is most apparent in the serifs of the letter **X**. The Sabon **y** is narrower than the Stempel with a heavier stroke weight and shorter descender. Also remarkable is the ball terminal on the Sabon descender, which differs from the teardrop terminals in the Stempel version. The teardrop terminals are fluid and cursive, while the ball terminals seem static. Other particular attributes of the Sabon types are the tapered crossbar on the **f**, the truncated descender on the italic **f**, and the minimal angularity found on the bowls of the **a** and **g**. The **K** lacks a left serif on its leg and the top serifs of the **w** do not connect. The **S** is subtly modular with more of a contrast in stroke width and longer, thinner strokes than those in Stempel.

XygfKawSf
XygfKawS

DIGITAL SABON AND LINOTYPE'S
DIGITAL STEMPEL GARAMOND, BOTH 30 POINT

11

12

Catalog cover, 1999. Design firm: Swallowall, Lynchburg, VA; photographer: David Steadman.

13

A comparison of Robert Slimbach's digital rendition
of Garamond (left) with an original specimen.

Toward the latter part of the 20th century, the advent of digital technology has provided yet another venue for new versions of Garamond. In 1989, Adobe introduced Adobe Garamond, whose designer, Robert Slimbach, deftly embraced the beauty of Garamond's romans and Granjon's italics. Actually, his decision to combine Granjon and Garamond types seems to have been an inevitable marriage. Slimbach reflects that the types "are such beautiful models—canons, really—of modern letter design. Granjon was the master of French old-style italics. Garamond's masterpieces were the roman letterforms. They took those forms further than anyone had previously taken them, in a sense drawing them to their logical conclusions."[2]

Slimbach studied original Garamond specimens intensively and based his digital rendition on the *vraye parangonne* type (approximately 18 point) from the Egenolff-Berner broadside. He was compelled to select this particular example because the forms successfully merged a calligraphic quality with the refined roman letter.

Because Claude Garamond cut punches at diminutive sizes, the letterforms have a sculptural quality and a natural inconsistency (Fig. 13). The organic aspects of the original types are retained in Slimbach's refined letterforms, yet the digital precision of the forms also meets the myriad demands of contemporary usage (Figs. 12, 16). Adobe Garamond is an exquisite reinterpretation of its prototype. The extensive family consists of three weights, italics, and an expert collection.

During the embryonic stages of his design, Slimbach made pencil drawings for the regular-weight type that were scanned for tracing in Adobe Illustrator. Computer drawing tools were then employed to create a bold version, which was blended with the roman to create a semibold that interpolates between the two.

A comparison is often made between the digital versions of Adobe Garamond and Stempel Garamond because the latter is more akin to the original Garamond than most other versions. Adobe Garamond's calligraphic form shines through its increased modularity and contrast in stroke weight, unlike Stempel Garamond, which relies heavily on angular forms. The fluid strokes of Adobe Garamond create a soft and harmonious string of characters, while embracing the calligraphic nuances inherent in the original Garamond. The differences between Adobe and Stempel are most obvious in the **a** and **p** (Fig. 14). A few elegant eccentricities in the Adobe Garamond romans are the tapered crossbar and swooping hook of the **f**, the subtle foot serif of the **G**, and the tapered leg of the **R**, among others (Fig 15). With such high stature, these roman typefaces work well in text and display scenarios. The Adobe expert collection has titling caps for display that are Adobe Garamond and Stempel slightly lighter in weight than regular caps.

14

15

fiflffffifl

1234567890

123

YPOGR

PQGR

Q

16

ct

18

Sinfonia
da Camera
Ian Hobson, *music director*

Ian Hobson, *conductor*
Nicholas DiVirgilio, *director*

Richard Strauss

Ariadne auf Naxos

A comic chamber opera

Saturday March 30 1996 at 8:00pm
Foellinger Great Hall
Krannert Center for the Performing Arts
University of Illinois at Urbana-Champaign
Ticket information: 217 333-6280

This performance is made possible through
the generosity of Richard and Rosann Noel.

Sinfonia da Camera appears under the auspices of the
University of Illinois at Urbana-Champaign in
association with the School of Music and the College
of Fine and Applied Arts.

painting: Titian. *Bacchus and Ariadne* 1520-23. National Gallery, London
design: David Colley
printing: Duplii Graphic, Chicago

17

Poster, 1996. Designer: David Colley; painting by Titian; client: Sinfonia da Camera.

The Adobe Garamond expert collection also contains alternate characters, old-style figures, small caps, and an f-ligature set (Fig. 16). The old-style figures, also called hanging figures, harmonize with body text because of their ascenders and descenders. The alternate character set contains swash lowercase letters, a **Q** with an extended tail, an old-world **ct** ligature (Fig. 18), and a variety of ornaments.

Adobe Garamond italics, based on Granjon's designs, are more orderly and uniform than versions based on Jannon's. When paired with Garamond romans, Granjon's italics appear more harmonious than Garamond's italics. This is due to the fact that Garamond, unlike Granjon, seldom paired italics with roman type, hence the synergy between the forms most likely did not concern him. Slimbach's interpretation of Granjon's italic melds harmoniously with the roman letterforms (Fig. 19).

19

"Typography is the craft of endowing *human language with a durable visual form,* thus with an independent existence."
—Robert Bringhurst

The extraordinary work of Robert Granjon parallels the legacy of Garamond type. Granjon's La Galliarde, cut in 1570 as an 8-point roman font, is another old-style design of considerable significance. Named after a spirited dance of the period, this sparkling face is similar to Garamond but livelier. A prolific punchcutter, Granjon produced nearly 65 fonts, some of which were commissioned by the printer Christopher Plantin. Ranging from decorative fleurons to exotics such as Hebrew, Granjon's *oeuvre* displays both energy and elegance.

The contemporary rendition of Granjon's types is aptly named ITC Galliard (Fig. 20). Designed by Matthew Carter at Mergenthaler Linotype in 1978, the face was later licensed and digitized by ITC. The roman and black weights were originally designed for phototype, while the bold and ultra weights were later created digitally. Galliard is an amalgam of forms based on the original La Galliarde roman specimens and Granjon's atypical italics. It captures the pristine quality of Granjon's distinguished old-style fonts.

Carter approached the design of ITC Galliard with a well-defined motive: to create a versatile face that reflects contemporary style and embodies the attributes of its prototype without falling into anachronism.[3] An earlier version of Granjon's types, Monotype Plantin, had departed radically from the original. Designed by F. H. Pierpont in 1913, Plantin incorporates shorter extenders and a nearly monotone weight. Unlike Pierpont, Carter endeavored to preserve the character of Granjon's original designs by emphasizing the core traits that make the letters so distinctive and beautiful. The ITC Galliard series was issued in four weights with italics.

The first digital versions of ITC Galliard lacked extensive supplementary characters such as small capitals, ligatures, alternate characters, and old-style figures. After Macintosh computers made desktop publishing feasible, Carter digitized and released extended fonts of Galliard roman and italic in 1992. This version, called ITC Galliard CC from his Carter & Cone Type foundry, is the definitive Galliard. Its range permits extreme flexibility of application.

20 18-POINT ITC GALLIARD CC

A B C D E F G H I J K L M N
O P Q R S T U V W X Y & Z
abcdefghijklmnopqrstuvwxyz
1 2 3 4 5 6 7 8 9 0

The expressive qualities of ITC Galliard distinguish it from its old-style counterparts. The crisp and angular roman forms create a unique, animated texture. The characters maintain a slight asymmetry: the axis of the **o** differs from the axes of other round forms. The strokes of the letters have a high contrast and the serifs are large and pronounced. The terminals are slightly calligraphic, and the hooked terminals of the **a** and **t** have rather flat angles. The exuberant capitals are characterized by long serifs and strongly modulated curved strokes. A few quirks (Fig. 21) include the foot serif on the **G**, the straight diagonal stroke of the **a**, the detached stem from the arm and leg of the lowercase and uppercase **k**, and the wedged serif on letters such as **h** and **d**. Because the typeface was originally designed for photocomposition, Carter took certain liberties that would have been impossible with metal type. For example, the lack of kerning restrictions permitted the large overhang of the **f**. Carter also designed a ligature and swash character set for both the roman and italic styles.

21

Gakohfd
1232 4578

Outre ces Divinitez communes & univerfelles,

22

A detail of Robert Granjon's *Gros Cicero* specimen (top)
is contrasted with the digital version of ITC Galliard CC.

Granjon's *Gros Cicero* (large pica) specimen is
one of the inspirations for many of Carter's
roman designs. The specimen is noteworthy
due to its large x-height of its letterforms, dis-
tinct from the canonical proportions of other
old-style typefaces. Rather than focusing on
anomalies appearing only sporadically in vari-
ous specimens, Carter assimilated all of the
constants and variables into a new whole. The
digital version, when paired with the *Gros
Cicero* specimen, appears considerably wider
(Fig. 22). This distinction also holds true when
the digital version is compared to the La
Galliarde specimen (Fig. 23). The placement of
serifs is quite consistent, although the serifs on
the digital forms seem slightly exaggerated.

23

Deus æterne, qui absconditorium cognitor
Deus æterne, qui abfconditorum cognitor

24 18-POINT ITC GALLIARD CC ITALIC

*A B C D E F G H I J K L M N
O P Q R S T U V W X Y & Z
abcdefghijklmnopqrstuvwxyz
1 2 3 4 5 6 7 8 9 0*

25

Alfonfus rex Arrag. Iden
let, ita demùm matrimon

Robert Granjon's *Ascendonica* italic is paired
with its roman counterpart.

Granjon designed four distinct italic styles.
ITC Galliard Italic (Fig. 24) is based primarily
on his *Ascendonica* (about 20-point) design.
Granjon's *Ascendonica,* Carter contends, is the
only italic that matches the size and color of
the roman while maintaining high textural con-
trast.[4] There is certainly harmony between
these italic and roman letterforms (Fig. 25).
Carter's reinterpretation of *Ascendonica* is strik-
ingly vibrant and complex. Several characters,
such as the **n** and **m**, have joins that branch
out close to the baseline, whereas other char-
acters, such as the **a** and **d**, have joins that
branch in close to the x-line (Fig. 26). Curves on
numerous characters are broken, as seen in the
d. These angles provide an interesting interplay
between letterforms. A particularly intriguing
element is the descender of the **g**, which has a
leftward extension and forms a counter within
the letterform.

Afcendonica Romaine.
Ascendonica Romaine

27

The digital version of ITC Galliard CC Italic
is shown below the *Ascendonica* italic.

26

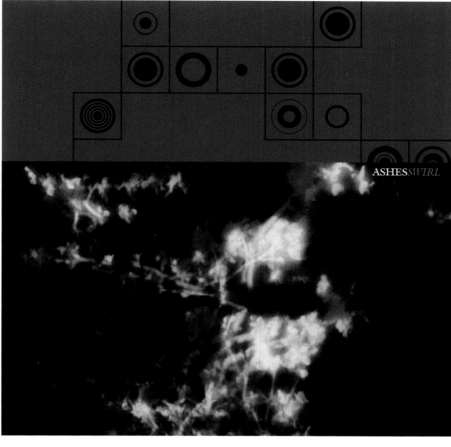

ASHES*SWIRL*

28
Album cover pairing
Galliard small caps with
black italics, 1998;
Design: David
Steadman;
photographer/
assistant designer:
Bruce Correll; zirkle sys-
tem type: Erik Brandt;
client: Seraph Records.

The warm and organic contours of the *Ascendonica* specimen differ from the hard edges of ITC Galliard (Fig. 27), therefore some compensation and compromises were made in translation. Carter was particularly sensitive to subtleties such as the sloped apex of the **A**. The integrity of the original design is maintained while the modularity and contrast are uniformly enhanced. Again, the digital letter-forms appear slightly wider, which might be attributed to their longer serifs.

As seen in the previous examples, the type-faces of Robert Granjon and Claude Garamond translate extraordinarily well into the digital age. The integrity of the originals has inspired numerous renditions over the last several centuries, now culminating in digital versions that satisfy contemporary demands. Garamond and Galliard are among the most popular typefaces used today, and will probably sustain their popularity for centuries to come.

NOTES

1 Ruari McLean, *Jan Tschichold: A Life In Typography* (New York: Princeton Architectural Press, 1997), 14.

2 Edward Lebow, "Type: The Newest of the Old," *American Craft* 57 (December 1997/January 1998): 46.

3 Matthew Carter, "Galliard: A Modern Revival of the Types of Robert Granjon," *Visible Language* 24 (Winter 1985): 87.

4 Ibid., 88.

abcdefghijklmnopqrstuvwxyz
ABCDEFGHIJKLMNOPQRSTUVWXYZ
1234567890&!?.:;""

28-POINT ADOBE GARAMOND ROMAN

Riding the wave of an esthetic ideology washing over Europe in the 1920s, Futura was the inevitable typographic manifestation of a new design attitude. Circles, squares, and triangles—the basic geometric elements of mechanical technology—became the symbols of the new industrial society. An interest in these basic geometric shapes manifested itself in such art and design movements as Dutch De Stijl and Russian Constructivism. Traditional type usage, particularly roman serif fonts, was beginning to be questioned. At the Bauhaus in Germany, a new design philosophy revolving around form and function flourished. Within this context, Futura was born.

Since its introduction as one of the early sans serifs to depart from the 19th-century gothic model, Futura has been among the most popular geometric sans serifs. It was an instant success in Europe and the U.S. after it was released by the Bauer foundry in 1927. Although its success led to many copies and derivatives, not all of these were equally well crafted.[1]

geometric sans serifs

ABCDEFGHIJKLMNOP
QRSTUVWXYZÄÖÜÆŒÇ
abcdefghijklmnopqrſstuvw
xyzäöüchckﬀﬁﬂﬀﬁﬂﬁﬀßæœç
1234567890&.,-:;·!?('«»§†*

Auf besonderen Wunsch liefern wir auch nachstehende Figuren

agmnä& 1234567890

1 Renner's final version of Futura, released in 1927.

dbqp

2 These four letterforms demostrate the symmetry within the Futura typeface.

Futura was designed by Paul Renner, a book designer, writer, and founder of the Masters' School for German Printers in Munich. He worked for seven years on its development. A trial cut of the first version of Futura was made by the Bauer foundry in 1925 (Fig. 3). Renner's initial design was achieved with the use of a compass and a straightedge, with the circle, square, and triangle as basic building blocks. The lowercase characters were highly geometric abstractions of the traditional roman letters. When he presented the design to the Bauer foundry, he was asked to bring the unconventional lowercase characters of his first version closer to the traditional forms. His final version of Futura (Fig. 1)—owing to its perfect geometric construction, architectural characteristics, and lack of decorative elements—probably best reflects the spirit of *die neue typographie* and the early European modernist movement.[2]

aaaabbþbc
ddefgghij
klmnooopp
qqrrſstuv
wxxyz
ﬀﬁﬂckß

3 Renner's first version of Futura, 1925.

Futura became the paradigm of a geometric sans serif: it is constructed of basic geometric shapes, with little stroke contrast, and usually with a single storied **a**. In actuality, Futura is not geometrically perfect—nor are its strokes of uniform width. A primary attribute of the lowercase character set is the seemingly perfect round **o**. If a perfect square is placed on this character, its true—slightly condensed—proportion is visible (Fig. 4). The horizontal curved strokes of the lowercase **o** are slightly thinner than the vertical strokes. With the addition of one stroke, the **o** functions as the base for eight other characters: **a, b, c, d, e, g, p,** and **q** (Fig. 2). Optical corrections were so successfully incorporated that they are difficult to notice. To prevent the appearance of dark areas where the strokes intersect—for example in the design of the **d** and **p**—curved horizontal strokes were made slightly thinner where they meet vertical strokes. Other characteristics of the lowercase character set include long ascenders; the absence of a tail on the **j**; the absence of a foot on the **t** and **u**; round dots on the **i** and **j**; the pointed apices on the **v** and **w**; and the terminals of the **c** cut on a vertical axis.

If you place a perfect square around the lowercase **o**, a slight difference between the height and the width of the character is discernible. The white square around the counter shows that the vertical strokes of the letter are thicker than the horizontal strokes.

4

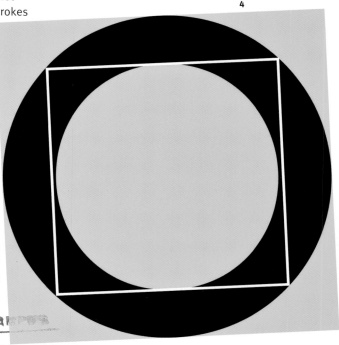

122 **123** By Jarik van Sluijs

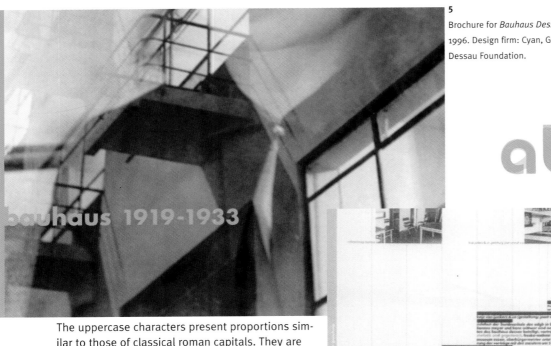

5

Brochure for *Bauhaus Dessau 1919–1933* exhibition, 1996. Design firm: Cyan, Germany; client: Bauhaus Dessau Foundation.

The uppercase characters present proportions similar to those of classical roman capitals. They are shorter than the ascenders of the lowercase characters. The reason for this is that written German has a large number of capitals because all nouns are capitalized. The shorter cap height keeps them from appearing too prominent in the text. This is also a feature of old-style roman type. Attributes of the uppercase character set include the following: the tail of the **Q** is longer inside than outside of the counter; characters like the **E**, **F**, and **H** have high middle bars; and the apices of characters like the **A**, **M**, and **V** are pointed. These apices are square-cut in the bold, heavy, and extra bold weights.

Digital versions of Futura licensed from Bauer Types do not greatly differ from the version released in 1927, except for the lowercase **r**. In the 1927 version, the **r** consisted of a vertical stroke and a detached round dot functioning as an arm. The 1927 version was released with alternative characters for the **a**, **g**, **m**, and **n**, along with an alternative ampersand. These characters disappeared in the subsequent Futura type specimens, and the **r** was given a more conventional form. In 1993, The Foundry, London, released Architype Renner, a digital translation by David Quay and Freda Sack of the first trial cut of Futura.

Although it was the most successful geometric sans serif, Futura was by no means the first sans serif to depart from the 19th-century gothic model. In 1916, Edward Johnston was commissioned to design a typeface for the London Underground (Fig. 6). With compass and straightedge, and a background in teaching calligraphy, he designed a humanist sans-serif typeface that would later greatly influence the design of Gill Sans by Eric Gill. Perhaps it also influenced the design of Futura, although Renner claimed never to have seen Johnston's sans serif before finishing Futura.[3]

Edward Johnston's typeface **6**
for the London
Underground, 1916.

ABCDEFGHIJKLMNOP
QRSTUVWXYZ
abcdefghijklmnopqrst
uvwxyz
1234567890 &£

abcdefghi
jklmnopqr
stuvwxyz
a
dd

Herbert Bayer's universal alphabet, 1925.
7

hijklmnopqrstuvwxyz

1930

abcdefghijklmnopqrstuvwxyz
1234567890

9

ERBAR-GROTESK, 1926.

Another typeface that set a precedent for the geometric sans serif was the universal alphabet (Fig. 7) of Herbert Bayer in 1925 (the same year that the trial cut of the first version of Futura was made). The universal alphabet was an experimental typeface consisting of lowercase characters only. Uppercase characters were omitted simply because Bayer felt there was no need for them in modern typography. Bayer, a teacher of typography at the Bauhaus, envisioned the universal alphabet as a simplification of the alphabet. He believed there was a need to design clearer, less ornate letterforms, so they could be recognized and remembered more easily. The letterforms are highly geometric and there is no contrast between stroke widths. The complete set of characters presents a harmonious formal unity. However, due to factors such as the equal stroke width throughout the characters, the universal alphabet is not very legible.

Ed Benguiat and Victor Caruso were inspired by Bayer's universal alphabet when they designed ITC Bauhaus in 1975 (Fig. 8). ITC Bauhaus is a rounded geometric sans serif with almost no contrast in stroke width. The main difference between it and the original Bayer design is that all characters, with the exception of the **o**, have partially open counters. Some of the characters that most closely resemble the universal alphabet are the **m, n, o, u, v,** and **w** because they adhere best to the geometrical simplicity of Bayer's design. Other characters were brought closer to traditional forms: the **r** is composed of two strokes, instead of just one, and the **t** has acquired a foot. The **g** is one of the characters altered the most, by getting a lower loop. The **s** and the **y**, on the other hand, are more geometrical. The irony of ITC Bauhaus is that Benguiat and Caruso designed an uppercase character set to go along with the adapted lowercase characters. ITC Bauhaus inherited the formal features of Bayer's universal alphabet, but not its stringent philosophy.

abcdefghi
jklmnopqr
stuvwxyz

ITC BAUHAUS
8

In 1926, Jakob Erbar designed Erbar-Grotesk (Fig. 9), a sans serif inspired by the same ideology as that of Futura. Released by the Ludwig & Mayer foundry, Erbar-Grotesk can be said to be the first geometric sans serif, though it was quickly overshadowed by the introduction of Futura a year later. The uppercase characters and numerals of Erbar-Grotesk share a formal similarity with those of Futura. The main distinction from Futura is its double-storied lowercase **a**.

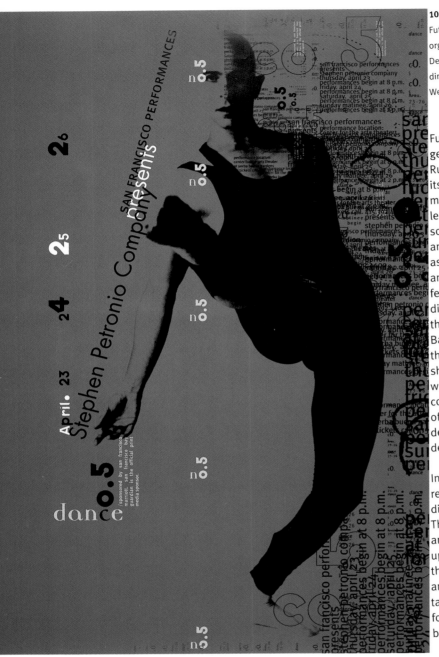

10
Futura's geometric forms contrast with the organic shape of a dancer in a contemporary poster. Design firm: Sterling Design, San Francisco; art director/designer: Jennifer Sterling; copywriter: Corey Weinstern; client: San Francisco Performances.

Futura was released the same year as another geometric sans serif, Kabel (Fig. 11), designed by Rudolf Koch. Kabel also had great success after its release by the Klingspor foundry. Koch, a more traditional designer than Renner, departed less from accepted norms. The stroke endings of some characters are slanted and the lowercase **a** and the **g** retain the traditional roman forms. The ascenders, as those of Futura, are relatively long, and the lower- and uppercase **o**s are almost perfect circles. Other characteristics of Kabel are the diagonal bar of the lowercase **e**, reminiscent of the venetian scripts; the lowercase **b** that, like Bayer's universal alphabet **b**, has a vertical stroke that does not meet the baseline; the diamond-shaped dots on the **i** and **j**; the uppercase **Q**, which has a tail that does not penetrate its counter; and the unconventional open lower loop of the **g**. The influence of Koch's Kabel on the design of ITC Bauhaus can be seen in the similar designs of the lowercase **e** and the distinctive **2**.

In 1976, International Typeface Corporation released ITC Kabel (Fig. 12). The redrawn typeface differs considerably from the original Kabel design. The x-height is larger, which makes it more legible, and some characters have been changed. In the uppercase characters, the slanted stroke endings of the **C** have an outward inclination; the **D** is wider, and more horizontal on top and bottom; the **Q** has a tail that penetrates the counter; the **U** has lost its foot, bringing it closer to a Futura **U**; and the crossbar on the **f** projects out of both sides of the stem.

The German geometric sans serifs created great excitement after their arrival in the U.S., and American foundries were quick to release their own versions. The Mergenthaler Linotype Company released Metro (Fig. 13), designed by William A. Dwiggins, in 1929. Metro was extremely successful, especially as newspaper type. It is less geometric than Futura: there is a noticeable stroke contrast in **e** and **y**. Dwiggins clearly had his own ideas about appropriate design for a sans-serif typeface.

18
A closer look at the differences
between **Futura** and **ITC Avant Garde**

A M C G Q R

i j k r u

abcdefghijklmnopqrstuvwxyz 1234567890

abcdefghijklmnopqrstuvwxyz 1234567890

abcdefghijklmnopqrstuvwxyz 1234567890

abcdefghijklmnopqrstuvwxyz 1234567890

abcdefghijklmnopqrstuvwyz 1234567890

abcdefghijklmnopqrstuvwyz 1234567890

Three typefaces more closely resembling Futura appeared in the early 1930s. Spartan (Fig. 14) was released by both the American Type Founders Company (ATF) and Mergenthaler Linotype, while Twentieth Century (Fig. 15) was released by Monotype. Both are almost exact copies of Futura. Tempo (Fig. 16) was released by the Ludlow foundry and resembles Futura very closely except for the double-storied lowercase **a** and the **g** with its less circular bowl. Owing to these two main differences, Tempo resembles Erbar as much as it does Futura.

More recently, in 1970, Herb Lubalin and Tom Carnase designed ITC Avant Garde (Fig. 17), a typeface based on Futura and the geometric sans serifs of the late 1920s. (It was the very first typeface released by ITC.) Avant Garde—even more geometrical than Futura with a more uniform stroke width—was based on a logotype designed by Lubalin and Carnase for *Avant Garde* magazine, and was initially composed of only uppercase characters. A series of distinctive ligatures and alternative characters were created for many of these characters.

At first glance, the lowercase characters of ITC Avant Garde look almost identical to those of Futura (Fig. 18). The main difference is that Avant Garde has a much larger x-height but shorter ascenders, which are the same height as its uppercase characters. In addition, the terminals of the **c** and **C** are cut on a horizontal axis instead of a vertical one; the apices of the lowercase **v** and uppercase **A** are square instead of pointed; the **Q** has a sensuous tail while the **j** has a loop; the **r** is less curled and the counter of the **R** is left open; and the stems of the **M** are vertical, not diagonal.

19
Futura amplifies the crisp geometry of a modern chair on this exhibition poster, 1977. Designer: Wim Crouwel.

ABCDEFGHIJKLMNOPQRSTUVWXYZ
abcdefghijklmnopqrstuvwxyz &?1234567890

In 1962, Aldo Novarese designed Eurostile (Fig. 20), a typeface that has almost no resemblance to Futura because of its square proportions and forms, but still is categorized as a geometric sans serif. Its only similarity to Futura lies in the uppercase **Q**: the tail is longer inside the counter than outside in both cases. Eurostile's uppercase characters were designed by Aldo Novarese and Alessandro Butti and released by the Nebiolo foundry in 1952 under the name Microgramma.[4] Eurostile is highly modular, and seems to have been drafted on a matrix grid. The **a**, **b**, **c**, **d**, **e**, **g**, **h**, **n**, **o**, **p**, **q**, **s**, and **u** all share a similar character width. Strokes and curves shared by some characters add to the harmonious whole. For example, the stroke contrast and form of the upper bowl in a lowercase **g** is similar to the counter of the **d**. Although Eurostile is not suited for setting long texts due to the verticality of its characters, it does lend itself to the creation of logotypes or display type with a extremely modular and geometric character. If Futura expresses the mechanical technology of the 1920s, Eurostile expresses the refined technology of the 1950s.

At the end of the 1960s, Dutch designer Wim Crouwel proposed a new alphabet designed to meet the possibilities and limitations of the emerging printing technologies. The New Alphabet (Figs. 21, 22), designed in 1967, was presented as a substitute for the traditional alphabet. It was envisioned as an alphabet that could be aligned and spaced by a computer and would not require the human eye to set it. The cathode-ray tube as a means of reproduction was taken as a starting point. Crouwel arrived at highly modular and geometric forms, since only those could best be rendered on a cathode grid.[5]

The characters do not have any curved shapes, the strokes are all equal in width, and the ascenders and descenders are of equal length. The alphabet is made up of abstractions of lowercase characters except for the **e**, which resembles an uppercase character.

"The proposed unconventional alphabet shown here is intended merely as an initial step in a direction which could possibly be followed for further research," wrote Crouwel in 1967. "The letter symbols will be introduced into the memorizing mechanism of a computer. Because circular and diagonal lines are least suitable for this technique of screen reproduction, the proposed basic alphabet consists entirely of vertical and horizontal lines. It will be possible for the typographer, by adding appropriate directives, to arrive at the final form of the text. Other signs can be used to specify italics, roman, bold or light, wide or condensed, as well as differences between the boldness of vertical and horizontal, the relation between typeface and spacing, or any other wanted detail. Capitals are denoted by a line above the letter."[6]

The design of the New Alphabet was one of the first attempts to develop type in a functional manner for the digital medium. The result was one of the most abstract sets of geometric characters ever designed. The reader must decode and relearn the different letterforms before reading is possible. Owing to the alphabet's highly modular character, letterforms start to look alike: the **k** resembles a **t**; the **g** can easily be confused with a **q**; and the **x** looks like an uppercase slab-

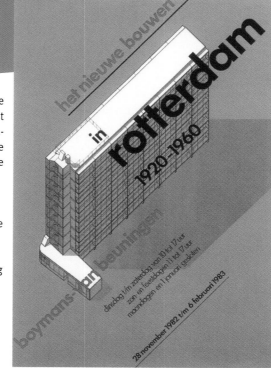

22
Cover for the presentation booklet of the New Alphabet, 1967. Designer: Wim Crouwel; publisher: Steendrukkerij De Jong & Co., Hilversum.

serif **i**. Nevertheless, the ideology behind the New Alphabet is similar to that of Renner's first version of Futura and Bayer's universal alphabet. All three are attempts to simplify the appearance of letterforms in order to explore and complement the technology of the time.

Futura, other geometric sans serifs, and related experimental alphabets occupy a distinctive position in the typographic lexicon. Their mathematical structure makes it advisable to set text sizes with the fairly loose letterspacing found in Renner's original fonts; otherwise, letters tend to merge and words become hard to read. Used with care, these fonts bring precision and clarity to visual communications.

23
Poster for an architectural exhibition, 1983. Designer: Wim Crouwel; client: Boymans-Van Beuningen Museum, Rotterdam.

NOTES

1 Christopher Burke. "The Authorship of Futura." *Baseline* magazine, 33–40.

2 *die neue typographie* (the new typography) is a European design movement that began in the 1920s. It is characterized by sans-serif type, asymmetrical composition, emphasis on functionalism, and an embrace of machine technology.

3 Christopher Burke. *op. cit.,* 33-40.

4 J. I. Biegelson, *Art Directors' Workbook of Typefaces,* Third Edition (New York: Arco, 1978), 134.

5 Wim Crouwel. *Nieuw Alfabet: Een mogelijkheid voor de nieuwe ontwikkeling* (Hilversum: Steendrukkerij De Jong & Co.), 1967.

6 Ibid.

24- POINT FUTURA

abcdefghijklmnopqrstuvwxyz
ABCDEFGHIJKLMNOPQRSTUVWXYZ
1234567890&!?:;"

> **"The sans serif is in fact an Egyptian with the serifs knocked off, and it is probable that that was the manner of its creation."**
> A.F. JOHNSON

As the Industrial Revolution changed the face of Victorian England, new typefaces were designed to meet the new demands. Nicolete Gray, type historian, describes a cultural context of the early 1800s in which "not even letters may be irresponsible or insincere."[1]

Compressed fat faces and weighty sans serifs were developed to communicate serious and utilitarian messages in the increasingly cluttered typographic landscape. Letterforms that came to be known as the grotesques were infused with the capitalist impulse to shout the loudest over the marketplace's many voices. These unadorned typefaces were successful for display because they could be recognized quickly and remembered clearly. When considered in context with the ornamental typefaces that they followed, the grotesque letterforms are significantly more geometric and minimal. And to many who had become accustomed to the delicate, elegant lines of typefaces such as Baskerville and Bodoni, grotesque sans serifs were shocking and vulgar.

When the first sans-serif type was published by the Caslon foundry in 1816, the two-line English Egyptian was a modest typeface used for subheadings and short lines of text (Fig. 1). Soon after, "jobbing type,"[2] as it came to be known by those in the print trade, was introduced by Robert Thorne in his 1819 specimen book. These sans serifs, like the fat faces before them, were cut specifically for commercial applications such as newspaper advertisements, lottery tickets, programs, and posters. By 1820, there were ten English foundries competing to provide printers with various text and display specimens. A general decline in type quality was caused by the pressure on foundries to produce an endless supply of new display types. A sans serif published by Vincent Figgins in 1832 is an example of poor cutting, especially the unresolved characters of the **S**, **N**, and **G** (Fig. 3).

After many prosperous years at the helm, Thorne died in 1820, with the result that type production at his foundry came to a standstill, the foundry eventually ending up in the hands of an auctioneer. When no apprentices were financially able to step forward to purchase their master's business, William Thorowgood parlayed lottery winnings into a high bid and gained ownership. In the spirit of the times, Thorowgood capitalized on his good fortune by immediately publishing 132 pages of type specimens already prepared by Thorne. The new owner had no previous experience in type design or production but, following his *laissez-faire* instincts, he managed to successfully market Thorne's inventory.

W CASLON JUNR LETTERFOUNDER

1

Published by the Caslon foundry, this example is the earliest known version of sans-serif type, 1816.

By 1834, Thorowgood and Company had become a competitive force in the type market by continuing to build on the body of Thorne's work and popularize the sans serif. The company was the first to produce a sans serif with a lowercase (Fig. 2) and was first to use the name grotesque, a term still employed to describe the style of sans-serif types designed in England during this period. The simplicity and flexibility of the sans-serif design led to fully realized families of type that doubled for both text and display (an idea that wasn't fully accepted until the 20th century).

The grotesques are distinguished by an absence of serifs and have stroke weights that are often of near equal thickness. The slight fluctuation in stroke weight, along with slightly tapered terminals, helps to maintain legibility. Curved forms are often thinned where they meet other curved forms or vertical strokes. The capitals are of equal width; the **G** has a spur and the **M** is square. During the mid-1800s, the grotesques were most often employed to shout headlines or for advertising display. For text use, no lowercase versions seem to have been cut in England before the 1870s. As printed matter became more influential, trade activity was stimulated and, in turn, more jobbing type faces were commissioned.

Simultaneous to these developments, important technical innovations were being made across the Atlantic. The mass manufacture of wood types became economically feasible after the New York-printer Darius Wells invented a lateral router to carve the letters from the end-grain face of wood blocks. Wells found that he could make larger wood display type more dimensionally stable than metal and was the first to produce wood type commercially in 1827. In the casting of large metal type, uneven cooling temperatures left depressions in the printing surface. Wells's advance in technology and materials opened up exciting possibilities for faster, cheaper production of wood blocks rivaling the quality of metal type. The bulky proportions of the grotesque, fat-face, and Egyptian types were perfectly matched to this new means of production.

MENINCHURNE

mountainous

2

Sans-serif type by Vincent Figgins, 1832.

3

TO BE SOLD BY AUCTION, WITHOUT RESERVE; HOUSEHOLD FURNITURE, PLATE, GLASS, AND OTHER EFFECTS.

The American wood-type industry was launched in March of 1828, when Wells released his first type-specimen catalog. In addition, his router-machine enabled easy reproduction of competitors' specimens and widespread pirating of designs occurred; plagiarism was fast becoming the standard vice of the machine age.

By the end of the 19th century, many foundries had produced a full range of grotesques, spanning the gamut from light to ultra, condensed to expanded. One of the more popular grotesques, No. 9, was published by Eleisha Pechey in 1906. By this time, the oddities and irregularities of the original grotesques were being redrawn. While the No. 9 letterforms seem even in stroke weight, close inspection reveals a slightly organic line that reflects the work of a craftsman rather than the calculations of a drafting engineer. Grotesque No. 9 is characteristic of the early grotesque form, keeping the tucked-in quality of letters such as **c**, **e**, and **r** (Fig. 4). Uppercase Grotesque No. 9 shows the uniform stroke widths with exceptions such as **M** and **W**. Stroke uniformity make the **E** and **F** seem particularly wide. Fluctuations in stroke thick-

abcdefg
hijk
lmnop
qrs
tuv
wxy
&z

ness are more easily discernible in the lowercase. The thick and thin strokes of the **e** contrast significantly with the even thickness of other letters such as **v**, **w**, and **x**. All uppercase letters extend to a common capline, reinforcing the face's substantial presence. Vertical letters such as **E**, **F**, **H**, **I**, **L**, and **T** all have the perfect rectangles found in many sans-serif typefaces. The **G** is stabilized by a solid spur at the bottom of the vertical stroke—the only uppercase letterform to have this notched detail—and the unusual **R** is balanced by its strong, sensuous double-curve tail. The **R** is the crown jewel of the grotesque group, with its sinuous leg and delicately flipped terminal (Fig. 5).

As for the lowercase, spurs can be found on the vertical strokes of **b** and **q**, differentiating them from their unbroken reciprocals **d** and **p**. Other notable characteristics are the recurrence of a hook-curl form in the appendages of the **f**, **j**, and the drooping tail of the **r**. Dots over the **i** and **j** are no-nonsense squares and hover close to their stems, reiterating the design's compactness. Ascenders and descenders are designed to be low and short. Type designers began to see the utilitarian advantages of chopping the extenders short, allowing a greater number of lines to fit on the printed page. In response, typographers began to space the lines out to reestablish legibility.[3]

Today, the typographic din of the wood-type era seems to have hardly subsided. As happened with wood-type foundries, the advent of desktop publishing has opened a technological floodgate to both typographic innovation and instantaneous appropriation. It is in this visually overcrowded environment that contemporary type designers are exhuming the beautiful audacity of the grotesques introduced at the beginning of the last century.

David Berlow created a grotesque typeface in 1989 for Font Bureau, finding his inspiration in Stephenson Blake's specimens from the 1800s (Fig. 6). Ever more exacting modern design methods required a typeface of clean, sophisticated lines, carefully judged weights and proportions, and a comprehensive range of sizes. Developed for Roger Black, Inc., the Tribune Companies, and *Newsweek*

30-POINT BUREAU GROTESQUE THREE-SEVEN

20-POINT GROTESQUE NO. 9

1234567890

SOCIETY OF ARTS.
NOTICE TO STUDENT
THE LECTURES AT THE AN
ACADEMY,
WILL COMMENCE O
₆ MONDAY NEXT.

Type by Stephenson Blake, 1800s.

magazine, the Font Bureau's first grotesques reintroduced the tooth and character of 19th-century versions and met with immediate success (Fig. 7). Berlow designed additional weights for *Entertainment Weekly* and *El Sol*, a Madrid daily. By 1993, Bureau Grotesque had developed into a total of 12 weights that effortlessly cover both text and display functions. This contemporary grotesque reinvents the even, thick, and gray appearance of Victorian broadsides with many versatile weights. Many of today's most widely read magazines attract readers with these sensuous but serious letterforms. *Gentlemen's Quarterly*, *Us*, and *Details* are among the publications that use Bureau Grotesque's confident, sturdy lines to great esthetic and communicative effect. Like the sidewalk broadsides of 100 years before, an example from *US* magazine (Fig. 8) shows letterforms compressed into a rectangle. This pull-quote is crisp, bold, and begs to be read.

7

NOTICE!
30-POINT BUREAU GROTESQUE FIVE-THREE

NOTICE!
30-POINT BUREAU GROTESQUE FIVE-ONE

NOTICE!
30-POINT BUREAU GROTESQUE THREE-SEVEN

NOTICE!
30-POINT BUREAU GROTESQUE THREE-ONE

NOTICE!
30-POINT BUREAU GROTESQUE THREE-FIVE

NOTICE!
30-POINT BUREAU GROTESQUE THREE-THREE

NOTICE!
30-POINT BUREAU GROTESQUE FIVE-FIVE

0987654321
36-POINT BUREAU GROTESQUE THREE-FIVE

"I TEND TO THINK THAT MUSICIANS TAKE THEMSELVES MUCH TOO SERIOUSLY. IT'S GOOD FOR ART TO HAVE A SENSE OF HUMOR. THAT'S HOW YOU GET THROUGH THE DAY."
B E C K

8

Type treatment using Bureau Grotesque from *US* magazine, July 1997. Art Director: Richard Baker. From the article "He Rock" by Lauren David Peden. Reprinted with permission from *US* Magazine Company, L.P.

A study of grotesque revivals would not be complete without the enormous contributions of Jonathan Hoefler. Hoefler has drawn extensively on both English and American sans serifs from the 1800s for his versatile designs. Initially hired to do production at *Smart* magazine, he worked with art director Roger Black and in the process learned the skills of type archaeology. In a 1995 interview with *Wired* magazine, Hoefler reflected on his approach to past font designs: "In many ways, designing typefaces has provided me an excuse to spend time looking at historical typefaces. And increasingly, I'm finding that I'm influenced not so much by the look of a historical typeface, but wondering about the thinking behind it. It's usually a theoretical underpinning that precipitates a new design, rather than merely the look of something old."4 Hoefler's highly successful revivals appear on the pages of the world's most influential periodicals, blending studied typographic craftsmanship with intelligent irreverence.

Originally commissioned by *Sports Illustrated* in 1990, Hoefler's Champion Gothic family is often employed for display settings when notions of strength, confidence, and swagger must be conveyed. While excellent as a display type, Hoefler's articulate letterforms remain legible in small sizes and can be used for short text settings. Champion's flexibility is illustrated by one of Hoefler's promotional letterpress posters (Fig. 9). The widths of these six fonts are analogous to boxing classifications, ranging from extremely condensed to unusually wide: Bantamweight, Featherweight, Lightweight, Welterweight, Middleweight, and Heavyweight. Another inventive specimen communicates the quality of the face by cleverly referencing the names of famous contenders and the aggressively set broadsides on which their bouts were advertised (Fig. 10).

200-POINT HTF CHAMPION BANTAMWEIGHT

200-POINT HTF CHAMPION FEATHERWEIGHT

200-POINT HTF CHAMPION LIGHTWEIGHT

9

Promotional poster featuring Champion Gothic. Design firm/client: The Hoefler Type Foundry, New York City; designer: Jonathan Hoefler.

ǪOGC

40-POINT HTF CHAMPION HEAVYWEIGHT

ǪOGC

120-POINT HTF CHAMPION WELTERWEIGHT

Champion Gothic retools the traditional type-family structure of normal, condensed, and expanded versions. Instead, Hoefler has designed a face cut in a series (Fig. 11), an approach first practiced by 19th-century American wood-type makers, in which various degrees of extending, condensing, and weight changes are applied to a single design. In contrast, these six fonts do not have a central face from which regular and subsidiary faces are articulated. In all but the Heavyweight font, Hoefler has modified the 19th-century proportions by reducing the vertical curves of the **Q**, **O**, **G**, and **C** to a straight line. This sheer verticality greatly reduces spacing difficulties and is one of the most significant departures from the Bureau Grotesque's more curvaceous proportions. The tail of the **Q** has been reconsidered as a tight, bulbous hook that projects from the center of the oval stoke. This condensed curl has pronounced thick-and-thin-dynamics with a tapered end and is the only such form in the entire series. The descenders of the **j** and **y** are less eccentric than their grotesque predecessors. The resulting face is one of supreme editorial versatility.

HTF CHAMPION GOTHIC BANTAMWEIGHT
GENE TUNNEY JOE LOUIS FLOYD PATTERSON
In this corner wearing the purple trunks and weighing in at one hundred and fifty nine pounds, the contender hailing from Birmingham

HTF CHAMPION GOTHIC FEATHERWEIGHT
ROBERT PROMETHEUS FITZSIMMONS
England, Kid Johnny Baskerville. In this corner, wearing red trunks and weighing in at one hundred and sixty two

HTF CHAMPION GOTHIC LIGHTWEIGHT
JACK DEMPSEY JOE FRAZIER
pounds and hailing from the City of London, the undisputed champeen, Mister William

HTF CHAMPION GOTHIC WELTERWEIGHT
ROCKY FRANK MARCIANO
Bulldog Caslon. All right boys, I want a good clean fight: no hitting below the

HTF CHAMPION GOTHIC MIDDLEWEIGHT
SUGAR RAY ROBINSON
x-height, no manual kerns, no downloading, no upper swashes.

HTF CHAMPION GOTHIC HEAVYWEIGHT
MUHAMMAD ALI
Get to it boys, and may the better man win. DING!

10

Page from *The Hoefler Type Foundry
Catalogue of Typefaces No. 2.*
Designer: Jonathan Hoefler.

134 **135**

11

Top row. 19th-century wood-type specimens (from left):
Gothic XXX Condensed, XX Condensed, X Condensed,
Condensed, Gothic.

Bottom row. 20th-century Hoefler type specimens (from left):
Champion Bantamweight, Featherweight, Lightweight,
Welterweight, Middleweight, Heavyweight.

ZIGGURAT	SARACEN	ACROPOLIS	LEVIATHAN
R	**R**	**R**	**R**
egyptian	*latin*	*grecian*	*gothic*

12

By the 1840s, all primary and many secondary faces were being cut in a series. In his Proteus Project, Hoefler has subtly tamed the lines of gothic wood type by asserting a tighter geometry and sense of order. The slightly organic quality that defines type from the 1800s remains clearly intact.

1234567890

13

LEVIATHAN BLACK AND LEVIATHAN BLACK ITALIC

When *Sports Illustrated* asked for a sans serif that could be condensed mathematically, Hoefler added three more weights to the Champion family—Flyweight, Cruiserweight, and Sumo—and renamed the face Knockout. Thus, he created a functional face that would be legible in small text for charts but still be interesting enough for display copy.

The Proteus Project, another set of designs by Hoefler, puts a postmodern spin on the cut-in-a-series method, in which the primary design element is a conceptual one. First done for *Rolling Stone*, the series consists of four subfamilies, each created in a different 19th-century idiom: a slab-serif egyptian, a sans-serif gothic, a wedge-serif latin, and a chamfered grecian (Fig. 12). These seven fonts share a common set of character widths and can be used interchangeably. This close interrelationship between families reconfigures the derivative nature of many 19th-century wood-type designs into a cohesive whole, for the fonts work well in combination.

325-POINT LEVIATHAN BLACK

325-POINT LEVIATHAN BLACK ITALIC

Like its grotesque and gothic predecessors, the Hoefler Leviathan is a sans-serif variation of an Egyptian typeface, HTF Ziggurat. Designed in two styles, Leviathan Black and Leviathan Black Italic (Fig. 13), these typefaces are hybrid designs with details borrowed from Latin typefaces. The **R** has a pointed leg that has a strong reference to calligraphy. This sensual line is juxtaposed with the thick, straight rectangle of the main vertical stroke. Likewise, the entire Leviathan design shows dynamic thick-and-thin fluctuations set against very monolithic, vertical elements. The **z**, in both upper- and lowercases, clearly illustrates this tension between curves and right-angled stokes. Other notable differences include the triangular tail that sprouts from the **g** very much as it does in the Grotesque No. 9, and the **f** with its long descender (Fig. 14) that makes an "s" formation.

14

The strong presence of grotesques has brought a boldness and vigor to commercial messages for over 150 years. They will undoubtedly continue to serve this role for decades to come.

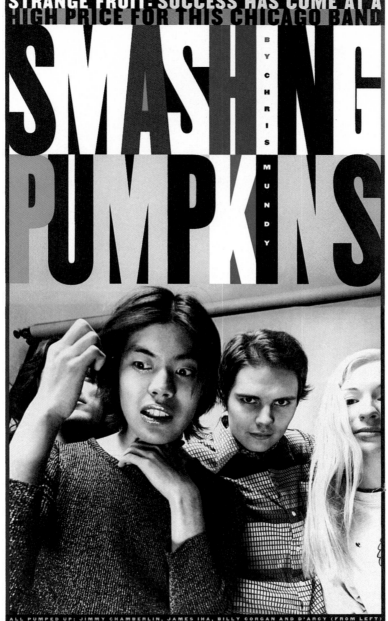

STRANGE FRUIT: SUCCESS HAS COME AT A HIGH PRICE FOR THIS CHICAGO BAND

SMASHING PUMPKINS

BY CHRIS MUNDY

ALL PUMPED UP: JIMMY CHAMBERLIN, JAMES IHA, BILLY CORGAN AND D'ARCY (FROM LEFT)

PHOTOGRAPHS BY GLEN LUCHFORD

15

Editorial layout using Champion Gothic, 1994. Art
Director: Fred Woodward; designer: Geraldine Hessler;
photographer: Glen Luchford; client: *Rolling Stone*.

NOTES

1 Nicolete Gray, *Nineteenth Century Ornamented Typefaces* (Berkeley: University of
California Press, 1967), 145-147.

2 Jobbing type was a term given to those emerging types with a quality of utilitarian
versatility. In an increasingly urban landscape, these typefaces were used heavily for their
visual impact.

3 Geoffrey Dowding, *The History of Printing Types* (London: Wace & Company Ltd., 1961),
181.

4 Unpublished excerpt from an interview by Douglas Cooper for the article, "The Year
Mozart and Sid Vicious Shared an Office in New York," *Wired* 3.03 (March 1995).

abcdfghijklmnopqrstvwxyz
ABCDEFGHIJKLMNOPQRSTUVWXYZ
1234567890&!?:;""

During the 1950s, Swiss design, also referred to as the International Typographic Style, emerged as a dominant influence. At the time, it was argued that sans-serif typography best expressed clarity and unity; to this end, designers who embraced these ideals sought to achieve them within a single type family. Several European designers advocated elementary type forms without embellishment; thus, sans-serif type, in a range of weights and proportions, came to epitomize modernity. The sans-serifs' wide range of value and texture in the black-and-white tonal scale easily accommodated modern design's abstract, intellectual attitudes.

12-POINT AKZIDENZ GROTESK

ABCDEFGHIJKLMNOPQRSTUVWXYZ
abcdefghijklmnopqrstuvwxyz
1234567890&.,-:;!?('{}

1

The influential face known as Helvetica came into being in the early 1950s. Edouard Hoffman, of the Swiss typefoundry Haas, wished to refine the Akzidenz Grotesk fonts, an alphabet produced at the turn of the century. Max Miedinger made the drawings and worked closely with Hoffman in the design of the new face, introduced in 1957. Originally released by Haas as New Haas Grotesk, it was soon purchased by the Stempel foundry in Germany. Stempel reissued it in 1961, renaming it Helvetica after the Latin word for Switzerland. (Hoffman was shocked to learn that Stempel had taken the liberty of renaming the typeface without consulting him.) Today, Miedinger is lauded for designing one of the most popular and successful typefaces of the 20th century.

2
Cover of *Menswork Magazine* using Helvetica Bold Condensed. Design firm: Liska Associates, Inc., Chicago; art director: Susanna Barrett; designer: Marcos Chevez; client: American Crew (Revlon).

MENSWORK
A MAGAZINE WHAT THE HELL PREMIER ISSUE
SCHOOLING AT MENSWORK – ON THE EDGE OF CUTTING
612 WORDS SHAVING GRACE WISE GUYS
ON HAIR AMERICAN CREW TREND RELEASE ARMANI STANDS FAST
6+FASHION VOLUME 01
MEN'S ROOM FOR YOUR HEAD

JKRQCB

3

One of Helvetica's most remarkable features is its large x-height, which is even larger than the x-height of Adrian Frutiger's Univers (Fig. 4). This gives the letterforms an increased volume, allowing for better legibility than many san serifs. The increased x-height, along with the face's pronounced stroke weight, gives it a darker appearance in large bodies of text than other sans serifs. These characteristics add to its consistency in color and printing quality. The most obvious differences between Helvetica and Akzidenz Grotesk are found in the x-height, counters, and finials. The finials in Akzidenz Grotesk are angled, whereas Helvetica has flat finials, apices, and terminals on its ascenders. Helvetica has oval counters, whereas Akzidenz Grotesk, with its smaller x-height, has counters that are more rounded. There are several differences between the two uppercase alphabets (Fig. 3). For example, the loop of the **J** in Helvetica is more complete than that in Akzidenz Grotesk. Also, while the legs of the **K** and **R** in both faces are stepped, the Helvetica **R** has a curved leg. The Helvetica **Q** has a straight, angled tail that intersects the counter. There is a narrow aperture with flat terminals in the Helvetica **C** and **G**, and the **G** has an angled spur. The central junction of the Helvetica **W** is flat, as is the junction of the **M**, which rests on the baseline. The bowl in the Helvetica **B** is slightly wider than that of Akzidenz Grotesk. As for lowercase, the shoulders of several Helvetica letters, the **g** for example, are thinner than those of Akzidenz Grotesk (Fig. 5). The dots on the Helvetica **i**, **j**, and in all its punctuation marks are square, and the double-storied **a** has a hooked tail.

4

5

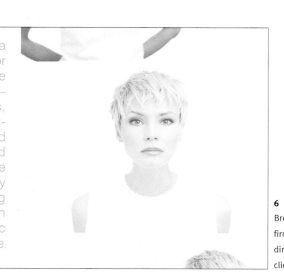

mop modern organic products, a new simple approach to hair care for a modern world. Modern, because it's designed for today's lifestyle – simple, natural, quality conscious, and easy. Organic, specially formulated with natural, time-honored ingredients to enhance beauty and healthful living. Products that are created to be the finest quality cleansing, conditioning and styling line for all people in today's modern family. Mop is modern organic products for modern organic people.

6

Brochure for MOP set in Helvetica. Design firm: Liska Associates, Inc., Chicago; Art director/designer: Susanna Barrett; client: Modern Organic Products (Revlon).

Helvetica Neue	25	ultra light
Helvetica Neue	26	ultra light italic
Helvetica Neue	35	thin
Helvetica Neue	36	thin italic
Helvetica Neue	45	light
Helvetica Neue	46	light italic
Helvetica Neue	55	regular
Helvetica Neue	56	regular italic
Helvetica Neue	65	medium
Helvetica Neue	66	medium italic
Helvetica Neue	75	bold
Helvetica Neue	76	bold italic
Helvetica Neue	85	heavy
Helvetica Neue	86	heavy italic
Helvetica Neue	95	black
7 Helvetica Neue	96	black italic

Helvetica is available in a variety of weights, widths, and italics. This was a problem when the typeface was new as many individual designers separately created versions of the face, including Helvetica Compressed, Ultra Compressed, Inserat Roman, Narrow Bold, Rounded Black, Textbook Roman, Fraction, and Cyrillic Upright, to name a few. Character construction was also inconsistent: a close inspection of the condensed versions reveals square design elements, which do not coincide with the versions based on round and oval letterforms (Fig. 9). A single weight was often given two names, and proportions in widths and italics varied with each collection of metal fonts. In 1983, a cohesive version became available when Linotype released the digital font Helvetica Neue (Fig. 7). Linotype corrected many inconsistencies, including differences in alignment, to make Helvetica Neue work harmoniously as one family. The range of weights increased with additional variations, such as heavy and ultra thin. In comparison to the original Helvetica, Helvetica Neue is a wider typeface with more rounded counters. The characters **f** and **t** are designed with longer bars to improve readability. When **r** is used with **n** in older versions it merges into an **m** letterform. The arm of the **r** in Helvetica Neue is longer to remedy this problem (Fig. 8).

Like Univers, Helvetica Neue uses a numbering system to identify the variety of weights and styles. (For information on the Univers family numbering system, see page 170.) Helvetica Neue 55 is the parent face and is used as a basis for the other fonts. As evident in this example (Fig. 10), weight increase is indicated by the first digit, with 2 being the lightest and 9 the heaviest. The second digit indicates whether the weight is roman, oblique, or italic. Roman faces are indicated with a 5 as the second digit, while a 6 designates oblique and italic faces.

9

Helvetica / Helvetica Neue

rn m
rn m

8

Close inspection of the Helvetica Condensed **t** on the left reveals square design elements. This is unlike the original on the right, which is based on round and oval letterforms.

	25	ultra light
	26	ultra light italic
	35	thin
	36	thin italic
	45	light
	46	light italic
	55	regular
10	56	regular italic

The system used for the condensed or extended fonts has another arrangement (Fig. 11). The first digit designates weight and the second digit indicates a condensed or extended version of that weight. Condensed versions have the number 7 as their second digit, while extended versions are designated by the number 3. The range in the condensed face includes extra black condensed, identified by the number 10.

Many of the promotional pieces designed for Knoll, a manufacturer of office furnishings, use the Helvetica Neue family in a range of weights and sizes. In 1994, the company published *Knoll Celebrates 75 Years of Bauhaus Design* (Fig. 12). Printed on recycled paper, this Constructivist-inspired book pays homage to the Bauhaus. Most of the cover type is set in Helvetica Neue 75 and Helvetica ultra compressed. Printed in five different languages within the book, the main body text is also set in Helvetica Neue 75. In the book, architect Peter Blake discusses the company's Bauhaus heritage. Blake writes, "For more than 50 years, Knoll has adhered to one of the main tenets of Bauhaus philosophy: that it is possible to produce objects that embody design excellence and technological innovation while being affordable."[1]

Helvetica Neue	27	ultra light condensed
Helvetica Neue	27	ultra light condensed oblique
Helvetica Neue	37	thin condensed
Helvetica Neue	37	thin condensed oblique
Helvetica Neue	57	regular condensed
Helvetica Neue	57	regular condensed oblique
Helvetica Neue	77	bold condensed
Helvetica Neue	77	bold condensed oblique
Helvetica Neue	97	black condensed
Helvetica Neue	97	black condensed oblique
Helvetica Neue	107	extra black condensed
Helvetica Neue	107	extra black condensed oblique

Helvetica Neue	23	light extended
Helvetica Neue	23	light extended oblique
Helvetica Neue	63	medium extended
Helvetica Neue	63	medium extended oblique
Helvetica Neue	83	heavy extended
Helvetica Neue	83	heavy extended oblique

11

12

Cover of *75 Years of Bauhaus Design: 1919–1994* uses Helvetica Neue 75 and Helvetica Ultra Compressed, 1994. Design firm/client: The Knoll Group.

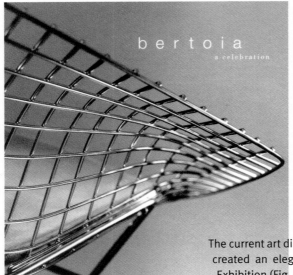

13

Announcement for the
Knoll Harry Bertoia
Exhibition, 1999. Art
director: Heesun Lisa
Choi; photographer:
James Wojcik.

The current art director of the Knoll In-house Graphics, Heesun Lisa Choi, created an elegant announcement for the Knoll 1999 Harry Bertoia Exhibition (Fig. 13), a show intended to recreate the Knoll exhibition of December 1952. The cover of the announcement uses a cropped image of Bertoia's wire chair, accompanied by his name set in Helvetica Neue 45 with a subtitle in Bodoni. This combination of Helvetica Neue and Bodoni for display is repeated inside the announcement, while the body text is set exclusively in Helvetica Neue. For the announcement card of Knoll's Frequent Seller Club in Spain (Fig. 14), Choi uses attractive colors and a simple layout that complements the style of the illustrations. This playful piece uses variations of Helvetica Neue to enrich the minimal composition.

There are a number of Helvetica-inspired fonts used throughout the world; Meta is one attempt to move beyond Helvetica. In 1984, the German State Post Office, the Bundespost, was persuaded by Erik Spiekermann of MetaDesign to commission a new, exclusive font for use on all of the Bundespost's printed material. The aim of the project, which began in 1985, was to develop a face that was easy to read in small sizes, available in several weights, unmistakable as an identity, and technologically up-to-date. Although the font was digitized, tested, and approved in the summer of 1985, the project was canceled. The Bundespost returned to using one of its many previous typefaces, Helvetica, assuming that digital type would not catch on.

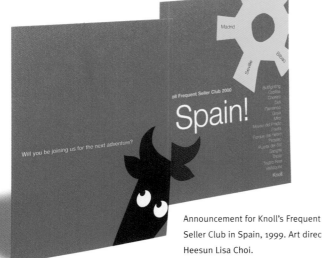

Announcement for Knoll's Frequent
Seller Club in Spain, 1999. Art director:
Heesun Lisa Choi.

14

abcdefghijklmnopqrstuvwxyz
ABCDEFGHIJKLMNOPQRSTUVWXYZ
1234567890&!?().,;"$%

The differences between Helvetica and Meta are visible when the faces are overlaid. Both are shown here in regular to demonstrate that Meta is more condensed and has a smaller x-height.

Corporate identity brochure for MetaDesign using the Meta family. Art director: Terry Irwin; designer: Rachel Wear.

15

18-POINT FF META

ABCDEFGHIJKLMNOP
QRSTUVWXYZ

abcdefghijklmnopqr
stuvwxyz

In 1989, after design software made creating new fonts more efficient, MetaDesign refined the Bundespost typeface for its own exclusive use, renaming it Meta (Fig. 16). Initially, Meta was just used for in-house projects, but soon MetaDesign began to use it in mail-order catalogs for FontShop, a digital type foundry, cofounded by Erik Spiekermann. FontShop encouraged the parent company to license the face. Released as FF Meta, it has become one of the most successful typefaces available from FontFont, a subsidiary of FontShop.

MetaDesign's corporate identity system includes several informational brochures that use the Meta face (Fig. 15). The name of the company, reversed out of a brilliant red cover, sits in the foreground, while other images and typographic elements animate the background. The body text is set in the different weights, sizes, and colors of the Meta family. In this design, MetaDesign strategically combines a passion for typography with a problem-solving visual approach.

As for the construction of its letterforms, Meta has capitals with flat apices, similar to those of Helvetica. It has a wider opening in the **C**, which also has angled finials. Angled finials also occur in the top strokes of the **E**, **F**, **G**, and on both ends of the **S** (Fig. 17). The **E** has an extended base, while the base of the **G** has no spur and the **J**, no loop. The **K** has one

junction, and the junction of the **M** rests on the baseline, like in Helvetica, except that the Meta stems are oblique. The tail of the **Q** is wavy and the leg of the **R** is slightly curved. The junction and the base of the **W** are both flat. The **Z** has angled finials on both ends, unlike the lowercase **z**, which has an upright finial at the top and an angled one at the bottom. Several of the Meta lowercase have particular traits that distinguish the face from other sans serifs. The ascenders of the **b**, **k**, **h**, and **l** are slightly bent at the top (Fig. 19), a feature that is carried through the stems of the **m**, **n**, **p**, **q**, and the spur of the **u**. The finials of the **v**, **w**, and **y** are slightly angled, unlike the Meta family capital letters. Other distinguishing features include the double-storied **g** that has a highly unusual open bowl. This is a

18
Corporate identity books and CD-ROM for MetaDesign using Meta. Art directors: Terry Irwin, Rick Lowe; designers: Rachel Wear, Rick Lowe, Nikita Tselovalnikov.

19

20
Cover of course catalog for Massachusetts College of Art and Design combining Baskerville and Meta. Design firm: Stoltze Design, Boston; art director: Clifford Stoltze; designers: Kyong Chou, Rebecca Fagan, Peter Farrell, Clifford Stoltze.

feature shared by the transitional typefaces Baskerville and Cheltenham (Fig. 22); only a few other sans-serif typefaces, such as Kabel, have this feature. The **l** has a slight curved tail and the **y** has an offset junction (Fig. 21). Overall, Meta is a more condensed face than Helvetica, and it has only a slightly lower x-height. Both Meta and Helvetica have thin shoulders. While the dots of Meta letterforms and punctuation are round, Helvetica has square dots. The nuanced construction of the Meta typeface sets it apart from Helvetica's regularized structure, creating the face's appealing personality. (Even the designers of this book responded to Meta's unique combination of ease and eccentricity, by using it as the running text for the entire publication.)

The history of these sans-serif typefaces began over a century ago. Akzidenz Grotesk was designed in 1889, Helvetica in 1957, Helvetica Neue in 1983, and Meta in 1989. A progression of influences has shaped these innovative alphabets, each one an attempt to reexamine its predecessor. Each has its own unique personality, an integral factor in perpetuating the popularity of this group into the 21st century.

META

BASKERVILLE

KABEL

CHELTENHAM

NOTES

1 Peter Blake, "Foreword," *75 Years of Bauhaus Design 1919-1994*, (New York: The Knoll Group, 1994)2.

28-POINT META REGULAR

abcdefghijklmnopqrstvwxyz
ABCDEFGHIJKLMNOPQRSTUVWXYZ
1234567890&!?().,.;"" $ %

28-POINT HELVETICA NEUE 55

abcdefghijklmnopqrstvwxyz
ABCDEFGHIJKLMNOPQRSTUVWXYZ
1234567890&!?().,.;"" $ %

"The type of today and tomorrow will hardly be a faithful recutting of a classical roman of the Renaissance, nor the original cutting of a classical face of Bodoni's time—but neither will it be a sans serif of the 19th century." [1]

Hermann Zapf

1

Humanist letterforms are reminiscent of handwriting in their inclined stroke axes, which lean to the left. The line indicates the stroke axis common to the letterforms of Optima, Gill Sans, and Rotis.

OPTIMA, GILL SANS, ROTIS

The story of humanist sans serifs is the story of a bridge. At the time of their emergence, the humanist sans serifs spanned the chasm between two very different typographic genres: serif and sans-serif typefaces. Sans-serif faces often endured the scorn of critics who regarded them merely as roman letters with their serifs—and consequently their beauty—extracted. Others disagreed, however, and embraced the idea of a typographic form stripped of ornament and decoration. By 1930, the geometric sans serifs had arrived, with Paul Renner's Futura as their acclaimed leader. Proponents praised Futura and faces like it for the adjusted widths and proportions, monotone characters, and interchangeability of typographic parts. Wary skeptics, on the other hand, bemoaned the apparent illegibility caused by the similarity of letterforms. The stage was set for a typographic compromise between traditional roman typefaces and the new geometrics. The humanist sans serifs were designed for this purpose; they spanned the gap between serifs and sans serifs while drawing on the best features of each.

While the designers of humanist typefaces looked to the sans serif for inspiration, they created more personal, human-oriented faces that, although inspired by geometrics such as Futura, avoided the mechanical rigidity of those faces. Specifically, humanist faces are characterized by an inclined stroke axis, reminiscent of handwriting, and a modulated stroke width (Fig. 1). The humanist types incorporate aspects similar to 15th-century handwritten script and its old-style roman type progeny, and most include chancery-derived italics. The stroke suggests the gesture of a broad-nibbed pen as it forms a letter. The typographic structure, however, of the early humanist sans serifs were initially modeled after geometric sans serifs rather than roman faces (Fig. 2). As a result, their structure permits variation of both width and weight, while their graceful strokes afford increased legibility. For this reason, many believe humanist sans serifs to be better suited than geometric sans serifs for lengthy text.

A wide range of digital humanist sans serifs have been released in recent years, including ITC Stone Sans, Adobe's Myriad, and Syntax (Fig. 3). Other digital releases include ITC's Legacy Sans; Monotype's Ocean Sans; Adobe's Lucida Sans and the multiple master Cronos; FontFont's Scala Sans and the curiously named The Sans.

These digital fonts continue a rich legacy of 20th-century humanist sans-serif fonts. Early in the century, Edward Johnston designed a sans-serif alphabet for the London Underground Railway in 1918 (Fig. 4). Johnston was a calligrapher, yet he drew his block-letter alphabet by geometric means. This alphabet, though san serif, differed in structure from the grotesques of the preceding century. The marriage of inscriptional and calligraphic influences with geometric construction resulted in an important shift in the interpretation of sans-serif letterforms. Johnston's alphabet ultimately inspired designers of both geometric and humanist sans serifs alike.

The most direct descendant of Johnston's alphabet, Eric Gill's Gill Sans (Fig. 5, p. 148), was also designed for railway use. Eric Gill, a typographer and signmaker, drew his sans-serif alphabet for the London & Northeastern Railway. A former student of Johnston, Gill drew direct inspiration from their pedagogical and working relationship. Regarding the alliance, the type scholar Beatrice Warde wrote, "There is no reason to assume that Eric Gill played a creative part in the design of the famous 'London Underground' letter. But there is every reason to note that he was drawn-in upon what must have been memorable conversations."[2]

2 aaeeiioouu Gill Sans and Optima, both humanist sans serifs, share structural qualities with the geometric sans Futura.

4 JOHNSTON'S SANS LETTERS LT

3

36-POINT ITC STONE SANS

Handgloves *Handgloves*

36-POINT ADOBE MYRIAD

Handgloves *Handgloves*

36-POINT LINOTYPE SYNTAX

Handgloves *Handgloves*

gliex

123456789 abcdefghijklmnopqrstuvwxyz

5

Gill Sans Serif as released in metal by the Monotype Corporation.

ABCDEFGHIJKL MNOPQRSTUV WXYZabcdefgh ijklmnopqrstuv wxyz

24-POINT MONOTYPE GILL SANS

6

This logotype for Gliex LLC, an organization specializing in brain tumor research, uses a digitally manipulated version of Monotype's digital Gill Sans. Designer: Jamie Barnett, Richmond, Virginia.

Though similar to Johnston's sans serif, Gill Sans is more refined and distinctive (Fig. 7). Eric Gill replaced Johnston's diamonds over the **i** and **j** with round dots. He also simplified the lowercase **l** in comparison to the hooked **l** in Johnston's alphabet. Notable differences in the uppercase include the open counters in Gill's **S** and the humanist stroke and joinery on the tail of the **Q**. Gill Sans has points at the base of the **V** and the **W** in contrast to the flat bases of

Johnston's letters. Monotype manufactured Gill Sans in 1927; ultimately it consisted of 24 related series, available only in one size, with minimal variations. Johnston's alphabet was used extensively by London Transport for nearly 50 years. After a decade of disuse, it was revived by Colin Banks and John Miles in the 1980s. The Banks & Miles digital version named New Johnston is not widely available as of yet, compared to Gill's popular face.

7

A comparison of Edward Johnston's alphabet with Monotype's metal Gill Sans and digital Gill Sans

Large apertures, attention to ligatures (Fig. 9), and a true sans-serif italic (Fig. 8) characterized the original drawings of Gill Sans. While Gill was the progenitor of the face, its final appearance was significantly altered by Monotype technicians, who incorporated their own enhancements. In the 1950s, Monotype released a Greek companion set to Gill Sans. This version was not designed by Eric Gill, but rather was based solely on the work of Monotype's draftsmen.3

The digital version of Gill Sans is available from Monotype, Adobe, Agfa, FamousFonts, and Linotype; it is used widely in contemporary graphic design (Figs. 6, 11). Just as Monotype's release of Gill Sans differed from Eric Gill's drawings, digital versions of the typeface differ from the original font. A study of Monotype's 60-point Gill Sans and the digital version under the same name reveals alterations in many upper- and lowercase characters. The changes result in an overall modified appearance. In the digital lowercase, the x-height remains the same but ascenders and descenders are both

8 abefGjJMpqQrst

Gill Sans has a true italic companion set. In contrast to obliques—essentially, slanted versions of roman letters—italic fonts consist of unique characters.

24-POINT MONOTYPE GILL SANS ITALIC

9 The **fi** ligature in Gill Sans and Gill Sans Italic.

shortened. The digital **a** has a hooked finial in contrast to the angled terminal of its ancestor. The **e** is significantly altered by a lowered bar, larger counter, and wider bowl. The bowls of the digital **p** and **q** meet precisely at the top of their stems; this affects not only the junction but also the shape and size of both bowl and counter. The original qualities of the uppercase (such as the midpoint apex of the **M**) are more faithfully reproduced than those of the lowercase. The most radical departure in the uppercase is found in the **J**, where the hook descends below the baseline. Conceivably, Gill Sans as we know it might be quite different had Eric Gill lived to see the digital age.

Several of Eric Gill's contemporaries enjoyed varying degrees of success with drawings of humanist sans-serif typefaces. Remembered primarily for other typographic contributions, designers R. Hunter Middleton and Warren Chappell are among a handful of established designers who drew humanist faces in the late 1920s and '30s (Fig. 10). One respected typographer, William Addison Dwiggins, tirelessly petitioned Mergenthaler to manufacture his design for a humanist sans serif. Mergenthaler had previously commissioned Dwiggins for the design of Metro, the manufacturer's version of Futura, released in 1929. After its completion, Dwiggins persisted with correspondence regarding his humanist sans, commenting to C. H. Griffith of Mergenthaler, "If it is possible to make a sans serif body-letter that the American public can read without noticing the fact that it is reading, we are the ones who can do it. Yes?"4 Finally, Dwiggins' proposal was rejected. Mergenthaler would ultimately accomplish this goal, not by publishing the work of the eager Dwiggins, but rather in the American release of Hermann Zapf's Optima.

ABCDEFGHIJKLMNOPQRSTUVWXYZ

10

Lydian, designed in 1938 by Warren Chappell, and Stellar, designed in 1929 by R. Hunter Middleton.

abcdefghijklmnopqrstuvwxyz

abcdefghijklmnopqrstuvwxyz

LYDIAN

STELLAR

11

Annual report for Nine West using Gill Sans, 1995. Design firm: Pentagram, New York City; art director: John Klotnia; designers: Ivette Montes de Oca, Seung-il Choi; creative director: Woody Pirtle.

12
Page from *About Alphabets* by Hermann Zapf, 1970.

36 p Optima Nr. 5699
ABCDEFGHIJKLMNOPQRS
TUVWXYZ
ÆŒÇÄÖÜÅØ & MN
abcdefghijklmnopqr
stuvwxyz chckfffififlftß
|abcdefghijklmnopqr|
|a| |stuvwxyz| æœçäöü
åøáâàéêèëíîìíìjóôòúûù
.,:;!?„"-'—»«//*†[(§)]
$1234567890 £
The Museum of Modern Art
D. Stempel AG 8.11.1958

13
Stempel proof sheet showing corrections for 36-point Optima Roman, 1958.

Optima is an elegant typeface with variable stroke weights and graceful tapers (Fig. 12). Zapf originally planned to name the face Neu Antiqua (New Roman), reflecting the roman sensibility of the letterforms. In an attempt to maximize the fluidity and legibility of the face without compromising its sans-serif structure, Zapf substituted subtle flares for traditional roman serifs. Optima's capitals were influenced by ancient and Renaissance inscriptions, and the lowercase letterforms were based on the Golden Section. The lowercase proportional adjustments contrasted with the German Standard Line, a system used in the design of German typefaces produced in metal. Zapf contended that the German Standard Line rendered overly shortened descenders and extended ascenders due to a lowered baseline.[5] Proportional fidelity was an important part of Zapf's goal for Optima, as was his interest in designing a face that would accommodate both text and display. He ultimately spent six years perfecting the details that made the face suitable for continuous reading. Finally in 1958, Stempel and Linotype released Optima Roman (Fig. 13), Italic, and Bold. Several years later in 1967, Stempel manufactured Zapf's drawings of Optima Medium and Black. As another companion to the set, Zapf drew a full Greek variety that was released by Linotype in the early 1970s (Fig. 16).

Optima's release in metal occurred just before the dawn of the phototype era. Flipping through a phototype specimen book from the early 1980s unearths, quite literally, the "darker days" of Optima. Many phototype versions are significantly heavier than the metal-type originals; in fact, a dubious inclusion, Optima Ultra Thin, is closer in color to Zapf's original Optima Roman than any of the other varieties. To go from dark to darker, the phototype era also spawned Optima Condensed, Semibold, Ultra Bold, and one curious face titled Neon Optima Black (Fig. 14).[6]

Contemporary digital versions of Optima, available through Adobe, Bitstream, and Linotype, are decidedly closer to the original cut than were their phototype relatives. Like the technology that spawned the phototype era, new digital techniques have allowed an expansion of the number of weights available. In addition to roman, bold, medium, and black, Adobe offers Optima variants in demi, demibold, and extrablack weights with corresponding obliques. When viewed in total, the digital Linotype Optima appears darker in color than Zapf's Optima Roman, though to a much lesser degree than the phototype variants. In Linotype's digital version, the thick and thin stroke contrast remains relatively faithful to the original, but stem tapers and flares are greatly diminished. This straightening

abcdefghijkl mnopqrstuvwxyz

Neon Opt**** a Black

A.... .JHIJKLMNOPQRSTUVWX 1234567890 (&.,:!?"-$¢%) fffifl YZ

OPTIMA ROMAN (STEMPEL), LINOTYPE OPTIMA

15 optima 1HQ

αββγδεζηθικλμνξοπρςοτυφφχψω & 12345¢789).
ΑΒΓΔΕΖΗΘΙΚΛΜΝΞΟΠΡΣΤΥΦΧΨΩ

16

of the stems has been criticized by some as altering the personality of the font. Though the digital typeface is modestly extended—as seen in the uppercase **H**—the integrity of individual characters has been well maintained (Fig. 17). The only noticeable, albeit quite minor, exceptions occur in the **1**, which has a shorter beak, and uppercase **Q**, where the tail is angled differently. Linotype Optima is an accurate rendition of its metal predecessor with one exception: the reduction of the tapers and flares detracts from the subtle grace and elegance of the original.

Zapf's career as a type designer has spanned the range of technologies from handset metal to digital type. Involved in digital typography from its earliest stages, Zapf has encouraged designers to be mindful of the parameters of bitmapped type and the effects of output resolution. Recalling the early era of digital typography, Zapf experienced frustrations with staircased, bitmapped representations of curved and diagonal lines. He recalls, "The special problem of all the Optima designs was the slight curved outline of the stems."[7] Today, Zapf praises the quality of high-resolution digital output and reminds typographers how far the medium has advanced. Zapf also lauds the ability to correct lowercase proportions in digital typefaces that are no longer governed by the German Standard Line. Zapf cautions, however, that digital typography's assets may also be its liabilities. He says, "The digitization of Optima permits better letter combinations (such as **Ta**, **Va**, **Wa**, and **Ya**) since spacing is much more controlled than in the original metal version. However, the technol-

ogy also permits reduced fitting—the distances between characters—to the extent that the letters may touch. This 'kissing' effect decreases the legibility of an alphabet and ignores the fact that the main purpose of a typeface is to be easily read without any delay."[8]

Frequently appearing on designers' short-lists of favorite typefaces, Optima is readily found in book text, logotypes, poster text, online digital display, and in many other media.

Typographische Variationen

Typographic Variations designed by Hermann Zapf

78 Buchtitel und Textseiten als

on themes in contemporary book design and typography

Gestaltungsmöglichkeiten der

in 78 book- and title-pages, with prefaces by

Typographie und Buchgraphik

G.K. Schauer, Paul Standard and Charles Peignot

entworfen von Hermann Zapf

17

Both the title page and the dust cover of *Typographic Variations* share this design by Hermann Zapf, 1963. Publisher: Museum Books, New York.

The range of humanist sans serifs borrowing from the tradition of Optima and Gill is far reaching. Poppl-Laudatio (Fig. 21), designed by Friedrich Poppl and issued by Berthold in 1982, boasts a strong calligraphic appeal and significantly flared stem ends. The lowercase b and h illustrate how the ends of the ascenders swell substantially to the left. International Typeface Corporation (ITC) released humanist typefaces such as ITC Mixage in 1985 and Eras in 1986 (Fig. 20). More recently, ITC's online edition of the magazine U&lc featured a new humanist sans serif, Latina. This face earned an honorable mention for its designer, Inigo Jerez, in the 1998 U&lc typeface design competition. Jerez's type family, which contains both serif and sans-serif versions, is a blend of his personal vision with the tradition of classical humanist forms.

With an increasing number of designers working with humanist typeface families, typographic classification is a continuing struggle. Humanist sans serifs originated as hybrids, and their emergence generated a new typographic category. The boundaries of this category, however, are not hard-and-fast, as these faces blur one of the most fundamental and accessible polarities in typography: the difference between serif and sans-serif faces. When tapered strokes swell at the terminals, where does the line of demarcation occur between serif and sans? Opinions differ. Goudy Sans, for example, a contemporary of Gill Sans, is often categorized as a humanist sans serif, though its swells are arguably too articulated for it to be championed as a pioneer of this group.

HISZPAŃSKIE MALARSTWO INFORMEL

Manolo

MILLARES

Antonio

SAURA

Antoni

TÀPIES

3 październik –2 grudzień 1990

Muzeum Sztuki, Łódź

PENN

19

Poster for an exhibition using Optima, 1990. Designer, Tadeusz Piechura; client, Museum of Art, Lodz, Poland.

Cozy lummox gives smart squid who asks for job pen.

20

18-POINT ITC ERAS

In the case of Rotis (Fig. 18), a typeface released in 1989, the German designer Otl Aicher specifically explored a dimension beyond which he perceived as "two separate [serif and sans-serif] graphic cultures."[9] Concerned primarily with legibility, he sought to define new territory in which the unadorned quality of a sans serif met the legibility of a serif. The result of this effort is a type family consisting of four subfamilies, which builds a bridge between serifs and sans serifs.

abcefghijop 123 AO
abcefghijop

21

POPPL-LAUDATIO

All of the four Rotis variants are uniform in width and basic structure. Their characters, which are best set with slightly looser letterspacing, appear more condensed relative to Gill or Optima. Rotis Sans Serif (Grotesk) has a fairly uniform stroke. The more expressive Rotis Semi Sans (Semigrotesk) shows greater modulation in stroke width. Several characters in this font are distinctive: the **b** has no spur; both **m** and **n** have rightward oblique stresses; and, similar to the **a**, the terminal of the **c** ends in a marked thickening. Rotis Semi Serif (Semiantiqua) is based on Carolingian minuscules that had pronounced upstrokes but no base serifs. Incomplete serif treatment is most notable in the Semiantiqua **I**, **L**, **A**, and **x**. Rotis Serif (Antiqua) is the fourth member of this type family. There is slight accentuation at the base of strokes above gently bracketed serifs.

14-POINT ROTIS SANS SERIF 55

abcdefghijklmnopqrstvw xyz ABCFGHIJKLMNOPQRSTU VWXYZ 1234567890

14-POINT ROTIS SEMI SANS SERIF 55

abcdefghijklmnopqrstuvw xyz ABCDEFGHIJKLMNOP QRSTUVWXYZ 1234567890

14-POINT ROTIS SEMI SERIF 55

abcdefghijklmnopqrstuvw xyz ABCDEFGHIJKLMNOP QRSTUVWXYZ 1234567890

14-POINT ROTIS SERIF 55

abcdefghijklmnopqrstuvw xyz ABCDEFGHIJKLMNOP QRSTUVWXYZ 1234567890

As suggested by the late-20th-century emergence of faces like Latina and Rotis, the story of humanist sans serifs is still evolving. The contemporary visual environment is quite different from that of Eric Gill's time, when the battle was simply between serif and sans. The model established by these humanist pioneers has inspired a growing number of type designers to generate personal interpretations of humanist sans serifs and to experiment in their own idioms within this grand tradition.

abcdefghijklmnopqrstuvwxyz
ABCDEFGHIJKLMNOPQRSTUVWXYZ
1234567890&!?:;"

24-POINT LINOTYPE OPTIMA

NOTES

1 Alexander Lawson, *The Anatomy of a Typeface* (Boston: David R. Godine, Publisher, Inc, 1990), 327.
2 Ruari McLean, *The Thames and Hudson Manual of Typography* (London: Thames and Hudson Ltd, 1980) 65.
3 Robert Bringhurst, *The Elements of Typographic Style* (Vancouver: Hartley & Marks, Publishers, 1992), 204.
4 Lawson, op. cit., 330.
5 Hermann Zapf, letter to the author, 1999.
6 *Cardinal Photo Display Type Catalogue* (New York: Van Nostrand Reinhold Company, Inc., 1983), B-94 through B-97 and B-129.
7 Hermann Zapf, letter to the author, 1999.
8 Ibid.
9 Otl Aicher and Josef Rommen, *Typographie* (Ludenscheid: Druckhaus Maack, 1988), 170.

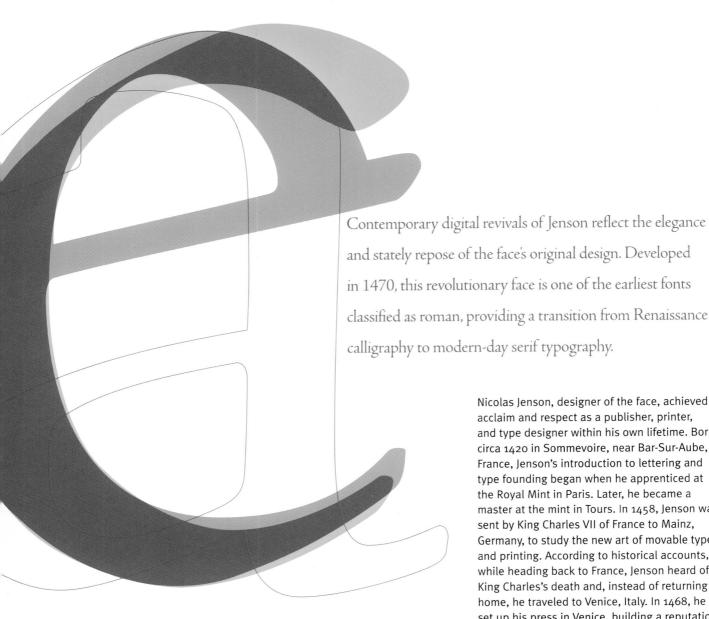

Contemporary digital revivals of Jenson reflect the elegance and stately repose of the face's original design. Developed in 1470, this revolutionary face is one of the earliest fonts classified as roman, providing a transition from Renaissance calligraphy to modern-day serif typography.

Nicolas Jenson, designer of the face, achieved acclaim and respect as a publisher, printer, and type designer within his own lifetime. Born circa 1420 in Sommevoire, near Bar-Sur-Aube, France, Jenson's introduction to lettering and type founding began when he apprenticed at the Royal Mint in Paris. Later, he became a master at the mint in Tours. In 1458, Jenson was sent by King Charles VII of France to Mainz, Germany, to study the new art of movable type and printing. According to historical accounts, while heading back to France, Jenson heard of King Charles's death and, instead of returning home, he traveled to Venice, Italy. In 1468, he set up his press in Venice, building a reputation for accuracy of transcription and fine printing. Historian Martin Lowry describes Jenson as a "businessman and technocrat. He received most of his education in the workshop rather than studying classical literature."[1]

Venice's first printer was Johann von Speyer, a German who called himself Johannes de Spira. His type (Fig. 1) is one of the earliest classified as humanist because it has characteristics similar to calligraphic writing. Exclusive rights were granted to de Spira to print with roman type in

1
Detail from Johannes de Spira's edition
of *Historae Romanae*, 1470.

uideo quomodo aer folis & lunæ mĩ appellari
gis a luminaribus fiat & tranſmutetur q̄ ab ipſ
uero pgreſſus telluris uirtutem ueſtam appella
lacrum in foco ignis ſtatuitur:quæ uirtus quoȝ
eam ſpecie denotarū.Rhea uero quā opē latiꝛ
atꝗ mōtanæ terræ uirtuté deſignat.Ceres ferac
a Rhea quoniam bonam ioui peperit deam: aȝ
coronatur & papauera quæ fertilitatis ſymbolu
ponuntur.hic diligenter aĩaduerte quomodo ȝ
matrem quæ Rhea dicitur ad terram & lapides
cereri ait quibus adiecit.Quoniam aūt quædaꝛ
feminis in terram eſt:quam ſol ĩ hyemali ſolſ
dea quam & perſephonem uocant uirtus femĩ
qui tempore hyemis remoti opē mūdi parté pĩ
ab eo proſerpinā dicunt:quā ceres ſub terra laȶ
autem omniū uirtus Dionyſus nuncupatur:&
germina quædam quaſi ſui ſymbola protédit.
hab& et muliebriformis eſt ꝑmiſcuā uirtutem
ſignificans. Plutonis autem raptoris galea cap

2

Detail of Nicolas Jenson's
edition of *De Evangelica
Præparatione* by Eusebius,
1470.

set in typefaces by others, but Morris was eager
to produce his own type. He wrote, "I began by
getting myself a fount of Roman type. And here
what I wanted was letter pure in form; severe,
without needless excrescences; solid, without
the thickening and thinning of the line, which is
the essential fault of the ordinary modern type,
and which makes it difficult to read; and not
compressed laterally, as all later type has grown
to be, owning to commercial exigencies. There
was only one source from which to take exam-
ples of this perfected Roman type, to wit, the
works of the great Venetian printers of the 15th
century, of whom Nicolas Jenson produced the
completest and most Roman characters."[3]

Venice. After de Spira died in 1470, Jenson was
free to use de Spira's roman types and began to
produce his own groundbreaking type designs
later that same year.

Among Jenson's most highly regarded works is
the *De Evangelica Præparatione* by Eusebius
(Fig. 2). One of the finest examples of the pris-
tine proportion, clarity, and lightness inherent
in the Jenson face, the manuscript has contin-
ued to influence designers up to the present
day. William Morris, for example, referred to it
in creating his typeface Golden in 1892. Robert
Slimbach, type designer at Adobe Systems,
recreated a digital, multiple-mastered version
of Jenson in 1990 based on the Eusebius type.

Morris, a leading figure in the British Arts and
Crafts Movement, was a man of many talents.
In addition to writing, painting, weaving, and
furniture making, he also created beautiful
limited-edition letterpress books under the
imprimatur of the Kelmscott Press. Wrote
Morris, "I began printing books with the hope
of producing some which would have a definite
claim to beauty, while at the same time they
should be easy to read."[2] His first books were

In 1892, Morris used his new face, Golden, in
printing *The Golden Legend* (Fig. 3). The most
noticeable difference between Jenson and
Golden is the latter's lack of contrast in stroke
weights, which creates a rich, dense page. Type
designer and historian Stanley Morison explains
Morris's interest in this effect: "The rounder,
slighter, roman letter prescribes not a black but

Of the Lif
of Saynt
Siluester

OW it happed that the next nyght after saynt peter
and saynt poul appiered to thys emperour Constantyn,
sayeng to hym, By cause that thou hast had orrour to
shede and spylle the blood of innocentis, our Lord
Jhesu cryst hath had pyte on the, and comandeth the
to sende vnto suche a montayne where siluestre is hyd
with his clerkes, and saye to hym that thou comest for to be baptysed
of hym, and thou shalt be heled of thy maladye. ⁋ And whan he was
awaked he dyde do calle hys knyghtes, and comanded them to goo
to that montaygne & brynge the pope siluestre to hym courtoisly and
fayr, for to speke with hym. Whan saynt siluestre sawe fro ferre the
knyghtes come to hym, he supposed that they sought hym for to be
martyred, & began to saye to his clerkes that they shold be ferme and
stable in the faith for to suffre martirdom. Whan the knyghtes cam to
hym, they said to hym moche courtoysly, that Constantyn sente for
hym & prayd hym that he wold come and speke with hym, and forth-
with he cam, & whan they had entresalewed eche other, Constantyn
tolde to hym hys vision. And whan Siluestre demaunded of hym what
men they were that so appiered to hym, themperour wyst not ne coude
not name them. Seynt siluestre opened a book wherin the ymages of
saynt Peter and saynt Poul were pourtrayed, and demaunded of hym
yf they were lyke vnto them. Thenne constantyn anon knewe them,
and said that he had seen them in hys sleep. Thenne saynt Siluestre
prechid to hym the faith of Jhesu cryst, and baptised hym, and whan
he was baptised a grete lyght descended vpon hym so that he said that
he had seen Jhesu cryst, and was heled forthwith of hys meselerye.
⁋ And thenne he ordeyned vii lawes vnto holy chyrche, the first was
that all the cyte shold worshyppe Jhesu cryst as veray god, the seconde
thyng was that who someuer shold saye ony vylonny of Jhesu cryst
he shold be punysshyd, the thyrde who someuer shold doo vylonye
to Crysten men he shold lose half hys goodes. The fourthe that the
bysshop of Rome shold be chyef of all holy chyrche, lyke as thempe-
rour is chyef of alle the world. The fyfthe that who that had doon or

3

Detail from William Morris's
edition of *The Golden Legend*,
1892. Printing: Kelmscott Press.

By Sheilah M. Barrett

a gray page. Morris believed in colour. The generally slender roman can bear a thinner paper, and therefore slighter binding."[4] According to Lowry, while specific differences exist between the Golden and Jenson faces, they also reflect traits shared by their creators: "[Both men] embodied the same combination of enlightened patronage, literary commitment, artistic genius and technical skill. Above all, [they] had the same sense of mission, of partaking in giant upheavals of consciousness that would change the course of history."[5] Early releases of Golden were immediately successful in England, Germany, and the U.S. Shortly thereafter, American Type Founders (ATF) created several variations of Jenson type that were heavily influenced by Morris's work (Fig. 4).

A digital version of Golden was released by the German type company URW in November 1989 and was later licensed by ITC (Fig. 5). The URW design team describes its goals for the project: "[We] desired to create something dissociated from the technical perfection of digital type, to work closely together as a team on a private project, and to experiment with our theories concerning legibility and readability. The initial results pleased us immensely, and this combined with our increasing knowledge of Morris and his theories motivated us further to recreate a Golden type accurate in every detail and eccentricity."[6]

4

Eccentric versions of William Morris's Golden typeface include Jenson Oldstyle No. 2, Jenson Condensed, and Jenson Condensed Bold. These variations from American Type Founders's *Specimen Book and Catalogue 1923* were used as advertising display faces during the early 20th century.

YOU SET the tone of a magazine by the cover – that's very important. When ROLLING STONE started, there were no other rock magazines which had a proper cover. There were fanzine covers with millions of little cutout heads – with no proper iconic views. ROLLING STONE was the first one to do that: Having one big subject on the cover was new

5
Specimen of ITC Golden Black from the book jacket flap copy of *Rolling Stone: The Complete Covers*, 1998. Art director/designer: Fred Woodward.

When creating the digital version of Adobe Jenson in 1990, Robert Slimbach researched and analyzed letterforms from *De Evangelica Præparatione* by Eusebius at the Bancroft Library in Berkeley, California. Studying photographic enlargements of several pages from the book, he was able to scrutinize the typeface, giving considerable attention to the hidden details that convey its warm and earthy character. Slimbach cataloged and cross-referenced examples of characters from Jenson's printed work to distinguish between irregularities and the original type. The letterforms were then carefully retouched and further enlarged so the preliminary font could be drawn and digitized (Figs. 6–8). Says Slimbach, "Although it may sound appealing, a literal translation of Jenson's typeface is impractical, if not impossible. To make a useful digital type based on a model that is more than 500 years old required that I respect the original typeface while taking into consideration today's technology and typographic protocol."[7]

aaaabbbbbcccc
ddddeeefffgggg

abcdefg

ry prior to structural alterations, gave t
igating, in 1062, early material which h
reasons. The investigation showed the
number of very old type faces. The col

6 Cataloged and retouched Adobe Jenson letters.

7 A selection of Robert Slimbach's drawings for the Adobe Jenson digital font.

8 An early digital proof of Adobe Jenson, 1990.

MQZ
MQZ

removal of inside serif

altered serif

reduced letterform width

modified descender

Slimbach made adjustments in weight and contrast that adapt to contemporary printing methods. He felt that Jenson's original capital letters seen in context with the lowercase letters were obtrusive. Therefore, he slightly decreased the size of the capitals, creating greater uniformity. In addition to the variation in size, Slimbach analyzed the shape and width of each character. He modified the width of the **Z** and the excessively long tail of the **Q**. The top internal serifs on Jenson's **M** were eliminated because they tended to interrupt reading (Fig. 9). For purists, the original forms of these letters are available from Adobe and identified as the Alternate Roman set.

Slimbach's digital rendition of the Jenson lowercase contains several calligraphic moments. The rounded, roman lowercase letterforms such as the **e** and **a** have enlarged counters. When set in text columns, they contribute to the open and airy quality of the page. The angled crossbar of the **e** ends in a crisp, pen-formed terminal. The oblique apices in the lowercase **e**, **a**, and **r** imitate the calligraphic pen strokes mentioned above. The descender of the **j** is also unique because the loop is not rounded up, but instead has a downward taper.

The original Jenson font did not have an italic version. Slimbach used the chancery script Arrighi, developed by Ludvico degli Arrighi in 1522, as the model for Adobe Jenson Italic (Fig. 10). Again, Slimbach's analysis consisted of photographically enlarging manuscript copy. Since chancery italics are characteristically

compressed, Slimbach felt this feature would interfere with the open character of the roman. Thus, he widened the digital italic incrementally until he achieved a harmonious relationship between the two. The ascenders and descenders were also shortened, equalizing proportions in relation to the roman.

Multiple-master and expert versions of Adobe Jenson are also available. The multiple-masters include a primary set of the family and are scalable both for weight and optimal size. Adobe Jenson and Adobe Jenson Italic each include nine pre-built primary fonts.

The masterful type designs by one of the titans of the early days of printing live again, reinterpreted and extended into a comprehensive character set (Fig. 11) combining the grace of the originals with the refinement of digital technology.

10

Top to bottom:
A printed italic letter
designed by Arrighi,
a retouched letter,
an early digital letter,
and the finished 72-point
letter in regular, semi-bold,
and bold weights.

ITALIC

ABCDEFGHIJKLMNOPQRSTUVWXYZ
abcdefghijklmnopqrstuvwxyz&0123456789ÆŒØæœøfiflß
ÁÂÄÀÅÃÇÉÊËÈÍÎÏÌÑÓÔÖÒÕÚÛÜÙŸáâäàåãçéêëèíîïì
ñóôöòõúûüù´ˆ˜¯˘˙˚¸˝ˍ ©®™@ªº†‡§¶*!¡?¿.,:;""'''"„… ''‹›«»
()[]{}|/\-–—_·/.$¢£¥ƒ¤#%‰=−+~<>¬°^

SWASH ITALIC

ABCDEFGHIJKLMNOPQRSTUVWXYZ
abcdefghijklmnopqrstuvwxyz&0123456789ÆŒØæœøfiflß
ÁÂÄÀÅÃÇÉÊËÈÍÎÏÌÑÓÔÖÒÕÚÛÜÙŸáâäàåãçéêëèíîïì
ñóôöòõúûüù´ˆ˜¯˘˙˚¸˝ˍ ©®™@ªº†‡§¶*!¡?¿.,:;""'''"„… ''‹›«»
()[]{}|/\-–—_·/.$¢£¥ƒ¤#%‰=−+~<>¬°^

EXPERT

ABCDEFGHIJKLMNOPQRSTUVWXYZ&0123456789
ÆŒØÁÂÄÀÅÃÇÐÉÊÈÍÎÏÌĿŃÓÔÖÒÕŠÚÛÜÙÝŸŽ
 fffiflffiffl!¡?¿.,:;"'''"„… ,;:$¢1Rp₡ ⅛⅜⅝⅞¼¾⅓⅔½$¢(-.,1234567890)
$¢(-.,1234567890)/-—— ´ˆ˜¯˘˙˚˝" abdeilmnorst

EXPERT ITALIC

ABCDEFGHIJKLMNOPQRSTUVWXYZ&0123456789
ÆŒØÁÂÄÀÅÃÇÐÉÊËÍÎÏÌĿŃÓÔÖÒÕŠÚÛÜÙÝŸŽ
fffiflffiffl!¡?¿.,. .,;:$¢1Rp₡ ⅛⅜⅝⅞¼¾⅓⅔½ $¢(-.,1234567890)
$¢(-.,1234567890)/-—— ´ˆ˜¯˘˙˚˝" abdeilmnorst

ALTERNATE

ſſh ſi ſl ſſ ſſt ct st M M Q Q Z z

ALTERNATE ITALIC

ſſh ſi ſl ſſ ſſt ff sp st e...

11
Adobe Jenson basic
character sets.

NOTES

1 Martin Lowry, *Venetian Printing—Nicolas Jenson and the Rise of the Roman Letterform* (Denmark: Poul Kristensen, Printer to the Royal Danish Court, 1989), 18.

2 ITC Masterworks, "ITC Golden Type," 1989.

3 Stanley Morison, *Selected Essays on the History of Letter-Forms in Manuscript and Print* (Cambridge: Cambridge University Press, 1981), 23.

4 Ibid., 27.

5 Martin Lowry, op. cit., 38.

6 ITC Masterworks, "ITC Golden Type," 1989.

7 Adobe Systems, Inc. *Adobe Jenson* (Mountain View, California: Adobe Systems, Inc., 1996), 11.

8 Ibid., 14.

abcdefghijklmnopqrstuvwxyz
ABCDEFGHIJKLMNOPQRSTUVWXYZ
1234567890&!?:;"

During the Renaissance, a moment of innovation among sculptors created a unique lettering style of which Nicolete Gray wrote in *A History of Lettering*, "Clearly no canon of letterforms was established, and yet the style is unmistakable; it has a delicacy and clarity and that sense of the primitive and unexplored which comes so often with something new." Although this lettering style evinces a return to Roman inscriptional letterforms, it does not have serifs in the traditional sense; rather, subtle wedge-strokes taper from thick to thin, terminating with gently splayed diagonals. These numerous Renaissance sculptural inscriptions are often overlooked as merely supplementary to the sculpture itself. There can be little doubt, however, that the style of lettering from the Romanesque period played a significant role in influencing the emergence of these experimental unserifed letterforms. The face Optima, created in 1958 by Hermann Zapf, was clearly influenced by these inscriptions.

Inscriptions designed by four Renaissance sculptors—Bernardo Rossellini, Filippo Brunelleschi, Luca della Robbia, and Lorenzo Ghiberti—inspired the contemporary designers Paul Shaw and Garrett Boge to create digital fonts based on Renaissance letterforms, which were released by LetterPerfect in 1997 as the Florentine Set. While Optima is an example of a contemporary typeface inspired by the Renaissance inscriptions in S. Croce in Florence, digital typeface development had never focused specifically on these inscriptions until the release of the Florentine Set. "On my first trip to Italy in 1991, I had an opportunity to actually see the Florentine letters in person," recalls Shaw. "I made numerous rubbings, sketches and photographs of these letters not only throughout Florence but also in Siena, Pisa, and Rome. This material lay fallow until Garrett Boge and I joined forces to create a series of historically-based typefaces." Each of the four

Cantoria (choir balcony) by Luca della Robbia, 1431–1437. Museo dell'Opera di Duomo, Florence, Italy. Alinari/Art Resource, NY.

1

IS TO MAKE ABSOLETE THE SMART THINGS THEY DID LAST YEAR BY DOING SMARTER THINGS THIS YEAR. IT'S A HEAVY TASK, AND DESIGNERS ARE BUSY FOLKS, SAILING AWAY ON FLIGHTS OF FANCY, POOH-POOHING TABOOS, REVIVING OLD LUNACIES, RESTYLING THE CLASSICS, INVENTING NEW HERESIES, SCANDALIZING THE ELDERS.

OSWALD COOPER

DESIGN © 1999 HENRIK BIRKVIG, COPENHAGEN

fonts—Donatello, Donatello Alternativo, Beata, and Ghiberti—has large and small capitals and is intended for titling, although their elegance also provides an air of distinction to brief text settings.

The first of the set, Donatello, was modeled after lettering carved in the 1430s on the *cantoria* (choir balcony) by della Robbia in the Museo dell'Opera di Duomo in Florence (Fig. 1). It has classical proportions with a 10-to-1 height-to-width ratio, not unlike the Roman inscription on Trajan's Column (105 A.D.). The tapers are subtle, yet pronounced, and the letter strokes have a moderate weight, making Donatello the closest of the Florentine Set to Optima. Peculiarities of the face include a very slight descender on the **J**, curved strokes on the **K** and **R**, and a high apex on the **M**. An almost perfect circle is used to form rounded letters such as **C**, **G**, **O**, and **Q**, while other letters such as **B**, **E**, **F**, and **L** remain comparatively narrow (Fig. 2).

The alternate letters, Donatello Alternativo (Fig. 3), derived from Brunelleschi's inscriptions in the Duomo in Florence, are slightly more expressive. As a whole, the letters are wider than those of Donatello and in some cases, such as the **W**, they are even wider than their height. The apex of the **M** is higher than in the regular font. The strokes of the **K** and **R** are straight, while the **X** and **Y** have rather eccentric curved variations.

2

3

ASOLOSHOW

4

Inscription from the tomb of the Beata Villana by Bernardo Rossellini, 1451.

The most delicate and graceful font in the set is Beata. Based on a 1451 carved inscription by Rossellini at the tomb of the Beata Villana (Fig. 4), the letter strokes are very thin with a gentle, almost undetectable width variation in the tapers. More pronounced is the extreme difference among the letters, with a height-to-width ratio of almost 19-to-1. The **O** and **Q** follow a near perfect circle, while the **E**, **F**, **L**, **P**, and **S** are very thin. The rhythmic pattern created gives the font a lyrical quality. **B**, **P**, and **R** have small top bowls, with a large lower bowl on the **B** and a flared tail on the **R**. The diagonal crossbar of the **N** does not come into contact with either the top or bottom of the vertical strokes. Both the **6** and **9** have characteristically open bowls. Although light and airy, Beata is best set with open letter spacing, allowing each elegant letterform to subtly yet confidently express itself (Fig. 5).

The heaviest weight of the Florentine Set is Ghiberti, a bold font inspired by several inlaid marble and cast-bronze inscriptions. Ghiberti is named after the renowned Italian sculptor Lorenzo Ghiberti, who created the bronze doors known as the Gates of Paradise at the Baptistery in Florence. His inscribed signature is believed to be the earliest example of this lettering style. Ghiberti is a more robust font than Donatello or Beata, boasting a healthy stroke height of approximately six times its width. Tapering varies from pronounced wedgelike arms on the **E** and **F** to perfect sans-serif rectangles on the vertical strokes of the **H** and **I**. The **A**, **V**, and **W** are wide and equally as confident as the flamboyant, curved strokes of the **K** and **R**. The small capitals retain the same stroke weight but are about 10 percent of the height and width. Ghiberti exudes an air of sturdiness, making it ideal for use as a titling font (Fig.6).

HVORFRA KOM
DEN VIDUNDERLIGE,
HEMLIGHEDSFULDE KUNST
AT MALE SPROGET
OG TALE
TIL ØJNENE?
SOM LÆRER
OS AT FØLGE
MAGISKE
LINIER
OG
GIVE
TANKEN

FORM
OG
FARVE?

WILLIAM MASSEY

LETTERPERFECT BEATA

5

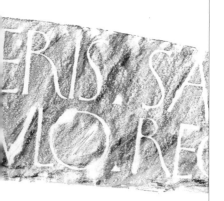

The fonts of the Florentine Set, all inspired by Renaissance inscriptions, retain the element of defiance and nonconformity on which they were originally based. Modern per its release date, the historical roots of the Florentine Set lend it sophistication, even wisdom. There can be little doubt that the designers, Shaw and Boge, immersed themselves in the lives and thoughts of the four Renaissance sculptors on whose work they based their own. Says Shaw, "There are still some varieties of the Florentine letter that we are intending to turn into fonts in the near future. I am in the midst of an ambitious project to inventory all of the inscriptions in Italy that are in the Florentine style." For Shaw and Boge, the documentation of Renaissance lettering and its inspiration for new fonts remains a work in progress. In an age where the ideals of classical beauty are often dismissed as insignificant, the Florentine Set deserves recognition as a faithful revival of ancient creativity, profundity, and foresight.

DESIGN © 1999 HENRIK BIRKVIG, COPENHAGEN

6

GOOD PAPER

A FEW SCRATCHES IN BLACK INK,

SOME RED

TO SET OFF THE BLACK, AND

THERE

(AS ÆSCULAPIUS HAD THE HABIT OF SAYING
TO THE THESSALONIANS)

YOU ARE

IN SHORT,
»LET PAPER DO MOST OF THE WORK.«

OSWALD COOPER

ABCDEFGHIJKLMNOPQRSTUVWXYZ
ABCDEFGHIJKLMNOPQRSTUVWXYZ
ABCDEFGHIJKLMNOPQRSTUVWXYZ
1234567890&!?:;"

28-POINT BEATA, DONATELLO, GHIBERTI

"It cannot be denied that the approval of such readers will be found if it be shown that the new typography is worthy of *The Times*—masculine, English, direct, simple, not more novel than it behoveth to be novel, or more novel than logic is novel in newspaper typography, and absolutely free from faddishness and frivolity."

This was written by Stanley Morison in his 1929 "Memorandum on a Proposal to Revise the Typography of *The Times*," after he was asked by *The Times* of London to design it a new text typeface. Prompted by an essay of Morison's titled "Newspaper Types: A Study of *The Times*," the paper's management wished to shed its typeface because it printed poorly and was out of date. Morison felt *The Times* needed a face that reflected the ideals of old-style type and also addressed issues of legibility, economy, and the demanding production conditions of the modern world. His perspective was a historical one. Morison wrote, "For whereas the history of the craft is that of letter cutting and founding as applied to the printing of books, the history of newspapers is that of the typesetting machine and the power press—the newspapers being left untouched either by the aesthetic movement of the '90s or the arts and crafts movement represented by William Morris."[1]

"Typography may be defined as the craft of rightly disposing printing material in accordance with specific purpose; of so arranging the letters, distributing the space and controlling the type as to aid to the maximum the reader's comprehension of the text. Typography is the efficient means to an essentially utilitarian and only accidentally aesthetic end, for enjoyment of patterns is rarely the reader's chief aim. Therefore, any disposition of printing material which, whatever the intention, has the affect of coming between author and reader is wrong. It follows that on the printing of books meant to be read there is little room for 'bright' typography. Even dullness and monotony in the typesetting are far less vicious to a reader than typographical eccentricity or pleasantry. Cunning of this sort is desirable, even

Morison's thinking was influenced by the 1926 Linotype release of Ionic, the first face in a series eventually called the Linotype Legibility Group. Ionic was designed to meet the requirements of the high-speed presses used in contemporary newspaper production, and it enjoyed immediate success. In devising the new font for *The Times*, Morison experimented with Perpetua, Baskerville, and several other faces to discern their relative legibility when printed at high speeds on newsprint using a curved stereoplate. Morison eventually settled on Monotype Plantin (Fig. 1) as his model for a new face to replace Times Old Roman.

1 24-POINT DIGITAL PLANTIN

abcdefghijklmno
PQRSTUVWXYZ
1234567890

Artist Victor Lardent assisted in drawing and revising the new alphabet until the look Morison desired was achieved. The result was a typeface quite similar to Plantin but with thinner, more refined serifs, and a deeper contrast between the thick and thin strokes (Fig. 2). The new face retained the old-style qualities of an oblique stress, oblique serifs on the lowercase letters, and bracketed serifs on the uppercase letters.

The name Times New Roman was taken from Times Old Roman, the original typeface used for *The Times*, and eventually the "new" was dropped from the name. In 1972, *The Times* replaced Morison's typeface with a commission from Linotype's designer Walter Tracy called Times Europa (Fig. 3). This face, which was better adapted to newspaper production, remained *The Time*s typeface until 1991. Interestingly, Times Europa is the most atypical of all the faces commissioned by *The Times* due to its heavy stroke weight and thick serifs. It is more influenced by the weighty Century Schoolbook than by its *Times* predecessors (see chapter on Century). Its heavy strokes improve readability but lose some of the typographic economy afforded by Times Roman.

To keep stride with digital technology, Aurobind Patel designed another new type family called New Times Millennium for the paper in 1991. In comparing this most recent development to the original Times New Roman, one finds that the body of the type has been slimmed down a bit. The bowl of the lowercase **a** is teardrop in shape. The numeral **7**

has a slight bow at the bottom of its stem; this elegantly echoes the curves of the **6** and **8**.

Morison's absorption with the history of printing led him to his appointment in 1923 as typographic advisor to the Monotype Corporation, where he played a major role in having many important type designs from the past adapted to machine composition. Morison saw his type revivals as an attempt to keep pace with the evolution of printing, but he incurred some difficulty in seeing his projects through to fruition.

2

essential in the typography of propaganda, whether for commerce, politics, or religion, because in such printing only the freshest survives inattention. But the typography of books, apart from the category of narrowly limited editions, requires an obedience to convention which is almost absolute—and with reason. Since printing is essentially a means of multiplying, it must not only be good in itself—but be good for a common purpose. The wider that purpose, the stricter are the limitations imposed upon the printer. He may try an experiment in a tract printed in an edition of 50 copies, but he shows the little common sense if he experiments to the same degree in the

3

TIMES EUROPA

abcdefghijklm

12345

His biggest setback in producing these revivals was his own lack of drawing expertise. The actual work of drawing and production was in the hands of the draftsmen (often women) and the engineers in Salfords, Surrey. Morison made proposals and suggested corrections, but his paucity of drawing skill left the final formalities of a typeface to the Salfords staff.[2] Although Morison is credited with the design of Times New Roman, it would not have been produced without the expertise of those artists who prepared the drawings from which the matrices were cut.

Morison was a champion of legibility and conservatism in type. His *First Principles of Typography*, written in 1929, is a short text that describes the elements of book design and production (see excerpt at right). In this text, Morison hailed the utilitarian nature of traditional book typesetting, going so far as to claim that dull and monotonous

tract of having a run of 50,000. Again, a novelty, fitly introduced into a 16–page pamphlet, will be highly undesirable in a 160–page book. It is the essence of typography and of the nature of the printed book qua book, that it perform a public service. For single or individual purpose there remains the manuscript, the codex; so there is something ridiculous in the unique copy of a printed book, though the number of copies printed may justifiably be limited when a book is the medium of typographical experiment. It is always desirable that experiments be made, and it is a pity that such "laboratory" pieces are so limited in number and in courage. Typography today does not not so much need Inspiration or Revival as Investigation. It is proposed here to formulate some of the principles already known to bookprinters, which investigation confirms and which nonprinters may like to consider for themselves. The laws governing the typography of books intended for general circulation are based first upon the essential nature of alphabetical writing, and secondly upon the traditions, explicit or implicit, prevailing in the society for

SUNDAY

typography was far less "vicious to the reader" than ornamental or ecstatic type. He felt that the "eccentric and cunning" types, as he called them, were essential to typographic propaganda in fields such as commerce, politics, and religion. In another essay in 1960, Morison added that modernist typography (such as was created at the Bauhaus) made an art out of something that should essentially be a service, not a violation of "tradition, convention, and orthodoxy."[3]

Times New Roman first appeared in *The Times* on October 3, 1932, but did not initially receive much attention in the U.S. The white, high-quality paper used for *The Times* carried more ink to the page, improving legibility, but this was not an expense American newpapers cared to absorb during the Great Depression of the '30s. Despite the initial rejection of Times New Roman by American newspapers, it came into favor for book and

which the printer is working. While a universal character or typography applicable to all books produced in a given national area is practicable, to impose a universal detailed formula upon all books printed in roman types is not. National tradition expresses itself the varying separation of the book into prelims, chapters, etc., no less than in the design of the type. But at least there are physical rules of linear composition which are obeyed by all printers who know their job. . . . The printer needs to be very careful in choosing his type, realizing that the more often he is going to use it, the more closely its design must approximate to the general idea held in the mind of the reader who is accustomed to the

commercial printing. Use of Times New Roman increased in America in 1941 when an issue of *Woman's Home Companion* used Morison's typeface in a spread. Soon after, both *American* magazine and *Collier's* employed it as well. In the 1990s, many magazines still use Times Roman as the running text for articles.

times new roman

MONOTYPE TIMES ROMAN

ADOBE TIMES ROMAN

PP

4

While Morison's concerns with economy and frugality in type played a large part in the design of Times New Roman, legibility studies conducted during the 1920s affected the whole field of newspaper font design. In 1931, the Mergenthaler Linotype company began to officially develop its Legibility Group. This group included fonts like Excelsior and Ionic, which were designed earlier, and Opticon and Paragon, which were designed specifically to avoid the ink-trap effect in the counterforms of tight characters.[4]

Another, more recent font developed mainly for news text and headlines is the Poynter series from Font Bureau (Fig. 7), released in 1998 as a part of the company's Readability Series. Designer Tobias Frere-Jones says, "A main goal for this type family was legibility, as well as an ability to withstand the rigors of mass-production media." In addition to an old-style serif, both Poynter Gothic, a sans serif, and Poynter Agate, for grades, weights, and fractions, complete the series. Poynter Oldstyle has a slightly heavier, bulkier look than Times New Roman. Its serifs are thicker and sturdier in order to hold up better on newsprint. While Poynter does gain some legibility, it loses some of the spatial economy found in Monotype's Times New Roman (Fig. 6).

In the 1960s, Monotype redesigned the Times family for use in photo-composition. The framework of its weights and character sets included

normal magazine, newspaper and book. It does no harm to print a Christmas card in blackletter, but who nowadays would set a book in that type? I may believe, as I do, that black-letter is in design more homogenous, more picturesque, more lively a type than the grey round roman we use, but I do not now expect people to read a book in it. Aldus's and Caslon's are both relatively feeble types, but they represent the forms accepted by the community; and the printer, as a servant of the community, must see them, or one of their variants."[5]

—Stanley Morison,
First Principles of Typography.

both display and text type sizes. Digitizing the Times family was the next logical step for Monotype. With the use of the phototypesetting master, the Times faces were converted to bitmaps for Monotype digital typesetting machines, and later converted to Postscript. Today, several versions of Times Roman exist in digital form, including those by Adobe and Monotype.

In comparing digital fonts such as Adobe's Times Roman and Monotype's Times New Roman (called Times NR MT), one finds little variation between lowercase letters except in the x-heights. Times NR MT carries a slightly larger x-height than Adobe's (Fig. 8). There is greater variety between the two in the capital letters. The tail of the Monotype **Q** has a gentler curl than that in the Adobe version (Fig. 5), while the Monotype **P** has a stronger, upturned bowl and greater contrast between the thick and thin strokes (Fig. 4). This characteristic is repeated on the capital **R**, where the top stroke of the bowl meets the stem stroke.

FONT BUREAU POYNTER TEXT 2

MONOTYPE TIMES NEW ROMAN

ABCDEFGHIJ PQRST abcdefg

An added note about Times Roman: in 1994, an article from *Printing History Journal* titled "W. Starling Burgess, Type Designer?" suggested that Morison was not the actual designer of Times New Roman. The author, Mike Parker, former director of type development at Linotype, began his story with an exploration of drawings for a lesser-known typeface called Monotype Series 54, a roman face much like Times New Roman. After speculating that these drawings were the real beginnings of Times New Roman, Parker offered that the true designer of the face was an American naval architect named W. Starling Burgess. Whether or not Parker's theory is valid, his article provoked a controversy in the type community that continues to this day.

Times Roman is not often lauded for its beauty, but due to its versatility, it remains a must-have typeface for today's designer. Digital versions of Times Roman are a mainstay of desktop publishing. The face's evolution through various technologies will undoubtedly continue, bringing to the reader a type that does not let its personality interfere with its purpose. Morison intended for Times New Roman to be read and not seen, and there is no doubt his intention has been realized.

60-POINT POYNTER OLDSTYLE DISPLAY

nn

8

abcdefghijklmnopqrstuvwxyz
ABCDEFGHIJKLMNOPQRSTUVWXYZ
1234567890 !$&:;'"?

24-POINT DIGITAL MONOTYPE TIMES NEW ROMAN

NOTES

1 Alexander Lawson, *Anatomy of a Typeface* (Boston: David R. Godine, Publisher, Inc., 1992), 270.

2 Robin Kinross, *Modern Typography* (London: Hyphen Press, 1992), 58.

3 Ibid., 61.

4 Lewis Blackwell, *20th Century Type* (Rizzoli International Publications, Inc., 1992), 116.

5 Stanley Morison, *First Principles of Typography* (New York: The Macmillan Company, 1936), 1-5.
 Reprinted with the permission of Cambridge University Press.

Remarkable for its revolutionary concept and innovative design, Univers set a new standard for typeface and type family creation. Adrian Frutiger's meticulously designed Univers has successfully stood the test of time and remains one of the most popular and versatile sans serifs.

In 1957, when the Paris type foundry Deberny et Peignot first distributed Univers, two qualities set Frutiger's new sans serif apart from its predecessors: the compatibility of all 21 members of the type family and the optical precision of each letterform, which was due to a reevaluation of the legibility of more geometric sans serifs such as Futura. Regarding the release of Univers, typographer Emil O. Biemann wrote, "What is significant here is not the birth of another typeface, for we are amply supplied with them, but upon the introduction of a completely new concept in type design that will have a profound effect not only upon the creation of new faces in the future, but upon the type selection process itself."[1]

The creation of Univers was the first instance in the modern era of a designer systematically developing nearly two dozen variations of one typeface. Frutiger elaborated on the concept of type families by creating an extensive, logically arranged palette of variations. The family's book face, Univers 55, was the basis for 20 other variations; each font was unique yet compatible with all others.

Using a designated numbering system, Frutiger arranged the members of the Univers family according to width, weight, and posture (Fig. 1). The x-axis governs the letter width in a transition between expanded and condensed. Along the y-axis, the stroke weight moves from heavy to light. Weight increase is indicated by numeric increase: Univers 83 is heavier, or bolder, than Univers 73. Most variations have an accompanying oblique. Univers obliques are consistently assigned even numbers: the light font is Univers 45, and the light italic, Univers 46.

1

Frutiger's original Univers palette is based on two major axes and includes oblique versions of most fonts. The first digit of each font number indicates the weight of the stroke, which increases as the number increases. The second digit indicates the stroke width, which again increases as the number increases. Odd numbers in the second position designate roman fonts and even numbers, obliques.

					39
	45	46	47	48	49
53	55	56	57	58	59
63	65	66	67	68	
73	75	76			
83					

The use of numeric variables, a key component of the system, was successful insofar as there was a sufficient degree of uniformity within the family, achieved in part by identical x-heights and consistent ascender/descender lengths. The integration of the 21 versions took three years of design effort and required cutting 35,000 final matrices.

Although Univers was a novel and commendable idea, type houses were not prepared for the new categorization system it established. Printers forced the Univers font into cases that organized and arranged preexisting type, overlooking the merits of Frutiger's original family structure. Because the Univers categories were not compatible with existing nomenclature, there were discrepancies among printers on how the Univers fonts were to be identified in type-specimen books, resulting in confusion for clients.

A revolutionary concept at the time, the model established by Frutiger has become a standard in modern type design and an inspiration for other designers. One type family developed in the tradition of Univers is Helvetica Neue, released as a digital face by Linotype in 1983 (see chapter on Helvetica and Meta, p. 140). And the numerical ordering of type established by Frutiger in the '50s is particularly well-suited to the digital realm, where typefaces appear on-screen as a menu list, a device recalling the sequential chart that typically describes the Univers type family.

To achieve the goal of an expansive, integrated type family, designers must be sensitive to the nuances of each letterform while simultaneously considering the overall system. In the case of Univers, this sophisticated approach to type-family design is supported by a well-considered set of typographical characters. Inspired by his study of the limitations of existing sans serifs, Frutiger began with the assumption that "a purely geometric character is unacceptable in the long run, for the horizontal lines appear thicker to the eye than the vertical ones; an **O** represented by a perfect circle strikes us as shapeless and has a disturbing effect on the word as a whole."[2] By overlapping a **Z** and **T** of the same point size, variation in stroke thickness becomes apparent (Fig.3). Frutiger's decision to use different stroke thicknesses for the horizontals, diagonals, and verticals was a response to his assessment of visual discrep-

2

Typeface sketches made by Frutiger that served as the basis for Univers, 1950.

omenst hf
udong pin

3

In the Univers type family, vertical, diagonal, and horizontal strokes are all assigned different thicknesses to compensate for illusions in optical perception. Overlapping a Z and a T of the same point size reveals that vertical strokes are thicker than diagonal ones.

By Jennifer Gibson

e e
e e

ABCDEF
ABCDEF
ABCDEF

5

76-POINT FUTURA BOOK BY PAUL RENNER, 1927.
60-POINT MICROGRAMMA BY ALESSANDRO BUTTI, 1939.
77-POINT UNIVERS 55 BY ADRIAN FRUTIGER, 1957.

ancies in other typefaces. It is also no coincidence that Frutiger's interest in creating a functional and efficient type family followed well-documented scientific research done in the 1930s and '40s on the mechanics of eye movement during reading.

In the 1990s, Adobe Systems took the idea of Frutiger's typographic palette a step further with the introduction of multiple-master fonts such as Myriad (Fig. 4), a face designed by Carol Twombley and Robert Slimbach in 1992. Whereas Frutiger had to generate new letterforms for each variation by hand, multiple-master faces allow the user to alter and interpolate letterforms automatically along specific axes, which may include width, weight, optical size, and extender length. Frutiger's typographic matrix was one of the precedents for this and other recent attempts to achieve a conceptual ideal within a single type family.

When Univers was designed, it was truly a contemporary typeface in production and form, created initially as both a metal type and a phototype—cutting-edge by 1957 standards. Its form was also a visual expression of the optimism of the 1950s regarding technology and mechanical sophistication. Like the Univers letterforms, many popular, "streamlined" consumer products—from cars to kitchen appliances (Fig. 6)—celebrated the sleek efficiency of the machine age.

A distinctive feature of Univers is the strong horizontal flow created by lines of text. To achieve this flow, Frutiger made round letters, such as **o**, less smooth and more square, creating a more fluid relationship between letters such as **n** and **m**, which typically have square contours. A precedent for this squaring-off of letter types appeared in Microgramma, an all-capital face designed by Alessandro Butti in 1939.

6

The smooth, sleek, aerodynamic curves of this 1950s Porsche connote speed and efficiency, much like lines of text set in Univers.

Photo: Porsche Cars North America.

Univers strikes a careful balance between the squareness of Microgramma and the roundness of Futura (Fig. 5). Frutiger also created horizontal stroke endings in letters such as **a**, **c**, **e**, **g**, and **s** (Fig. 7), which contributes to the typeface's linear quality.

While Frutiger's goal was to make letters that fit together so flawlessly that the assemblage formed a new and satisfying *gestalt*, he also deemed it important that individual letterforms remain distinct from one another. "Built up from a geometrical basis, the lines must play freely," Frutiger wrote, "so that the individuals find their own expression and join together in a cohesive structure in word, line, and page."[3] To maintain the integrity of each letterform, careful optical adjustments were made, based on the current knowledge of the principles of perception. The **c** is smaller than the **o** because in open letters the white space achieves greater penetration into the form, thereby appearing larger (see large letters, p. 170). The **n** is slightly larger than the **u** because white entering a letterform from the top appears more active than white entering from the bottom. Ascenders and descenders were shortened in comparison with existing typographic norms, and x-heights were increased. Larger x-heights also provided greater legibility, addressing the concern that sans-serif type was more difficult to read than serif type. All of these innovations contributed to the overall harmony among letters, allowing for a smooth line flow (Fig. 8).

7

Terminals of letters such as **s** and **e** are horizontal.

8

Having a large x-height in relation to cap-height enhances Univers's legibility

Ascenders and descenders in typefaces such as Linotype's Garamond No. 3 can be close to 50 percent longer than those in Univers.

9
Poster for Columbia School of Architecture lecture series, 1994.
Designer: Willi Kunz.

10
Univers is playful and kinetic in this book cover
for MIT Press. Designer: Jeffrey Kälin.

While a reflection of the decade in which it was created, Univers has many enduring qualities that have enabled it to survive despite the tremendous increase in typeface alternatives. Because of its well-crafted, well-proportioned letterforms and the diversity of its family, it can set the tone in a variety of design projects. For example, in a 1994 poster designed by Willi Kunz (Fig. 9), Univers's flexibility allows for a wide variety of emphasis within an extremely text-heavy composition. Rules and bars complement the typeface's strong linear character. Due to its clean lines, Univers works well both on its own and with other faces. For these reasons, such well-known designers as Kit Hinrichs, April Greiman, and Jeffrey Kälin employ Univers in their work (Fig. 10).

The Univers family, as we know it today, has not escaped the march of technology. However, there is a significant difference conceptually between Frutiger's presentation of the Univers family as a seamless palette of fonts and the way it has been packaged in its various digital incarnations. The Adobe fonts, for example, do not maintain all of Frutiger's labels, nor do they present themselves definitively as a unified system. They are organized in distinct suitcase sets: Univers, Univers Extended, Univers Condensed, and Univers Ultra Condensed. While the digital classifications correspond to the original Univers palette chart (with three additions: Univers 85 extra black, Univers 85 extra black oblique, and Univers 83 extended extra black oblique), they don't consistently use Frutiger's numerals as designators. Also, italics forgo the even number designation in favor of the descriptive term "oblique." For example, Univers 48 is referred to as Univers 47 oblique.

11
Univers can be extremely utilitarian. Here, it
remains highly legible at several sizes,
from the large display type naming the various
gasolines to the small instructional text type.

Photo: Jennifer Gibson.

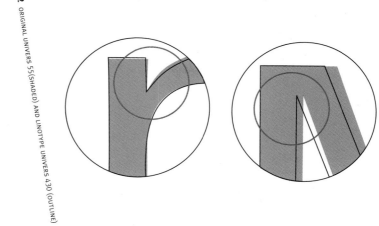

Linotype Univers, released by Linotype in 1997, is a recent attempt to reestablish the richness of Frutiger's design within the digital environment. Frutiger himself worked with the Linotype design team in updating the font. Adjustments were made to the outlines of many letterforms and letter spacing was modified. The goal, according to Linotype, was "to enhance the quality of the outlines and the design of individual characters and to develop the original 'Univers concept' by delivering closely graded, systematically matched weights." Differences between the original and the more recent Linotype release are evident in letter-by-letter comparisons (Fig. 12). Even more apparent than the subtle alterations of letterforms is the obvious restructuring of the numerical system. It was expanded from two to three digits, the first defining weight; the second, width; and the last, position (Fig. 13). The parent face for this version is Linotype Univers 430, rather than Univers 55.

In 1985, while the desktop computer was still in its infancy, type designer Zuzana Licko embraced the limitations of new technology by designing typefaces with intentionally bitmapped forms. Several of these fonts, such as Oakland 10, Universal 8, and Emperor 15 (Fig.14), include details with a nod to Univers: the indication of thick and thin strokes on the **m** and **n** in Oakland, the proportions of Emperor 15, and, in the case of Universal 8, the font name. Regarding her approach to type design, Licko says, "I search out a problem that needs to be addressed or a unique result that a certain production method can yield." In the case of her coarse resolution fonts, this philosophy led to a modular approach to letterform construction based on a one-unit pixel. Emperor, for example, maintains a one-pixel stem to two-pixel counter ratio, while the Universal family uses a one-pixel stem to three-pixel counter ratio.

13

Numerical system for the 1997 Linotype Univers, in which each weight is assigned a three-digit number. The first digit defines the weight; the second digit, the width; and the last digit, the position.

abcdefghijklmnopqrs

abcdefghijklmnopqrs

14

TOP ROW: 62-POINT EMPEROR 15 AND OAKLAND 10

BOTTOM ROW: 48-POINT UNIVERS (39) ULTRA CONDENSED THIN AND UNIVERS 55

16 30-POINT FRUTIGER 55

After Univers, Frutiger designed many other effective typefaces. The typeface Frutiger, originally called Roissy,[4] was viewed by its creator as a necessary evolution of both Helvetica and Univers. The Frutiger face was developed in 1975 for use on signage at the Charles de Gaulle airport in Roissy, France, outside of Paris (Fig. 15). According to Frutiger, the type's initial purpose—clarity in varying sizes from significant distances—was central to the creation of its letterforms, as was the need for the alphabet to be "suited to the architecture and function of the airport."[5] The manual for les Aéroports de Paris (Fig. 17) illustrates the carefully controlled alignment of the letterforms. However, functional requirements were tempered by the designer's desire to avoid letterforms that he called "too clinically constructed in appearance."[6] Rather, the letterforms reflect optical features of classical roman inscriptional fonts.[7] This latter influence clearly infuses the face with a human quality lacking in some sans serifs.

How do the Univers and Frutiger faces compare? They were designed nearly ten years apart, thus they project rather different sensibilities. Frutiger is perceived as warm, friendly, and approachable, while Univers is seen as clean, objective, and rational. Despite these differences, the 14-member Frutiger family and the 21-member Univers family share many formal qualities: Frutiger maintains Univers's rectangular dots over the **i** and **j** (Fig. 19); the treatment of thick and thin strokes is almost identical, as evident in a comparison of the **m**s and **n**s; and many other letterforms are structurally similar. The major formal difference between Frutiger and Univers is that the letters in the former tend to be more open, a fact most obvious in letters with curves that end in an opening such as **C, G, J, c, e, g, s** and the numerals **2, 3, 5, 6, 9** (Fig. 16). Any comparison of the Univers and Frutiger families reveals that only a slight shift in formal qualities can result in a significantly different emotive effect.

17

Detail from Frutiger's type manual for les Aéroports de Paris, 1975.

18

Unlike Frutiger, Myriad includes a true italic.

19

Like Univers, Frutiger has rectangular dots over the **i** and **j**.

Since its introduction in 1976, the Frutiger type family has been widely used by typographers and designers. A poster for the Council of Landscape Architecture demonstrates that mixing Frutiger's weights and sizes can result in a compelling texture that is both dynamic and unified (Fig. 20).

While also influenced by Univers, Myriad, the Adobe multiple-master font, seems to have even more in common with Frutiger, especially in the open letterforms of both faces. Potential limitations of Frutiger and Myriad are their lack of text figures and small caps, although Myriad, unlike Frutiger, does include a true italic (Fig. 18).

Adrian Frutiger's Univers and Frutiger type families are among the most popular and widely respected type designs of the 20th century. Given their timeless quality, the result of tremendous consideration on the part of their creator, it is no surprise that both typefaces have been admitted into the pantheon of classics.

NOTES

1 John Bielek, "Univers," *An Investigation of the Typographic Font* (Richmond: Communication Arts and Design Department, Virginia Commonwealth University, 1988).

2 Alexander S. Lawson, *Anatomy of a Typeface* (Boston: Godine, 1990), 304.

3 Adrian Frutiger, *Type Sign Symbol* (Zurich: ABC Edition, 1980), 16.

4 It was not until the following year, when Stempel asked Frutiger to redesign "Roissy" for printing, that the name was changed to Frutiger. Lawrence W. Wallis, *Modern Encyclopedia of Typefaces* (New York: Van Nostrand Reinhold, 1990), 76.

5 Adrian Frutiger, op. cit., 80.

6 Ibid., 82.

7 Philip Meggs, Rob Carter, *Typographic Specimens: The Great Typefaces* (New York: Van Nostrand Reinhold, 1993), 163.

20
Poster employing three weights of Frutiger, 1995. Designer: Paula J. Curran; client: Council of Educators in Landscape Architecture, Iowa State University.

abcdefghijklmnopqrstuvwxyz
ABCDEFGHIJKLMNOPQRSTUVWXYZ
1234567890&!?:;"

28-POINT ADOBE UNIVERS

abcdefghijklmnopqrstuvwxyz
ABCDEFGHIJKLMNOPQRSTUVWXYZ
1234567890&!?:;"

28-POINT ADOBE FRUTIGER

alignment. Precise arrangement of letterforms on an imaginary horizontal or vertical line.

alphabet length. Horizontal measure of the lowercase alphabet in a type font, used to approximate the horizontal measure of type set in that font.

ampersand. Typographic character (**&**) representing the word "and."

anti-aliasing. The blurring of a jagged line or edge on a screen or output device to give the appearance of a smooth line.

aperture. The opening to a counter in a letterform; for example, an **H** has two apertures.

apex. The peak of a triangle where two strokes meet.

arm. A projecting horizontal, or ascending diagonal, stroke that is unattached on one or both ends, as in **T** or **E**.

ascender. A stroke in a lowercase letter that rises above the meanline.

aspect ratio. The ratio of an image, screen, or other medium's height to its width. Images will become distorted if forced into a different aspect ratio during enlargement, reduction, or transfers.

backslant. Letterforms having a diagonal slant to the left.

base alignment. A typesetter or printer specification that the baseline for all letters should be horizontal, even in a line of mixed sizes or styles; also called baseline alignment.

baseline. An imaginary horizontal line on which the base of each capital letter rests.

Bézier curves. A type of curve with nonuniform arcs, as opposed to curves with uniform curvature, which are called arcs. A Bézier curve is defined by specifying control points that set the shape of the curve, and are used to create letter shapes and other computer graphics.

bitmap. A computerized image made up of dots. These are "mapped" onto the screen directly from corresponding bits in memory (hence the name).

bitmapped font. A font whose letters are composed of dots, such as fonts designed for dot matrix printers. See *outline font*, *screen font*.

body size. Depth of a piece of metal type, usually measured in points; now used for the vertical measure assigned to a character.

body type. Text material, usually set in sizes from 6 to 12 point. Also called text type.

boldface. Type with thicker, heavier strokes than those of the regular weight font.

bowl. A curved stroke enclosing the counterform of a letter. (An exception is the bottom form of the lowercase **g** which is called a loop.)

cap height. Height of capital letters, measured from the baseline to the capline.

capline. Imaginary horizontal line defined by the height of the capital letters.

capitals. Letters larger than—and often differing from—the corresponding lowercase letters. Also called uppercase.

caps. See *capitals*.

character. Symbol, sign, or mark in a language system.

cicero. European typographic unit of measure, approximately equal to the American pica.

column guide. Nonprinting lines that define the location of columns of type.

composition. Alternate term for typesetting.

composing stick. Adjustable hand-held metal tray, used to hold handset type as it is being composed.

compositor. Person who sets type.

condensed. Letterforms whose horizontal width has been compressed.

counter. The negative or white space fully or partly enclosed by a letterform.

counterform. Negative spatial areas defined and shaped by letterforms, including both interior counters and spaces between characters.

crossbar. A horizontal stroke connecting the sides of a letter such as **A** or **H**; or bisecting the main stroke as in **f** or **t**.

cursive. Typestyles that imitate handwriting, often with letters that do not connect.

dazzle. Visual effect caused by extreme contrast in the strokes of letterforms.

descender. A stroke on a lowercase letter that descends below the baseline, as in **g** or **y**.

desktop publishing. The popular use of this term is incorrect, because publishing encompasses writing, editing, designing, printing, and distribution activities, not just makeup and production. See *electronic page design*.

digital type. Type stored electronically as digital dot or stroke patterns, rather than as photographic images.

display type. Type sizes 14 point and above, used primarily for headlines and titles.

dots per inch (dpi). A measure of the resolution of a screen image or printed page. Dots are also know as pixels. Some computer screens display 72 dpi; many laser printers print 300 dpi; and imagesetters often print 1270 or 2540 dpi.

drop initial. Display letterform set into the text.

ear. A small stroke that often projects from the upper side of the bowl of a lowercase **g**.

Egyptian. Typefaces characterized by slablike serifs similar in weight to main strokes.

electronic page design. The layout and typesetting of complete pages using a computer with input and output devices.

em. The square of the body size of any type, used as a unit of measure. In some expanded or condensed faces, the em is also expanded or condensed from the square proportion.

en. One-half of an em. See *Em*.

expanded. Letterforms whose horizontal width has been extended.

eye. The enclosed part of the lowercase **e**.

face. The part of metal type that is inked for printing. Also, another word for typeface.

family. See *type family*.

fillet. The contoured edge that connects the serif and stem in bracketed serifs. (Bracketed serifs are connected to the main stroke by this curved edge; unbracketed serifs connect to the main stroke with an abrupt angle without this contoured transition.)

film font. A photographic film master used in phototypesetting machines. Characters from a film font are exposed through lenses of different sizes onto paper or film.

fit. Refers to the spatial relationships between letters after they are set into words and lines.

flush left (or right). The even vertical alignment of lines of type at the left (or right) edge of a column.

font. A complete set of characters in one design, size, and style. In traditional metal type, a font meant a particular size and style; in digital typography, a font can output multiple sizes and even alter styles of a typeface design

format. The overall typographic and spatial schema established for a publication or any other application.

foundry type. Metal type used in hand composition.

galley proof. Originally, a type proof pulled from metal type assembled in a galley. Frequently used today to indicate any first proof, regardless of the type system.

grid. Underlying structure composed of a linear framework used by designers to organize typographic and pictorial elements. Also, a film or glass master font, containing characters in a predetermined configuration and used in phototypesetting.

grotesque. Name for sans-serif typefaces based on 19th-century display models.

hairline. Thinnest strokes on a typeface having strokes of varying weight.

hand composition. Method of setting type by placing individual pieces of metal type from a type case into a composing stick.

heading. Copy that is given emphasis over the body of text, through changes in size, weight, or spatial interval.

headline. The most significant type in the visual hierarchy of a printed communication.

hot type. Type produced by casting molten metal.

imposition. The arrangement of pages in a printed signature to achieve the proper sequencing after the sheets are folded and trimmed.

indent. An interval of space at the beginning of a line to indicate a new paragraph.

inferior characters. Small characters, usually slightly smaller than the x-height, positioned on or below the baseline and used for footnotes or fractions.

initial. A large letter used at the beginning of a column; for example, at the beginning of a chapter.

interletter spacing. The spatial interval between letters, also called letterspacing.

interline spacing. The spatial interval between lines, also called leading.

interword spacing. The spatial interval between words, also called wordspacing.

italic. Letterforms having a pronounced diagonal slant to the right.

jaggies. The jagged staircase edges formed on raster-scan displays when displaying diagonal and curved lines. See *anti-aliasing*.

justified setting. A column of type with even vertical edges on both the left and the right, achieved by adjusting interword spacing. Also called flush left, flush right.

justified text. Copy in which all the lines of text—regardless of the words they contain—have been made exactly the same length, so that they align vertically at both the left and right margins.

kerning. In typesetting, kerning refers to the process of subtracting space between specific pairs of characters so that the overall letterspacing appears to be even. See *tracking*.

Latin. Type styles with triangular, pointed serifs.

leading (led´ing). In early typesetting, strips of lead were placed between lines of type for spacing, hence the term. See *linespacing*, *interline* spacing.

leg. A descending diagonal stroke, as found on **k** or **R**. (Sometimes, a leg is called a tail.)

letterpress. The process of printing from a raised, inked surface.

letterspacing. See *interletter spacing*.

ligature. A typographic character produced by combining two or more letters.

line spacing. The vertical distance between two lines of type measured from baseline to baseline. For example, "10/12" indicates 10-point type with 12 points base-to-base (that is, with 2 points of leading). See *leading, interline spacing*.

lining figures. Numerals identical in size to capitals and aligned on the baseline: 1 2 3 4 5 6 7 8 9 10.

link. The stroke that connects the bowl and the loop of a lowercase roman **g**.

Linotype. A machine that casts an entire line of raised type on a single metal slug.

loop. The bottom form of the lowercase **g**.

lowercase. The alphabet set of small letters, as opposed to capitals.

Ludlow. A typecasting machine that produces individual letters from hand-assembled matrices.

machine composition. General term for the mechanical casting of metal type.

makeup. The assembly of typographic matter into a page, or a sequence of pages, ready for printing.

matrix. In typesetting, the master image from which type is produced. The matrix is a brass mold in linecasting and a glass plate bearing the font negative in phototypesetting.

meanline. An imaginary line marking the tops of lowercase letters, not including the ascenders.

minuscules. An early term for small, or lowercase, letters.

minus spacing. A reduction of interline spacing, resulting in a baseline-to-baseline measurement that is smaller than the point size of the type.

modern. Term used to describe typefaces designed at the end of the 18th century. Characteristics include vertical stress, hairline serifs, and pronounced contrasts between thick and thin strokes.

Monotype. A trade name for a keyboard-operated typesetting machine that casts individual letters from matrices.

monospacing. Spacing in a font with characters that all have the same set width or horizontal measure; often found in typewriter and screen fonts. See *proportional spacing*.

multiple master. Adobe fonts with variable attributes such as stroke weight, width, posture, serif size, etc., that can be adjusted by the designer.

negative. The reversal of a positive photographic image.

oblique. A slanted roman character. Unlike many italics, oblique characters do not have cursive design properties.

offset lithography. A printing method using flat photo-mechanical plates, in which the inked image is transferred or offset from the printing plate onto a rubber blanket, then onto the paper.

old style. Typeface styles derived from 15th- to 18th-century designs, and characterized by moderate thick-and-thin contrasts, bracketed serifs, and a handwriting influence.

old-style figures. Numerals that exhibit a variation in size, including characters aligning with the lowercase x-height, and others with ascenders or descenders: 1 2 3 4 5 6 7 8 9 10.

OpenType. An initiative between Adobe Systems and Microsoft in 1996 to combine Type One and TrueType digital font representations into a compatible format. OpenType may be poised to be the emerging digital type standard.

optical adjustment. The precise visual alignment and spacing of typographic elements.

outline font. A font designed, not as a bitmap, but as an outlines of the letter shapes which can be scaled to any size. Laser printers and imagesetters use outline fonts. See *bitmapped font* and *screen font*.

outline type. Letterforms described by a contour line that encloses the entire character on all sides. The interior usually remains open.

paragraph mark. Typographic elements (¶, for example) that signal the beginning of a paragraph.

photocomposition. The process of setting type by projecting light onto a light-sensitive film or paper.

photodisplay typesetting. The process of setting headline type on film or paper by photographic means.

phototype. Type matter set on film or paper by photographic projection of type characters.

pica. Typographic unit of measurement: 12 points equal 1 pica. 6 picas equal approximately 1 inch. Line lengths and column widths are measured in picas.

pixel. Stands for picture element; the smallest dot that can be displayed on a screen.

point. A measure of size used principally in typesetting. One point is equal to 1/12 of a pica, or approximately 1/72 of an inch. It is most often used to indicate the size of type or amount of leading added between lines.

PostScript. A page-description programming language created by Adobe Systems that handles text and graphics, placing them on a page with mathematical precision.

processor. In a computer system, the general term for any device capable of carrying out operations on data. In phototypography, the unit that automatically develops the light-sensitive paper or film.

proof. Traditionally, an impression from metal type for examination and correction; now applies to initial output for examination and correction before final output.

proportional spacing. Spacing in a font adjusted to give wide letters (**M**) a larger set width than narrow letters (**I**).

ragged. See *unjustified type*.

resolution. The degree of detail and clarity of a display; usually specified in dots per inch (dpi). The higher the resolution, or the greater the number of dpi, the sharper the image.

reverse. Type or image that is dropped out of a printed area, revealing the paper surface.

reverse leading. A reduction in the amount of interline space, making it less than normal for the point size. For example, 12-point type set on an 11-point body size becomes reverse leading of 1 point.

river. In text type, a series of interword spaces that accidentally align vertically or diagonally, creating an objectionable flow of white space within the column.

roman. Upright letterforms, as distinguished from italics. More specifically, letters in an alphabet style based on the upright, serifed letterforms of Roman inscriptions.

rule. In handset metal type, a strip of metal that prints as a line. Generally, any line used as an element in typographic design, whether handset, photographic, digital, or hand-drawn.

sans serif. Typefaces without serifs.

screen font. A bitmapped version of an outline font that is used to represent the outline font on a computer screen.

script. Typefaces based on handwriting, usually having connecting strokes between the letters.

serifs. Small elements added to the ends of the main strokes of a letterform in serif typestyles.

set width. In metal type, the width of the body on which a letter is cast. In phototype and digital type, the horizontal width of a letterform measured in units, including the normal space before and after the character. This interletter

space can be increased or decreased to control the tightness or looseness of the fit.

shoulder. A curved stroke projecting from a stem.

slab serifs. Square or rectangular serifs that align horizontally and vertically to the baseline and are usually the same (or heavier) weight as the main strokes of the letterform.

slug. A line of metal type cast on a linecasting machine, such as the Linotype. Also, strips of metal spacing material in thicknesses of 6 points or more.

small capitals. A set of capital letters having the same height as the lowercase x-height, frequently used for cross reference and abbreviations. Also called small caps, and often abbreviated s.c.

smoothing. The electronic process of eliminating jaggies (the uneven staircase effect on diagonal or curved lines).

solid. Lines of type that are set without additional interline space. Also called set solid.

sorts. In metal type, material that is not part of a regular font, such as symbols, piece fractions, and spaces. Also, individual characters used to replace worn-out type in a font.

spine. The central curved stroke of the letter **S**.

spur. A projection, usually smaller than a serif, that reinforces the point at the end of a curved stroke, often on a **G** or **b**.

stem. The major vertical or diagonal stroke in a letterform.

stroke. Any of the linear elements within a letterform; originally, any mark or line made by the movement of a pen or brush in writing.

subscript. A small character beneath (or adjacent to and slightly below) another character.

superscript. A small character above (or adjacent to and slightly above) another character.

swash letters. Letters ornamented with flourishes or flowing tails.

tail. A diagonal stroke or curve at the end of a letter, as in **Q**, **R**, or **j**.

terminal. The end of any stroke that does not terminate with a serif.

text. The main body of written or printed material, as opposed to display matter, footnotes, appendices, etc.

text type. See *body type*.

tracking. The overall tightness or looseness of the spacing between all characters in a line or block of text. Sometimes used interchangeably with "kerning," which more precisely is the reduction in spacing between a specific pair of letters.

transitional. Classification of type styles combining aspects of both old-style and modern typefaces; for example, Baskerville.

TrueType. Digital font representation developed jointly by Apple Computer and Microsoft in response to Adobe Systems's Type One format.

typeface. The design of alphabetical and numerical characters unified by consistent visual properties.

type family. The complete range of variations of a typeface design, including roman, italic, bold, expanded, condensed, and other versions.

Type One fonts. Proprietary digital font representation developed by Adobe Systems in the mid-1980s as part of the PostScript page-description language. The Type One representation was made public with the release of Adobe Type Manager in 1990.

typesetting. The composing of type by any method or process; also called composition.

type specimen. A typeset sample produced to show the visual properties of a typeface.

typography. Originally, the composition of printed matter from movable type; now the art and process of typesetting by any system or method.

unit. A subdivision of the em, used in measuring and counting characters in photo- and digital-typesetting systems.

unitization. The process of designing a typeface so that the individual character widths conform to a unit system.

unitized font. A font with character widths conforming to a typesetter's unit system.

unit system. A counting system first developed for Monotype, used by most typesetting machines. The width of characters and spaces are measured in units. This data is used to control line breaks, justification, and spacing.

unit value. The established width, in units, of a typographic character.

unjustified type. Lines of type set with equal interword spacing, resulting in irregular line lengths; also called ragged.

uppercase. See *capitals*.

weight. The lightness or heaviness of a typeface, determined by ratio of the stroke thickness to character height.

white space. The negative area surrounding a letterform. See *counter, counterform*.

width tables. Collections of information about how much horizontal room each character in a font should occupy, often accompanied by information about special kerning pairs or other exceptions.

wood type. Handset types cut from wood by a mechanical router. Formerly used for large display sizes that were not practical for metal casting.

wordspacing. In typesetting, adding space between words to extend each line to achieve a justified setting. See *interword spacing*.

WYSIWYG. Abbreviation for "what you see is what you get;" pronounced Wizzywig. It means the screen image is identical to the image that will be produced as final output.

x-height. The height of lowercase letters, excluding ascenders and descenders; often measured by the lowercase **x**.